# DRAWING AND PAINTING
# BUILDINGS

To Marian
Best Wishes
from Jonathan Newey

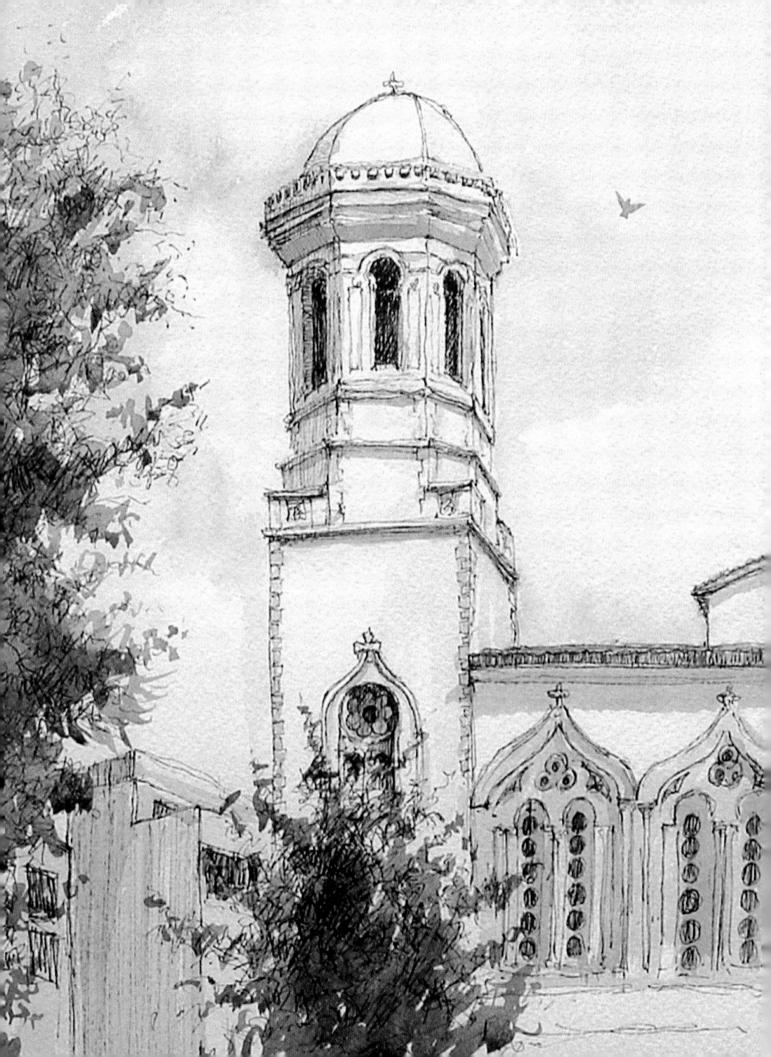

# DRAWING AND PAINTING
# BUILDINGS

JONATHAN NEWEY

THE CROWOOD PRESS

First published in 2008 by
The Crowood Press Ltd
Ramsbury, Marlborough
Wiltshire SN8 2HR

**www.crowood.com**

**British Library Cataloguing-in-Publication Data**
A catalogue record for this book is available from the British Library.

ISBN 978 86126 999 7

Typefaces used: text, Stone Sans; headings, Frutiger;
chapter headings, Rotis Sans.

Typeset and designed by Shane O'Dwyer
Swindon, Wiltshire.

Printed and bound in Singapore by Craft Print International, Ltd

# CONTENTS

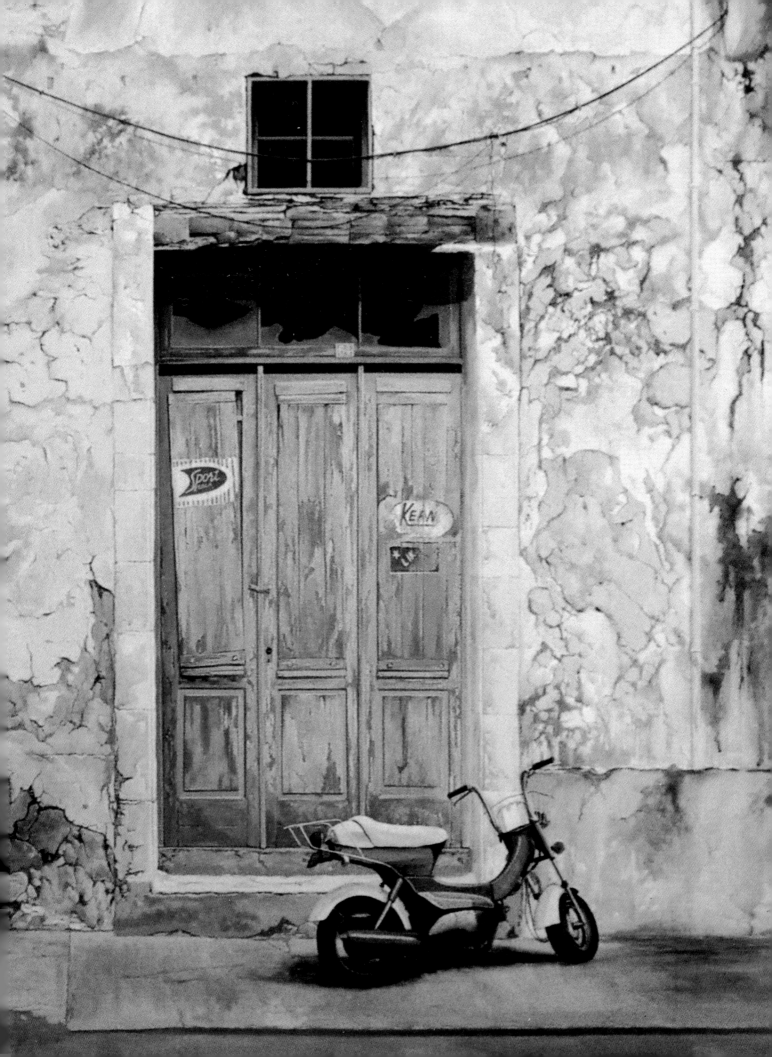

# PREFACE

There are tall buildings, short buildings, old, new, large and small buildings. A huge variety of architectural styles from all over the world and from thousands of years ago up to modern times. A vast and varied selection of buildings that will inspire and amaze you. This book will show you how to draw and paint these wonderful buildings and also how to use different mediums and styles to produce almost as many varieties of drawings and paintings as there are subject matters.

Using simple and easy to follow instructions, this book will describe the many different types of buildings and how to draw and paint them in a variety of styles and mediums. In the Introduction, you will be shown the different tools and equipment used to produce some of the illustrations in this book and which medium to choose for a particular style of painting.

*Drawing and Painting Buildings* comprehensively covers a variety of subjects including two and three dimensions, perspective, composition, how to draw and paint both old buildings and new buildings, architectural detail, buildings in the landscape, sketching and a chapter on alternative techniques that will cover subjects such as abstract work, impressionism and mixed media.

I hope that this book will inspire you to look at buildings in a different way and to get the maximum enjoyment from the mediums used in this book.

**OPPOSITE PAGE:**
*Little Green Scooter.*
**Acrylic on canvas.**

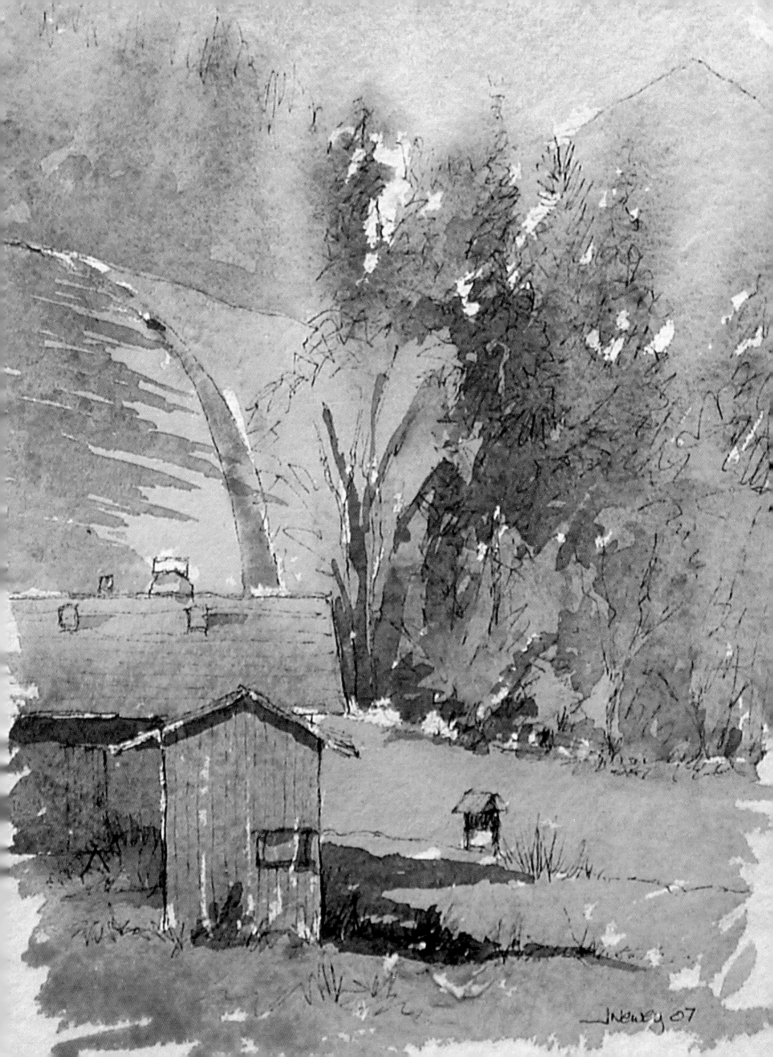

JNewey 07

# INTRODUCTION: TOOLS AND MATERIALS

## Drawing

There is a huge variety of drawing mediums and surfaces available to the artist today. Indeed, you can draw with anything that makes a mark on a piece of paper, such as pencil, charcoal, a stick dipped into paint or ink and so on. This means that drawing buildings is also the cheapest and easiest way to get started – all you need is a pencil and a sheet of paper

**OPPOSITE PAGE:**
***The Goat Herder's Hut, French Alps.***
**Pen and watercolour wash on paper.**

**THIS PAGE:**
**Graphite pencils come in a variety**
**of strengths, both hard and soft.**

## Graphite Pencils

Graphite pencils are available in varying degrees of hardness. Most artists use the 'B' range of pencils for drawing and sketching. The 'B' refers to the amount of graphite in the pencil, so a B is the hardest of the B range, whereas 9B is the softest. Each pencil within this range will give you a variety of different marks and shades depending on the softness of the pencil and how hard you press. There is also a range of hard pencils available called the 'H' range. These vary in hardness from H, which is the softest of the H range, through to 6H, which is extremely hard. In the middle of the H and B pencils is one called 'HB'. This is the grade of pencil that most people are familiar with.

In the exercises in this book you will be told at the beginning of each one which pencils are being used (none will be harder than the H pencils). Graphite pencil can be used on any white paper such as cartridge paper, although the rougher the paper, the more of the paper's texture will show in the drawing.

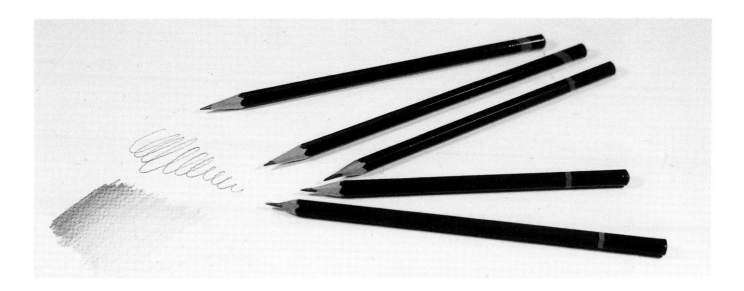

## Coloured Pencils

The coloured pencil, or 'crayon', has been available for almost as long as the graphite pencil, but has not, until recently, been used as a serious drawing medium by artists. Today, you can choose from a large selection of artists' quality coloured pencils and they are a useful edition to your pencil collection.

The hardness of the pencil is the same within the range of colours that can be purchased, but may vary slightly depending on which manufacture of pencil you purchase. They come in a wide range of colours, sometimes as many as one hundred different shades, and some types of coloured pencil can actually be used like a watercolour paint. These are called water-soluble coloured pencils and can be used with a brush and some water to produce a watercolour sketch effect. They can also be used dry like a normal coloured pencil. If using the water-soluble pencils wet, then you will need a small, round watercolour brush and a container of water with which to loosen the pigment.

Coloured pencil can be applied to any paper or board surface providing it is not shiny or greasy. Some favourites are white cartridge paper, coloured pastel paper, watercolour paper (especially if using the water-soluble coloured pencils) and the coloured mount board used in the picture-framing industry. As with the graphite pencils, the rougher the surface, the more of the paper texture will show through in your drawing. Coloured pencils do not need to be fixed once the drawing is completed.

## Charcoal, Chalk and Pastel

The pencils described above are all encased in wood, therefore have a thinner point to work with. However, if you wish to work on a larger scale and perhaps with a more energetic and freer style, then the best mediums to work with are the black, white and coloured sticks called charcoal (black), chalk (white) and pastel (coloured).

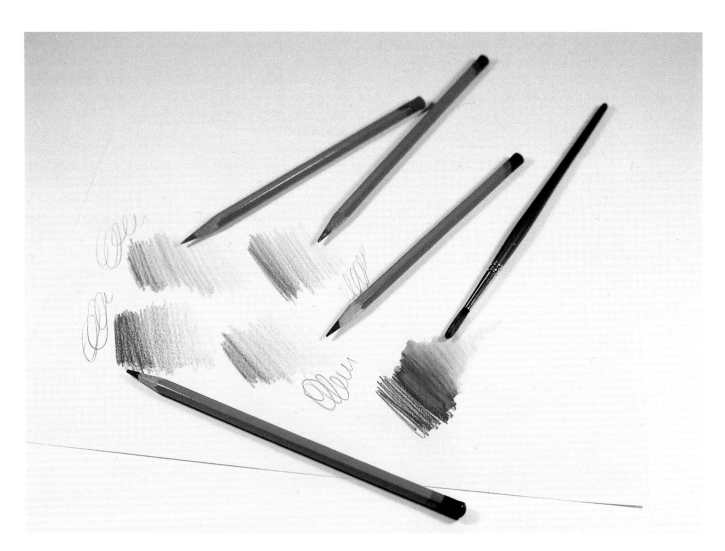

**Watercolour pencils can be used both dry and as a paint when wetted.**

Charcoal sticks have been used by artists for centuries. They are made from charred willow twigs and produce an extremely black mark. They can be used on white cartridge paper to produce quick, gestural drawings and sketches.

White chalk is a useful medium to use with charcoal if drawing on grey paper. The grey of the paper acts as a middle ground for the black and white of the charcoal and chalk.

Pastels are coloured sticks that are available as either dry chalk pastel or oil pastel.

Dry pastel can be used in the same way as charcoal and chalk and can be blended together to produce soft variations of colour that can achieve highly realistic results. Dry pastel is normally used on different coloured pastel paper. The colour of paper chosen would depend on the overall feel or appearance you are seeking for the finished picture.

Oil pastel is similar in appearance to dry pastel but the colour pigments are bound together by oil rather than chalk. This gives oil pastel a waxy feel and, therefore, produces drawings which have an oil painting feel to them. Oil pastels can also be thinned with any of the oil painting mediums available. The best support to work on with oil pastel is canvas or canvas paper. Some thinner papers may not stand up to the amount of colour and blending that is needed for oil pastels.

## Pen and Ink

Pen and ink have been used by artists for decades as a form of sketching. The dark, crisp line of an ink pen is a wonderful contrast to the subtle tints of watercolour painting. The traditional way of drawing with ink pen is to use the old-fashioned dip pen nibs and a bottle of drawing ink. These can still be purchased from any good art shop and come in a variety of sizes and colours of ink, although the most common ink colours are black and brown (sometimes called sepia).

The modern equivalent is the fibre or metal tip disposable drawing pen. These are sometimes referred to as pigment ink pens and, like the nib pens, they come in several different sizes indicated by a number written on the pen, usually starting at 0.1 as the finest and increasing in size up to 1.0 as the thickest. Some manufacturers call their pen sizes 'Fine', 'Medium' and so on. The advantage of the modern disposable pens is that you do not have to worry about a bottle of ink being knocked over or carried around with you when out sketching. However, some artists still prefer the old nib pens as the line thickness can be varied by applying different pressure to the nib, something that does not work so well with the modern drawing pens.

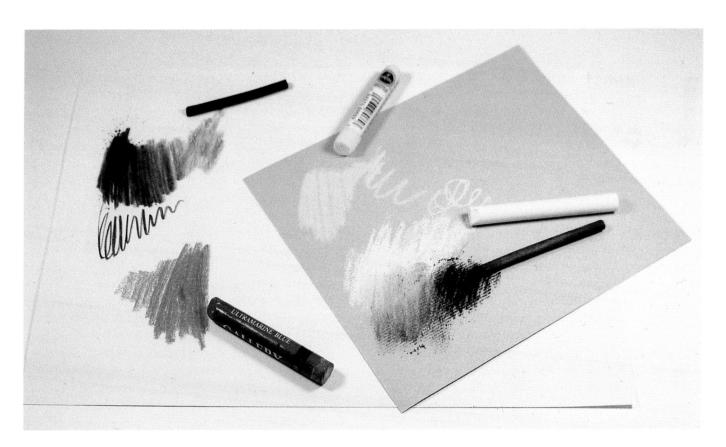

**Clockwise from top left: charcoal stick on white paper; soft pastel; chalk and charcoal on tinted pastel paper; and oil pastel on white paper.**

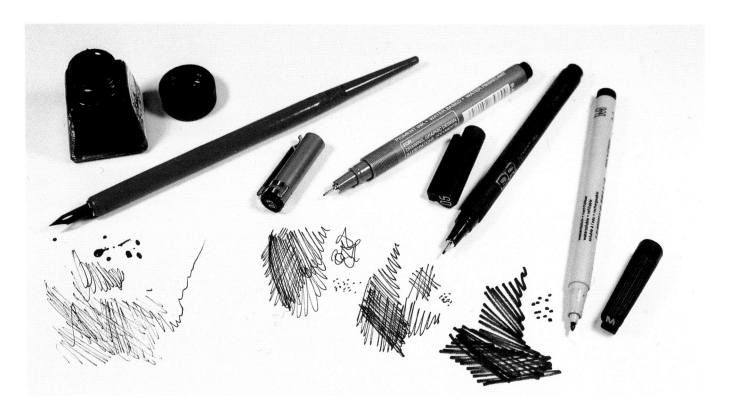

**Ink pens come in a variety of thicknesses, from the more traditional dip pen to the modern disposable felt-tip pens.**

Ordinary felt-tip pens can also be a good drawing tool. They come in a huge variety of colours and some can be diluted with water just like the water-soluble coloured pencils. All pens can be used on most papers, but be aware that the thinner the paper, the more chance there is of some of the cheaper pens bleeding through to the other side; also some papers can be more absorbent than others.

## Miscellaneous Drawing Equipment

If using drawing media such as pencils, charcoal and pastels, you will also need a few other items to use with them. Pencils need to be sharpened. The traditional way is to use a craft knife, although it can be a bit awkward and even dangerous if you are not used to using one. A safer and easier way is to use a pencil sharpener. Any of the cheaper sharpeners available from the shops will do. Alternatively, you can spend a bit more money and buy an electric pencil sharpener. These vary in quality and price but do give you a very good, sharp point. A small sheet of fine sandpaper or an emery board is a useful addition to the sharpeners as you can lightly rub the pencil on the sandpaper to maintain the sharp point.

Another useful tool to have with you when drawing with dry media such as pencils and pastels is an eraser. These are available as either a very soft putty eraser for lifting out delicate areas of graphite and charcoal, or harder erasers for rubbing out sharper lines and darker areas of tone. Coloured pencils can also be erased, but you may need to use a harder eraser than you would for graphite and charcoal. Electric erasers are also available for the more stubborn marks or areas of colour.

Erasers cannot be used with oil pastel, but can be used to a certain extent with the dry, chalky pastels. Dry pastels can also be blended with erasers, or you can use what is called a blending stick, or torchon, which is a stick of compressed paper that can be sharpened to a point or carved to a chisel edge.

All dry pastel pictures need to be fixed with a spray fixative, otherwise the pastel pigment could be accidentally rubbed off the surface of the paper. The fixative is available in either aerosol form or as a liquid in a bottle. If using a liquid, you would need to purchase a spray diffuser to blow the liquid onto the pastel drawing.

Most papers come in both sheet and pad format, but if you have individual, single sheets of paper you will need a board on which to rest the paper. Make sure the board is completely smooth and free of any bumps, dents and scratches, as these will show through the paper when you start to draw. Secure the paper with masking tape, pins or drawing-board clips.

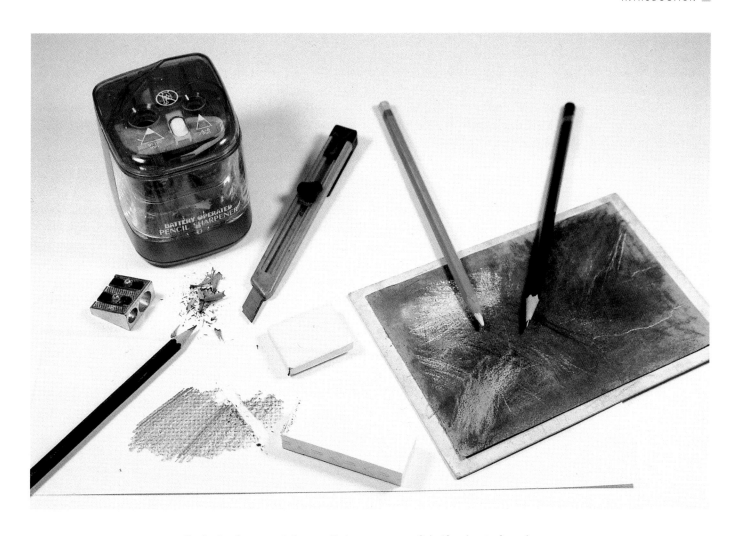

**Clockwise from top left: pencil sharpeners; craft knife; sheet of sandpaper (glasspaper); and hard plastic eraser plus soft putty eraser.**

## Paint

The variety of paint available is not as extensive as the range of drawing materials; however, the huge variety of colours, mediums, tools and brushes can be somewhat bewildering. In this book, we will deal with the three main types of paint: watercolour, acrylic and oil.

## Watercolour

This is the paint favoured by beginners and hobby painters the world over. It is small, compact and gives immediate results. However, because of its transparent, staining nature, it is actually the most difficult painting medium to work with – you cannot paint out your mistakes! Having said that, once you get it right, watercolour can produce wonderfully delicate paintings.

The paint itself comes in two distinct and different formats. For the sketchers, there is the pan. This is a small plastic cup filled with a solid paint that can be wetted with a brush. The pans can be purchased separately, but you will need a box in which to keep them. They come in two different sizes, small and large, and in both students' and artists' quality paint.

Tubes of watercolour paint are also available, normally used by artists if painting indoors in the studio. These, too, come in different sizes and are available as students' or artists' quality paint. If using tubes, you will need a palette on which to mix the paint.

The following is a list of paints that I have used for the watercolour exercises in this book: Ultramarine Blue, Cadmium Yellow, Raw Sienna, Raw Umber, Burnt Sienna, Burnt Umber, Sepia, Cadmium Red, Crimson, Sap Green and Payne's Grey. The watercolour exercises will contain some, or all, of these colours.

Watercolour painting brushes come in a wide range of shapes and sizes. The standard shape is the round brush, which varies in

size from extremely small (000) up to a size 20 and beyond, depending on the manufacturer. There are other shapes of brushes such as flat, filbert, hake, fan and rigger, but for the exercises in this book I recommend a size 4 round as a small brush and size 8, 10 or 12 round for the medium and large areas of painting.

Traditionally, the watercolour brush has been made with a soft, natural animal hair called sable. These are still available and are the best that money can buy; however, they are expensive, especially the larger brushes, so a cheaper synthetic hair brush has been available for some time. Also available is a synthetic sable blend which combines the water-holding capacity of a natural hair brush with the economy of a synthetic brush. All of these brushes are available in different shapes and sizes and from all good art shops and mail-order sites.

Watercolour is traditionally painted onto paper, in particular watercolour paper that is specially made for the watercolour artist. These papers are available with three different surface textures: the smooth surface, or Hot Pressed, which is similar to cartridge paper; Rough, which, as the name implies, has a rough surface texture to it; and the middle range of watercolour paper called 'Not', or Cold Pressed. The latter is the standard surface of watercolour paper that most artists use and which will be used for the majority of watercolour exercises in this book.

All watercolour papers are available as either pad or individual sheets, but if using sheets you will need a board on which to place the paper. Secure with tape, pins or clips.

When painting with a lot of watercolour onto paper it is sometimes advisable to stretch the paper or to use a heavier weight of paper such as 400gsm (200lb). To stretch your paper, first soak the sheet of watercolour paper in a bath of cold water for about ten minutes. Then, after draining off the excess water, place the wet paper onto a wooden board that is at least 4cm (1.5in) bigger all round than the sheet of paper. Next, use a gummed brown tape to secure all four edges of the paper to the board. Once you have done this, leave the paper to dry flat thoroughly before applying any paint.

Other equipment needed for watercolour painting includes water containers, tissues, soft sponges and palettes.

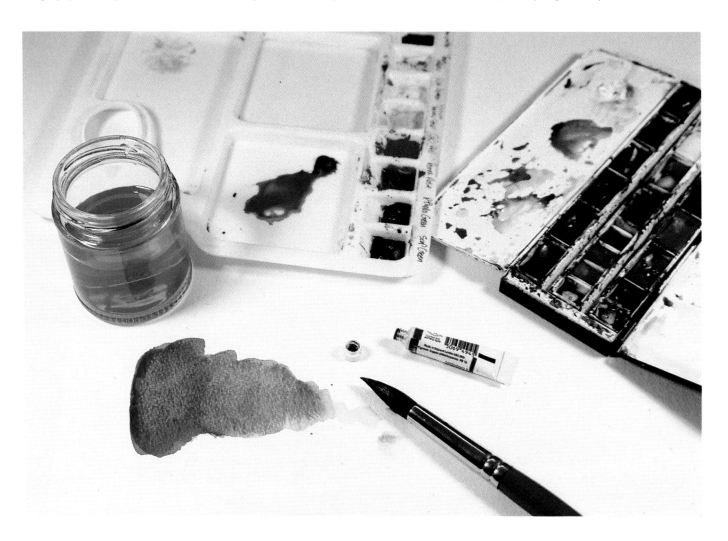

**Watercolour paint is available in both tubes and pans.**

## Oil Paint

Despite the recent advances in manufacturing of paint and all the new and exciting mediums that the manufacturers are inventing these days, nothing has been developed to equal the quality and feel of oil paint. Artists say that once you have tried oil paints, despite any experimenting with other mediums, you will always go back to them.

Oils have a unique feel that is unlike any other medium and the feel of the paint can change depending on the colour used. The following is a list of paint I have used for the oil painting exercises in this book: Ultramarine Blue, Cadmium Yellow, Raw Sienna, Burnt Sienna, Burnt Umber, Light Red, Sap Green, Yellow Ochre, Titanium White and Ivory Black. The oil painting exercises will contain some, or all, of these colours.

The paint can be applied with a brush or palette knife and the most common type of brush used in oil painting is the bristle or hog hair. These are available in a huge range of sizes and shapes and are generally used by oil painters for the majority of the painting. For the exercises in this book I recommend sizes 4, 6, 8 and 10 in both round and flat format. Any detail required can be put in with a small round sable or synthetic brush such as a 1 or 2.

Oil can be painted onto a variety of different surfaces, such as canvas, paper, wood and cardboard. However, the surface you are going to paint on, especially canvas, must be prepared or 'primed' with an acrylic or equivalent primer, otherwise over time the oil would slowly eat into the canvas, causing it to fall apart. Art manufacturers supply canvas on a roll should you wish to stretch your own, but for the exercises in this book we will be using pre-stretched and primed canvases and canvas boards available from most good art supply shops and mail-order sites.

There are several different mediums and thinners used to dilute and mix with the oil paint, including turpentine, linseed oil, white spirit and so on. Most of the oil painting mediums, especially turpentine and white spirit, have a strong odour that puts some people off oil painting. However, there are products on the market that do not have that pungent smell associated

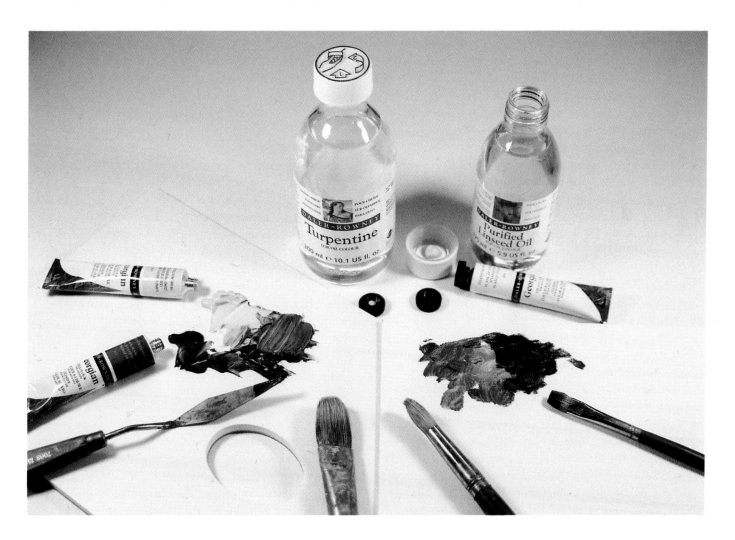

**Oil paint normally comes in tubes and can be applied with either a palette knife or brush.**

with thinners, such as Low Odour thinners and Zest-It, which is a derivative of citric acid from fruit and can be mixed with linseed oil. For the exercises in this book, we will be using turpentine and linseed oil.

All oil paint comes in tubes, so you will need a palette on which to squeeze the paint. The traditional style of palette to use is a wooden palette, but this can be expensive. There are cheaper alternatives, such as plastic or glass sheets and tin-foil trays, or you can buy pads of disposable tear-off palettes made from a paper similar to greaseproof paper or baking sheet. Oil paint can take a long time to dry depending on how thick the paint is or which thinners you have used, so bear this in mind when you have finished your painting. You will need to store it somewhere safe until it dries. A few extra things needed for oil painting are rags or tissues for cleaning brushes and small cups or jars for the thinners.

## Acrylic

Acrylic paints are the 'new kid on the block' in the art world. They are an extremely versatile painting medium and, when diluted with water, can be used either like oil paints or as a watercolour wash.

Acrylic paint is made using the same pigment or colours as used in watercolour or oil paint, but the binder these pigments are mixed with is made from a plastic. The pigments are suspended in a white fluid plastic that dries clear, which means that acrylic paint dries darker than the initial appearance of the colour. As mentioned above, acrylic is diluted with water as it is essentially watercolour paint, but when it dries it is permanent and cannot be re-wetted. The drying time, like oil paint, varies according to the thickness of the paint, but a thin wash will be dry almost instantaneously and even a relatively thick layer of acrylic paint will be dry overnight.

The following is a list of paint I have used for the acrylic painting exercises in this book: Ultramarine Blue, Cobalt Blue, Phthalo Blue Red Shade, Cadmium Yellow, Lemon Yellow, Raw Sienna, Burnt Sienna, Burnt Umber, Crimson, Cadmium Red, Yellow Ochre, Titanium White and Ivory Black. The acrylic painting exercises will contain some, or all, of these colours.

Acrylics can be painted onto most surfaces providing they are not too smooth or greasy and although it is advisable to prime the surface before painting, it is not essential.

All brushes available from sable through to synthetic and bristle brushes can be used with acrylic paint, but because of the paint's quick drying time it is advisable to keep the brushes wet or to clean them with soap and water when not using them for a long period of time, as an accumulation of dry acrylic paint will soon ruin the brush. For the exercises in this book I recommend sizes 4, 6, 8 and 10 in both round and flat format. Any detail

required can be put in with a small round sable or synthetic brush such as a 1 or 2. These are the same as the brushes recommended for the oil paint, but do not use the same brushes for both as you run the risk of cross-contamination and oil and water do not mix!

Acrylic paint is available in tubes and pots, but you will need a palette on which to mix the paint. Oil painting palettes can be used, but there is a palette that has been developed specifically for acrylic paint. This is called a stay-wet palette and is basically a plastic tray with a lid that has two different types of paper onto which the paint is put. The first is the reservoir paper, which is similar to blotting paper. This is soaked with water and after pouring off the excess, the second layer, or membrane paper, is placed on top. This is similar to greaseproof paper and it is on this paper that the paint is placed. The water from the reservoir paper slowly evaporates through the membrane paper, keeping the paint wet. Also, when you have finished painting for the day, just place the lid on the palette and it will keep the paint dry for quite a few days.

One of the advantages of acrylic paint is the availability of a huge range of mediums and additives that can be mixed with the paint to achieve different results. These include gel mediums of different consistency that enable you to thin or thicken the paint, gels mixed with sand, pumice, granite dust and fibres as well as additives that can slow the drying time or give the paint a matt or gloss finish. As was mentioned earlier, acrylic is the most versatile medium available and with the addition of the gel mediums, the possibilities are almost endless.

The colours recommended for the painting exercises are a suggestion only and incorporate most of the colours available in the starter sets that can be purchased from art suppliers. In most of the exercises the colours are indicated, but in some of them they are referred to as a general colour such as 'dark blue' or 'dark brown'. In some of the exercises I have referred to mixing greys with blue and brown, and also with the addition of white in oil and acrylic. This is because I do not like mixing greys using black, as I feel this provides a poor and dirty alternative to mixing your own dark. As an exercise, try experimenting with different types of dark blue and dark brown when mixing your darks.

## Easels

Most artists, especially when painting with oils or acrylics, use some form of easel to hold the support they are painting onto. For the exercises in this book it is not essential to have an easel. Providing you are working on a stable surface such as stretched canvas or paper taped to a board, all that is necessary is to prop up the surface on a flat table, at about a 30-degree angle, with a couple of books. There is no need to spend a lot of money on an easel before trying out all the different mediums. Have a go at the exercises in this book and then decide if you want to invest in a proper easel.

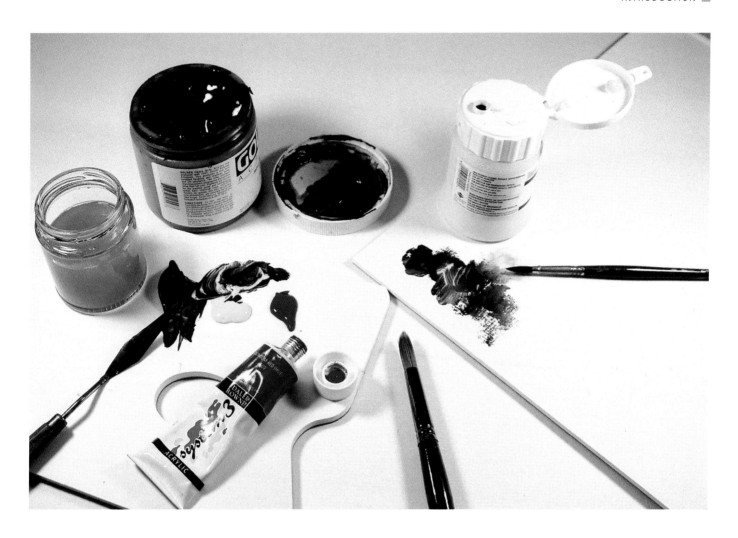

## Sketching Equipment

If you decide to go outside to do some sketching, there are a few things to bear in mind. If you are to be seated whilst sketching, you will need a lightweight, foldaway chair or stool. You will also need something in which to carry all your painting equipment, such as a bag or toolbox. What you require in terms of paint and brushes will depend on what medium you are painting in, but bear in mind that oil paint dries very slowly so if you are planning to sketch in oils you will be bringing home a wet painting and will therefore need to be careful how you carry it and where you put it on your journey home. Chapter Seven deals with sketching, and what is required to sketch, in more detail.

**Acrylic is one of the most versatile painting mediums available to the artist.**

sions on a two-dimensional surface and painting from flat photographs is not the correct way to do it. There is no better way than to draw and paint from life, but in some cases we have no choice other than to use photographs as reference. If this is the case, you must always try to use your own photographs rather than someone else's because of copyright laws. If you choose to use a photograph or image belonging to someone else then you must get written permission from that person to use their image.

## Photographs

Throughout this book, there are exercises done using my own photographs as reference material. Painting from photographs is not ideal. As artists, we try to convey a sense of three dimen-

## Finally

I have written this book in the hope that it will inspire you to look around at your local environment and see what you can achieve by drawing and painting buildings.

# BUILDINGS IN TWO DIMENSIONS

When drawing and painting buildings for the first time, just like any other subject matter, it is best to start at the beginning and with a fairly simple subject. We will be dealing with three dimensions and, specifically, perspective in Chapter Two, so in this chapter we will deal with the easier, two-dimensional buildings and the best way to do this is to look at buildings face on.

Buildings come in all shapes and sizes and in different styles, so try to pick a building which will not give you too much to do but still has character or something interesting as a focal point, such as a window, lamp post, tree or a figure. Another important thing to consider is the distance from yourself and the subject. The further away you are, the less detail you will see. This has both good and bad points. Standing further away means you have more buildings to put in, but also could mean more foreground and sky depending on how you intend to crop the picture. Cutting down on the amount of sky at the top and foreground at the bottom of your picture would result in a long, thin picture, or what is called a panoramic view. This is not necessarily a bad thing, but can result in an unusual and unsettling format if not intended.

Moving in closer to the subject would reveal more detail such as brickwork, doors, windows and other architectural embellishments – even door handles if you were close enough. You could also have a view into an open window or doorway. All of these points have to be thought out before starting your picture.

Before commencing your drawing and painting, there is one very important aspect to bear in mind. When producing any piece of artwork, be it two or three dimensional, you will need to consider the direction from which the light is coming. There is only one light source when drawing or painting anything outside and that is the Sun. If you are drawing from life, then try to pick a subject that has the light coming from right to left, or left to right, so that the features of the building throw some kind of shadow. If you are using a photograph and there is no discernible light direction, you may need to do small sketches called 'thumbnail sketches' to determine where the shadows should go. Also, remember that, if you are drawing outside for any length of time, the sunlight, and therefore the shadows, will move.

After deciding on your subject matter, the next step is to choose which medium to use. In the first exercise, we will be using graphite pencil on white paper.

## EXERCISE: **STREET SCENE IN GRAPHITE PENCIL**

— OBJECTIVE: To learn the basic drawing and shading techniques associated with graphite pencil.

— MATERIALS: Smooth white cartridge paper, 2B and 4B graphite pencils, pencil sharpener, eraser.

The graphite pencil is probably the easiest to use of all the mediums. The advantage is that you can correct with an eraser as you are progressing through your drawing, but the disadvantage is that the pencil will smudge so bear this in mind when working over a part of the drawing you have already done.

One of the most common questions asked is: 'Where do I start?' The best advice that can be given is to start in the middle of the paper with a strong vertical line such as a door or window, and, using fairly light pencil marks done with the 2B pencil, work out from this first line to the left and the right.

In the photograph chosen for this exercise, start from one of the strong verticals in the middle near the bicycle. Using the length of your pencil and your thumb as a marker on the pencil, measure the depth of the door or window, turn this measurement through 90 degrees and see how many times that measurement goes into the width of the whole image. Then, after drawing in the door or window on your paper, transfer this measured proportion to your drawing to check that you can get everything that you want to draw onto your paper without it

**OPPOSITE PAGE:**
*The Flower Boxes.*
**Acrylic on canvas.**

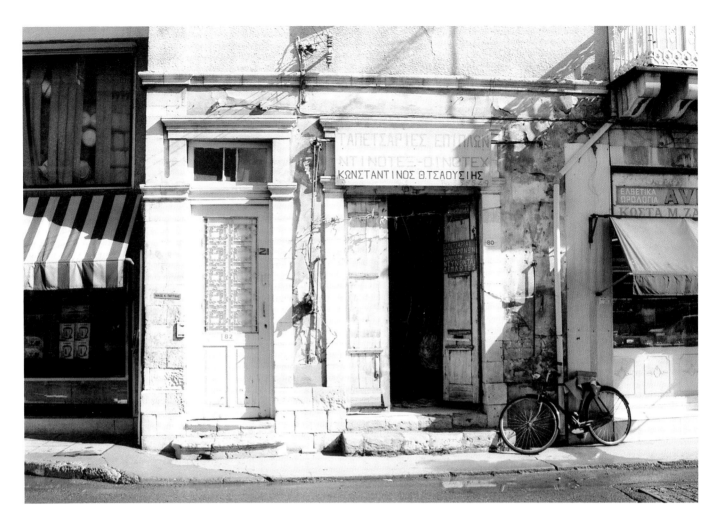

ABOVE: **A street scene in Limassol, Cyprus.**

LEFT: **Using a 2B graphite pencil, lightly draw in the outlines of the building.**

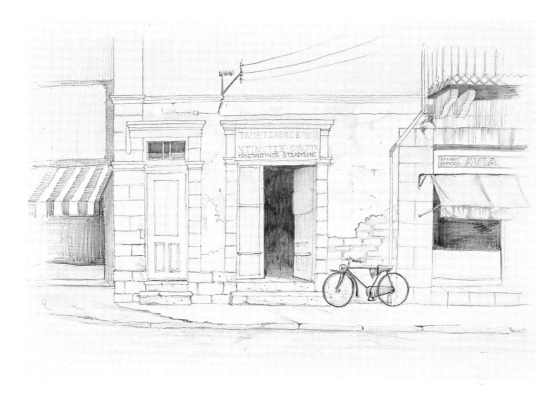

**Put in the darker
areas with both a
2B and a 4B pencil.**

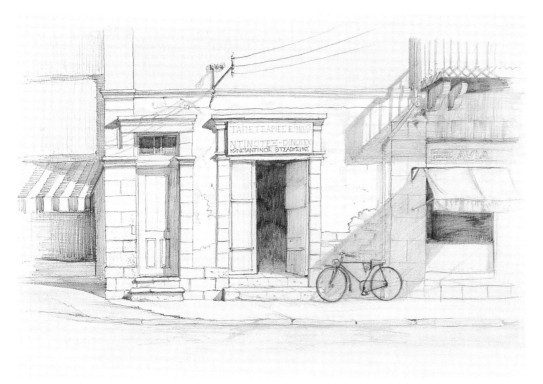

**Shade in the grey areas
and put in the detail.
Finish by putting in
the shadows.**

falling off the edge. If you think this will happen, make the depth of your door or window smaller, then re-check. Continue to adjust the depth of the door or window until you are happy that your overall image will fit on the paper.

This method of measuring and checking is called 'rule of thumb' and is used extensively by artists to check and maintain proper proportions throughout their drawing and painting.

Use this measuring technique throughout your initial drawing stage. Get everything correct and in proportion before you start to shade in. When doing this initial drawing stage it is important to compare shapes and angles against each other. Extend lines beyond corners to see where they meet other vertical lines. Look at spaces between lines as well as the actual objects. These spaces are called 'negative shapes'. If they do not look right then there is something wrong somewhere.

One of the most important things to remember when drawing buildings is to keep the vertical lines vertical. Any slight tilt to the left or right will give the impression that the building is leaning or about to fall over. It sometimes helps to turn your drawing upside down. This may give you an idea of what needs correcting. Put in as many outlines as possible and make sure you are happy with this initial drawing before going on to the next step.

One of the most difficult aspects of drawing with a single shade, in other words in black and white, is that you will have to decide how to convert the colours into what is called their 'tonal value'. Put more simply, this means judging what these particular colours would look like if in a black and white photograph. There is not an easy way to describe how to do this, but the best method is to start by putting in the darkest part of your drawing such as windows and doorways but not the shadows. These will be put in last of all once the drawing has been completed.

So, using the 4B pencil, start to fill in the dark parts of the drawing. You may find it easier to do two or three medium-grey layers rather than one dark layer, which might clog the paper's surface with graphite. A good method of shading to achieve this is called 'cross-hatching'. Shade in the first layer using vertical strokes of the pencil. When you have finished this first layer, turn your drawing through 90 degrees and do the next layer in the same way; again, once you have finished layer number two, turn your drawing through 90 degrees and do the third layer in the same way as the first two. This cross-hatching effect will help to achieve a solid dark area of graphite shading. Whilst doing this shading, protect your initial drawing under your hand with a sheet of paper or tissue paper to stop your hand smudging the pencil lines.

Once the dark areas have been laid down, you should have a better idea of how to judge the greyer and lighter areas of the rest of the drawing. Before shading your actual drawing, practise first on a separate piece of paper using both the 2B and 4B pencils. To achieve different strengths of grey, practise the shading by applying different pressure to each pencil, in order to obtain a variety of greys to use in your picture. The harder 2B pencil will give a lighter grey but show the pencil marks more than the 4B, while the 4B will give a darker, softer grey.

Once you are confident about what you can achieve with each pencil, start to shade in some of the grey areas on your drawing. It is a good idea at this stage to start to put in some of the texture, such as brickwork and crumbling plaster. Don't worry if the grey shading covers up some of the detail as you can put this

back in near the end of the drawing. Also, stop from time to time to look at your drawing to see how it is progressing. Take a step back as if you were viewing it in a gallery. Ask yourself a few questions. Is the basic drawing correct? Are the dark areas dark enough? Is there a good variation of contrast between light and dark? If you need to correct anything then now is a good time to do it. You can use the eraser to correct lines and also to put in more highlights by rubbing out some of the grey shading.

Once you are happy with the shading and any correcting you may have done, it may be necessary to re-establish some of the harder outlines in the picture as these may have been lost during the previous steps. After you have done this, take one more look at your drawing before proceeding onto the last stage, which is the shadows.

This last step is one of the most important parts of your drawing. The shadows create depth, contours, atmosphere and indicate light direction. When putting in the shadows, pay particular attention to the direction of the shadows and the contours and edges of the building that the shadows fall across. For example, in this exercise the shadow of the balcony on the right falls across a part of the wall that sticks out, causing the shadow to curve slightly and adding to the three-dimensional look of the drawing. Once you have put in all the shadows the drawing is finished.

Drawing with a graphite pencil is a wonderful way of depicting shadows, tone and texture. It has a quality all of its own. The single grey monotone effect of the graphite can give atmosphere, character and a quality of line not found in other mediums. However, should you wish to do a drawing in colour there are a few mediums you can use, one of which is the watercolour pencil.

## EXERCISE: **STREET SCENE IN WATERCOLOUR PENCIL**

— OBJECTIVE: To learn how to produce a watercolour sketch using watercolour pencils.

— MATERIALS: White, smooth, 300gsm (140lb) watercolour paper, a selection of watercolour pencils, watercolour brush, water container, pencil sharpener, eraser, tissues.

Coloured pencils have been used by artists for years, but have usually been associated with 'kids' crayons' and not taken seriously by the art world as a good drawing medium. Recent product development has produced a wide range of coloured pencils with a variety of uses, one of which is the watercolour or water-soluble pencil that can be wetted with a brush dipped into water. This enables you to use both the dry and wet properties of the pencil to produce a watercolour effect in your drawing. The names of the colours needed for this exercise would depend on the make of pencil you have. The manufacturers of watercolour pencils tend to have their own way of naming the colours, so choose the colours that you think match the ones that I have used.

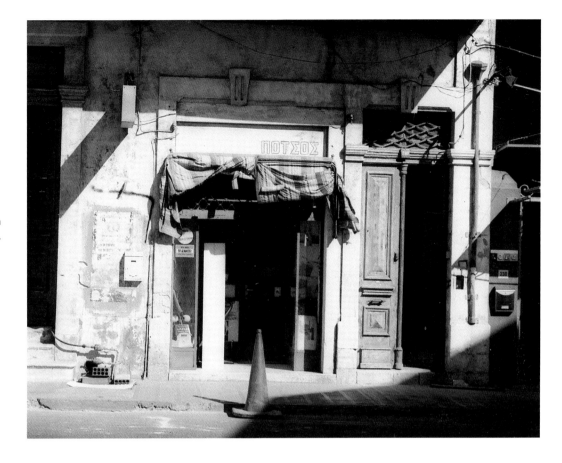

An old shop in
Limassol, Cyprus.

Start by putting in your
initial outline drawing.

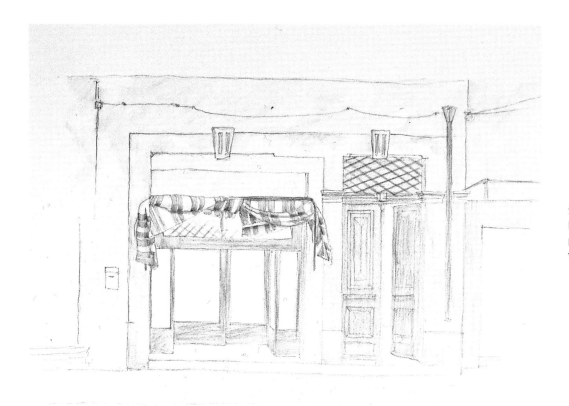

Shade in some of the lighter colours in the picture and wash over with a damp brush.

Put in the dark areas using a dark coloured pencil and then wash over this with the damp brush.

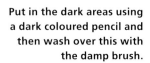
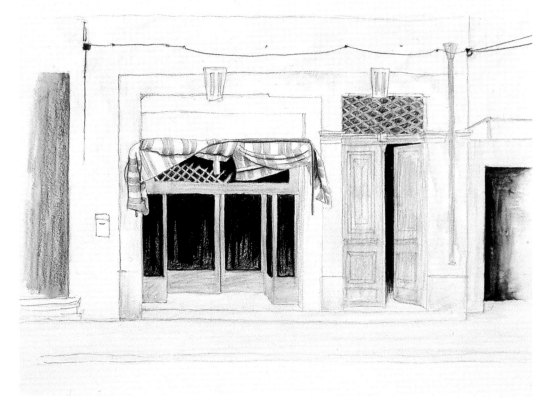

The next stage is to put in more of the detail and texture using a variety of different colours.

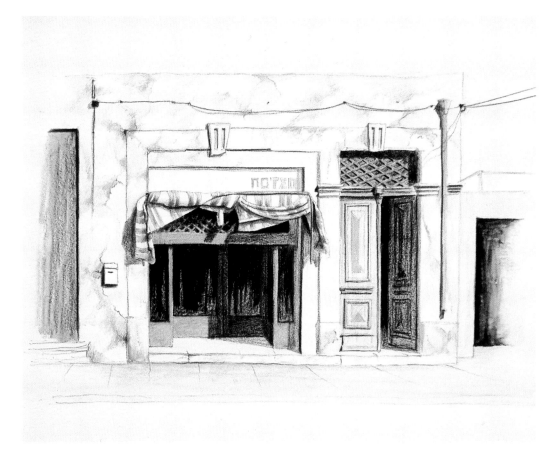

Finally, put in your shadows using a combination of blue, grey and black.

As with the previous exercise, start with an initial outline drawing. This can be done with coloured pencil or graphite; however, graphite is easier to erase and not water-soluble, so will not disappear when using the wet brush. Check that all your vertical lines are vertical and that your angles, proportions and measurements are correct before applying the coloured pencil.

When choosing the colours to use, it is always a good idea to test the colour first on the side of the paper to see what it looks like when applied to the paper, especially as you will be wetting the colour later. The colour from a watercolour pencil can look completely different when wet, so it is a good idea to create a colour chart of all the watercolour pencils you have for future reference.

Begin by applying a pale shade of colour to some of the lighter areas of the picture, such as the doors, windows and parts of the wall, in order to block in and cover up the bright white of the paper. When you have done this, use a wet watercolour brush to lightly soften the watercolour pencil. Do not wash over the whole of the picture as this will cause the colours to mix on the paper and give you an overworked and muddy appearance. Wash each section and colour individually, keeping within your initial outlines. When this is dry, go back in with the original colours you started with to sharpen up some of the detail.

When this step is completed, start to put in the dark areas like windows and open doors with strong, dark colours such as blue, brown or black. This will enable you to judge how much work the rest of the picture will need. First, however, test your dark-coloured pencils on the edge of the paper and wet the test area too. This will tell you how heavily to shade in with the pencil prior to wetting the shaded area. Some of these dark pencils are very strong when wetted. When you start to wet the dark areas, try to keep within the shaded part with your brush; it can be difficult to remove any unwanted colour once dry as the stronger, darker colours will stain the paper

Putting in these dark areas will make the rest of the picture look lighter, so the next stage is to go back into the lighter areas and start to add more texture and detail using some of the coloured pencils you started with. Using sharp pencils, start to put in small amounts of colour and detail as well as stronger shading to help to balance the strength of the dark areas in the picture. Before going on to the next step, take a look at your picture, especially the contrast between light and dark. Some areas may need strengthening or others may require additional washing over with the wet brush. Try not to use the brush everywhere. It helps if you have a combination of dry coloured pencil shading and wet washes of colour.

Once you are satisfied that you have done enough colour shading, it is time to put in the final stage, which is the application of the shadows. Start with a light blue-grey tint over the areas where the shadows fall. Use a few light shading layers on top of each other rather than one heavy layer. When you have done this initial light blue-grey, go back over it with a darker grey or black, making sure you maintain sharp, crisp lines to the shadows and keep them going in the same direction. There is no need to wet the shadows, as this might also wet the underlying colour and produce a patchy, muddy appearance. Once the shadows have been done, the picture is finished.

This exercise has taught you how to build up a small picture using the versatile medium of watercolour pencils. It has similarities to the graphite pencil exercise in that it deals with building up layers of pencil shading, finishing off with application of the shadows. In the next exercise, we will explore the use of watercolour paint and ink, but in a single shade known as 'Sepia Tint'.

## EXERCISE: **OLD BUILDING IN SEPIA PEN AND WASH**

— OBJECTIVE: To learn how to produce a sepia tint watercolour sketch using waterproof brown ink pen and watercolour paint.

— MATERIALS: White, 'Not' surface, 300gsm (140lb) watercolour paper, brown waterproof pigment ink pen or dip pen and brown ink, watercolour paints in various shades of brown, watercolour brush, water container, tissues. A 2B pencil, pencil sharpener and eraser are optional.

Sepia tint watercolour painting has been used for years to produce paintings that have an antiquated feel to them. Some artists use a pre-tinted watercolour paper for this type of painting, but in this exercise we will just tint white paper to the shade required.

Start by mixing a light brown wash of watercolour paint, such as sepia or raw umber, and paint a flat wash of this onto your watercolour paper. Because of the amount of water you will be using for this initial step it is a good idea to tape the paper to a board or stretch the paper prior to use, preferably the day before. Keep the board flat whilst the wash is drying.

The next step is to start your drawing. If you feel confident enough, draw straight onto your dry wash with the brown ink pen. However, the problem with doing the pen first is that it cannot be erased if you make a mistake, so you may prefer to do a few light pencil marks first to establish proportion, angles and perspective. Once you are happy that the initial pencil drawing is correct, you can proceed with the pen. Do not follow the pencil lines too closely with the pen as this could lead to the end result being too tight and rigid, giving a cartoonish feel to your picture. Draw in all the outlines except those of the shadows, which are best done with paint.

Using the same brown watercolour wash with which you tinted the paper, paint in some of the lighter tones. At this early stage, you are putting in the tones that depict the lighter colour in your picture, such as the background, the door and the darker parts of the wall. Start at the top of the painting and work your way down. Do not go in too dark at this stage, otherwise

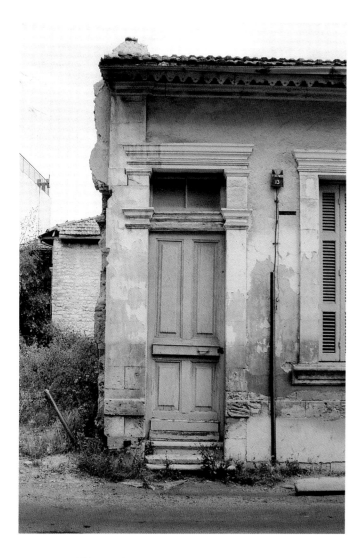

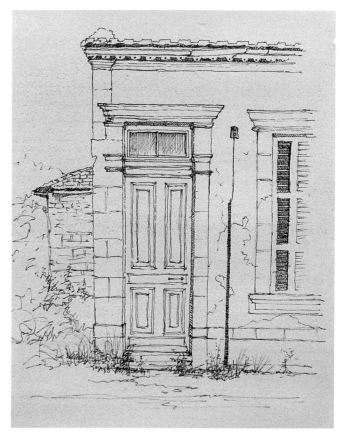

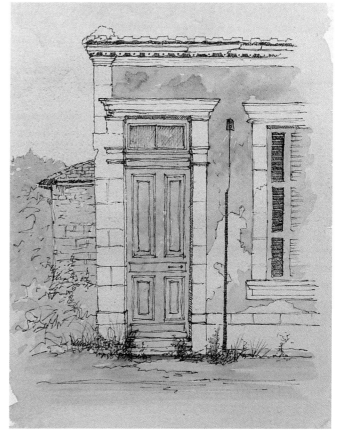

ABOVE: **An old house in Larnaca, Cyprus.**

ABOVE RIGHT: **Tint the paper with a watercolour wash of light brown and then put in your pen drawing when the paint is dry.**
RIGHT: **Use the same light brown paint to put in some of the basic light tones of the painting.**

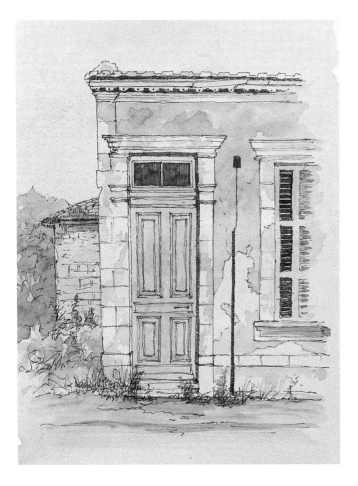

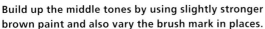

Build up the middle tones by using slightly stronger
brown paint and also vary the brush mark in places.

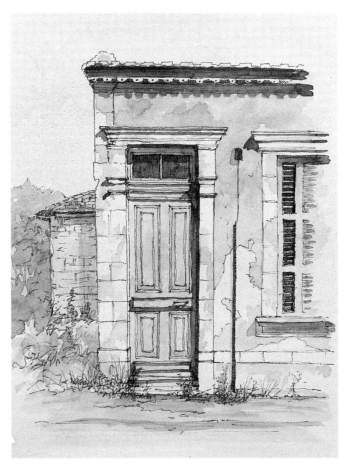

Using a darker, stronger mix of brown, paint in
the dark shadows to finish off your picture.

you may end up with a very dark picture. Vary the tones by
adding slightly different browns such as sepia or burnt umber,
diluting them in a few places to help break up the larger areas.

Next, start to build up some of the middle tones and detail,
such as dark windows, vegetation, brickwork and plaster. Try to
vary the brush mark, perhaps working with a smaller brush in
places, and vary the tone slightly by diluting the paint. Put in
some light shadows, for example door panels, and some of the
shadows in the distance. The painting is now nearly finished –
all that remains is to put in the strong shadows. Using a darker
and stronger mix of dark brown, paint in the dark shadows. Aim
to maintain the sharp edges of the shadows, as this will help to
give the impression of three dimensions and strong sunlight.

Finally, take a look at your pen and wash sepia picture. You
need to assess the balance between the pen and the paint. If the
paint is too strong and dark it will obscure some or all of the pen
work, so you may need to go back in with the pen. If the pen is
too dominant, put on more paint.

This exercise has taught you how to achieve a sepia tint paint-
ing using brown pen and wash. The monotone effect pulls the
picture together, creating a harmonious feel and character. This
is also a good exercise for judging tones and the effects of light
and dark.

The exercises in this chapter have dealt mostly with drawing
using pencil and pen. In the final exercise, we will switch to
drawing with the brush and do a painting in oil from start to fin-
ish in one go, or what is called *alla prima*.

### EXERCISE: **OLD BUILDING IN OIL PAINT**

— OBJECTIVE: To learn how to produce an oil painting of an
old building using the *alla prima* technique.

— MATERIALS: Primed canvas board, oil paints, flat and round
bristle brushes, palette, palette knife, turpentine, linseed oil,
rags or tissues, easel (optional).

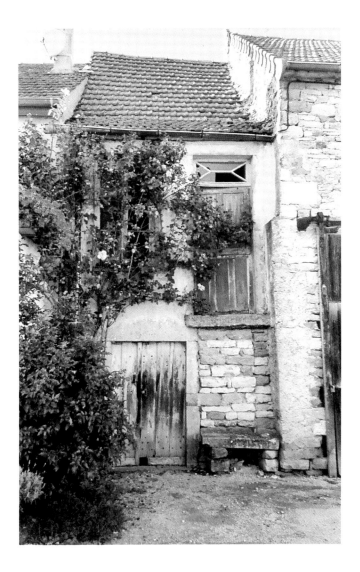

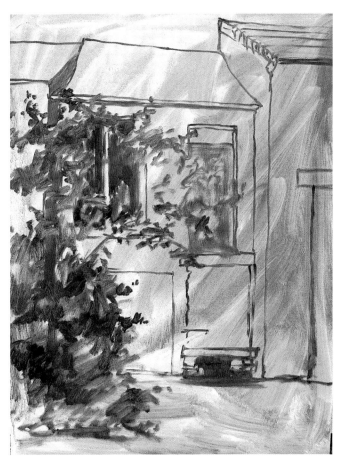

LEFT: **An old French house.**

ABOVE: **After painting the light brown wash onto the white canvas, start to draw in the building using a small brush.**

In the previous exercises, we explored drawing with pencil, pen and watercolour paint and ink. In this exercise, the drawing will be done with the brush and the whole painting will be completed using the technique called *alla prima*, which literally means all in one sitting.

Traditionally, oil paintings are done in stages whereby the artist waits for each stage to dry before moving onto the next. This sometimes means that an oil painting can take months to produce, as very thick oil paint takes a long time to dry. The *alla prima* technique allows the artist to produce an oil painting in one sitting, especially when sketching outside from life. The paint is applied whilst the previous layer is still wet, giving more of an impression than a realistic and photographic finish.

With oil painting, a lot of artists start with what is called an underpainting, which helps to establish tone and composition. Most of the underpainting will be hidden by the successive lay-

ers of paint but will peep through some of the gaps, helping to pull the picture together.

Start by applying a light brown wash of paint, such as raw sienna thinned with turpentine, to the white canvas board. This will get rid of the bright white of the primed surface, which can be a bit of a distraction. Next, using a darker brown such as burnt umber, start to put in your drawing with a small bristle brush. I suggest a small flat brush rather than a round one for this. Any mistakes with the paint can be wiped off with a rag or tissue. When you are happy that the drawing is correct, put in some of the darker areas of the painting with the same dark brown you used for the drawing. This is the tonal part of the picture that will enable you to create a three-dimensional picture on the two-dimensional canvas surface.

The next step is to start blocking in the basic colours of the painting. Oil paint is a wonderful, thick medium and we can use

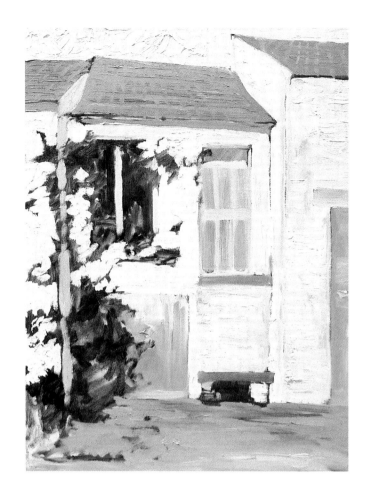
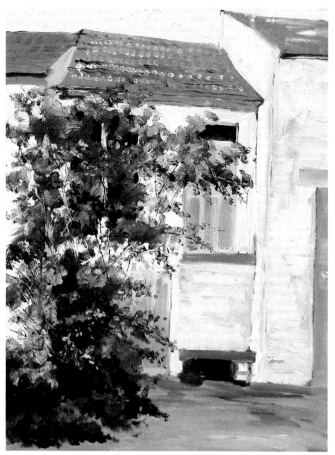
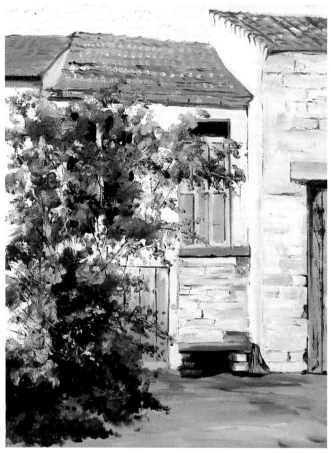
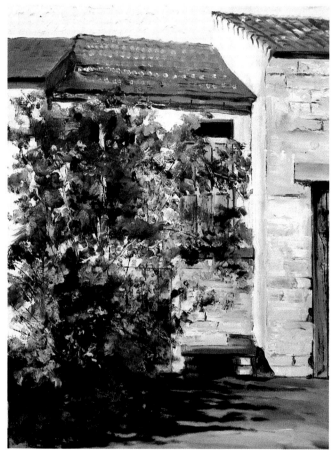

OPPOSITE PAGE:
TOP LEFT: **The next step is to start blocking in the basic colours of your painting.**
TOP RIGHT: **As this stage, you can start to paint in such areas as trees, shrubs, doors and windows.**
BOTTOM LEFT: **Build up the detail in the painting by adding brickwork, roof tiles, doors and windows.**
BOTTOM RIGHT: **Finally, paint in the deep shadows to give a sense of three dimensions.**

the brush marks to indicate texture and brickwork. When blocking in surfaces, try to paint in the direction the surface is going. In other words, use horizontal brush marks on a horizontal surface such as the road or pathway in the foreground. On vertical surfaces such as walls, paint in the initial colour using vertical brush strokes, use short, horizontal brush marks to indicate brickwork.

Work around the foliage at this stage. The trees and bushes can be painted in at a later stage. Because the oil paint remains wet for a long time, you may find your colours getting a bit muddy on the canvas. If you feel you have overworked an area, remove some of the paint with a rag or tissue wetted with turpentine, which will then allow you to go back in with some cleaner paint.

Once you have done the basic blocking in of colours, start to put in other areas, for example the tree on the left, using a mixture of ultramarine blue, cadmium yellow and white, and the very dark areas such as windows and deep shadows. Rather than use black for these dark areas, mix up your own dark colour with ultramarine blue and burnt umber. This will give you greater control over your dark colours. When doing foliage, try to vary the brush mark, using both flat and round brushes. Also, vary the colours slightly by applying lighter and darker variations of green. Place the lighter greens next to the darker greens to develop a sense of shadow, light and texture.

Next, take the palette knife and use the edge to put in twigs and branches, being careful not to overdo it. Then go back in with a brush to merge some of the twigs and branches in with the foliage and bring some of the leaves round in front of the twigs and branches. At this stage, it would be a good idea to start to add more detail. Some of the edges could do with sharpening and also putting in some highlights and dark areas will help to pull the picture together.

The next step is to put in the detail such as brickwork, windows, doors and the tiles on the roof. Remember that we are doing an impression of the building and not a photorealistic painting. So do not be too fussy with the detail. Use a variety of colours for the wall, such as yellow ochre, raw sienna and white,

and introduce burnt sienna for the rooftops. The fact that the previous layers of paint are still wet will prevent you from putting in too much detail, so use a small round brush to paint in the edges of bricks, roof tiles and windows. If the lines look too heavy or straight, run your finger over them in places to smudge the paint, thereby giving a more impressionistic feel to your painting.

The final stage is to put in the shadows. The colour and strength of the shadows can be mixed using ultramarine blue and burnt umber. Vary the mix and the strength according to the type of shadow required. As with the initial stage of blocking in colour, use brush strokes for the shadows that go in the direction that the shadow falls. In other words, use horizontal brush strokes for the road or pavement in the foreground and vertical strokes on the front of the building. Try to achieve a diffused look to the edges of the shadows. If these edges look too sharp, smudge them in places with your finger. When you have done the shadows, take a step back and view your painting as you would in a gallery. If you have a frame handy that fits the picture, place it in the frame to give you an idea of the finished look. If you are happy with it, then the painting is finished.

Oil paintings should be varnished at some stage, but, because of the slow drying time of oil paint, it is recommended that you leave your painting for a few months (depending on how thick the paint is) before varnishing.

In this exercise, you have learnt how to produce an oil painting using the *alla prima*, or all in one sitting, technique. This is an ideal way of sketching with oil paint from life and is a technique used by impressionist painters. For a more photorealistic technique, each individual layer and stage in the painting would need to be allowed to dry before moving on to the next step. A painting could therefore take a year or more to finish, so artists who use the photorealist technique will have about half a dozen paintings on the go, at different stages, at any one time.

## Summary

This chapter dealt with different ways of drawing and painting buildings in two dimensions, in other words, looking at buildings face on. It is the easiest way to produce a realistic picture of a building, but it does not have the three-dimensional quality necessary to produce an effective drawing or painting of a building. It does not have the depth and structure of a three-dimensional picture, so in the next chapter you will learn how to produce drawings and paintings of buildings in three dimensions using perspective. You will be taken through one-, two- and three-point perspective, including composition, tonal variation and how to achieve depth and distance in your pictures.

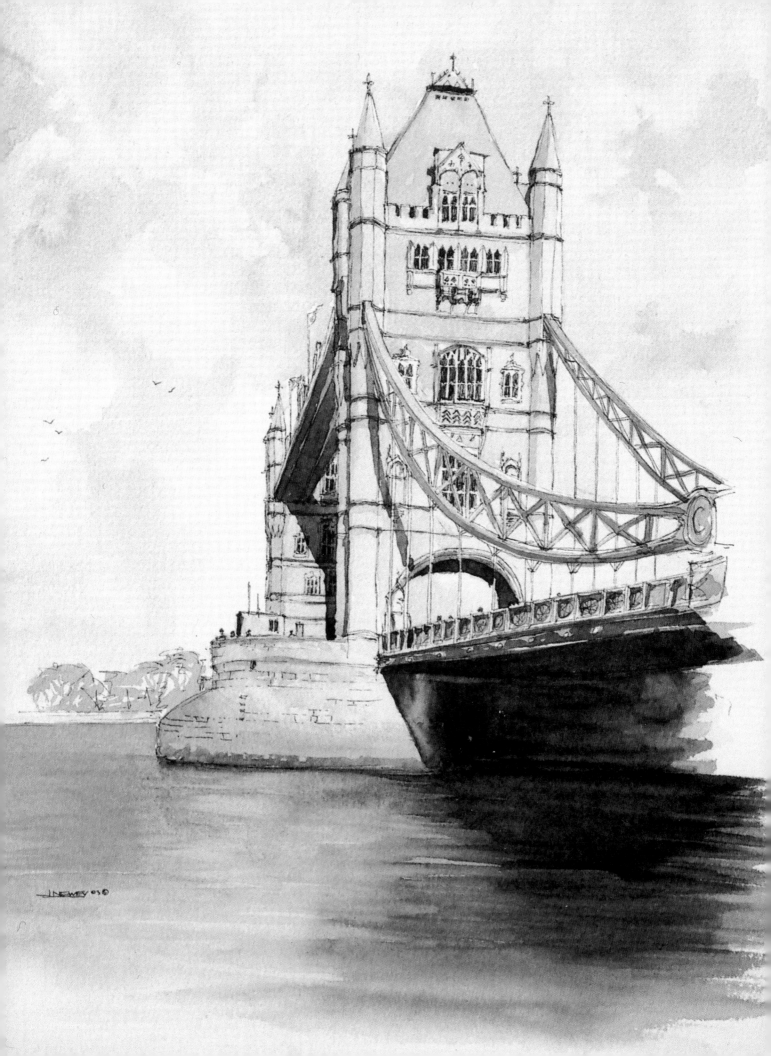

# CREATING THREE DIMENSIONS WITH PERSPECTIVE

Creating the illusion of three dimensions in buildings is achieved with the use of perspective. This is a word that can terrify some people because it can appear to be rather complex and mathematical. In this chapter, we will be studying the basics of perspective and how to apply those basics without being too tight and mathematical. We will also be looking at another very important part of the early stages of drawing and painting: composition.

So, how does perspective work? Basically, the further away a building is, the smaller it appears. This sounds simple and, once you have grasped the essence of perspective, this knowledge can be used to create distance and three dimensions on the flat working surface. The problem with perspective is that, as noted above, it can be too mathematical and precise, which is something we do not want to be when producing a work of art. The freer and looser we are with our drawing and painting, the better our finished pictures will look. So, in this chapter, I will be explaining how to achieve correct perspective by the use of straight lines and angles, but without applying the rules too analytically. The best approach is to use the exercises to practise perspective and, once you are familiar with each process, use this knowledge to check that the perspective is correct in your drawings and paintings.

There are several different types of perspective and we will start with the basic form, called 'one-point perspectives'.

## One-Point Perspective

This is the simplest type of perspective; however, it is not the form generally used by artists as it only deals with one side of a

building. The most common form used is two-point perspective, which we will cover later.

To achieve correct perspective, it is first necessary to establish where the horizon, or eyeline, appears. This is represented by a horizontal line drawn across the paper. The problem is that, unless you are looking out to sea, you will not be able to see the horizon because the buildings and any hills or mountains in the landscape will obstruct your view. It is best, therefore, to assume a position for the eyeline of about one-third up the picture. Draw this across the paper, making sure the line is straight and horizontal.

Before starting the sides of the buildings, draw in a vertical line that indicates where the closest corner of the building is. Next is probably the most important part of perspective. Take a look at your subject matter, especially lines like the top of the roof, the guttering, the tops and bottoms of doors and windows and the bottom of the building. As these lines go away from you – in other words, as they head towards the horizon – they will angle up or down depending on whether they are above or below the horizon. If they are above the horizon, they will slope down towards it, while if they are below the horizon they will slope up as they head away from you. The mistake that people make is getting these the wrong way round. In one-point perspective you should find that these lines, both below and above eye level, all converge at the same point on the horizon. This is called the vanishing point. Any building facing the same way and on the same level will have the same vanishing point.

When drawing in the windows and doors, make a mark to establish the top and bottom of the nearest doors or windows, then, from these marks, project a faint, straight line towards the vanishing point. This will enable you to position the other doors and windows that are further away. Have a go at drawing boxes to begin with. After all, buildings are basically boxes with rooftops, windows and doors. Do one at a time to get used to projecting up or down to the horizon. Once you are happy that you have the eye level and vanishing point in the correct places,

**OPPOSITE PAGE:**
*Tower Bridge, London, England.*
**Pen and watercolour wash.**

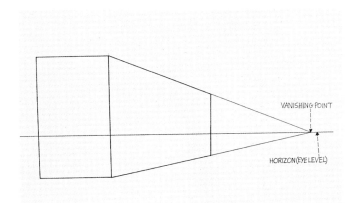

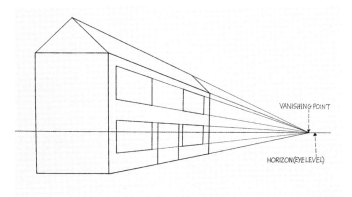

ABOVE LEFT: One-point perspective is used to give the impression that one side of a building gets smaller as it recedes towards the vanishing point on the horizon.

ABOVE RIGHT: Lines, for example the top of the roof, the guttering, the tops and bottoms of doors and windows and the bottom of the building, will meet at the same vanishing point on the horizon.

THIS PAGE:
The horizon in this photograph is one-third of the way up the picture.

OPPOSITE PAGE:
TOP: After putting in your horizon, draw in a vertical line for the corner of the building and then project the top and bottom down to a vanishing point. Use this point for all the other lines.

BOTTOM: Even smaller buildings, lines in the road and tops and bottoms of telegraph poles will converge at the same vanishing point.

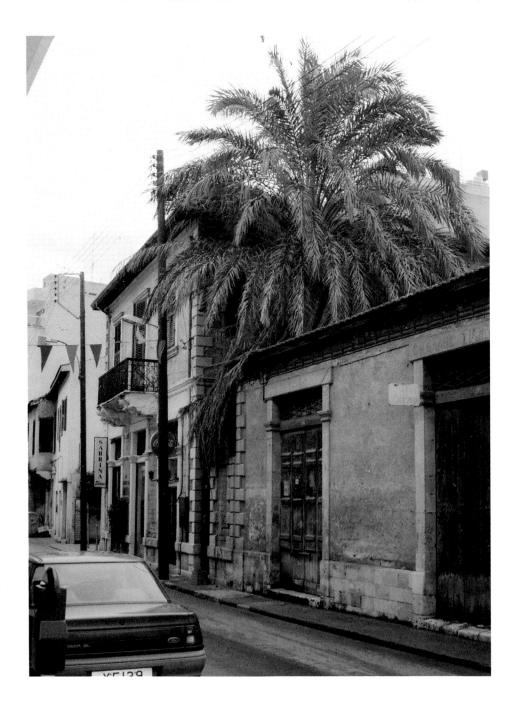

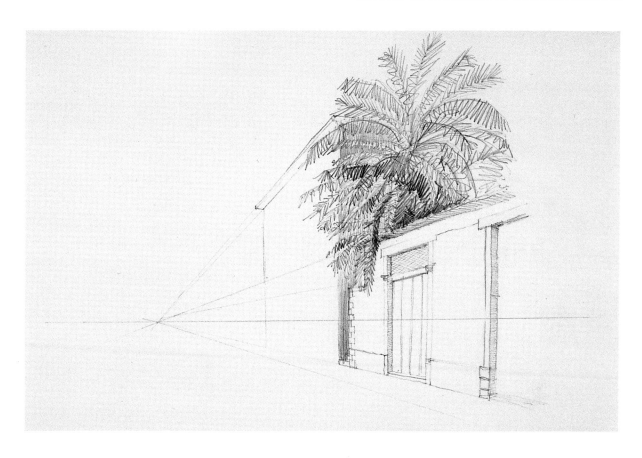

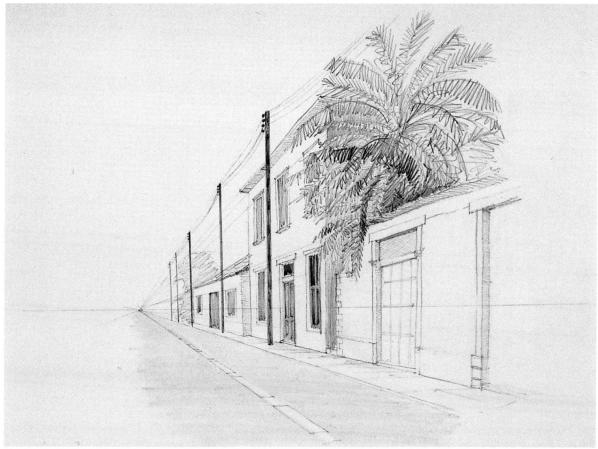

start to put in the detail or even other buildings. Try putting in smaller or larger buildings. Perhaps the first building was two storeys; you could add a one- or three-storey building next to it. Remember that if the buildings are on the same level and facing the same way (in other words, in the same row), they will have the same vanishing point as the first and closest building that you drew.

## Spaces

So far, we have dealt with buildings in one-point perspective and the illusion of buildings getting smaller as they go into the distance. Another aspect of perspective is that spaces between objects get narrower as they recede towards the horizon. There is no specific way of working out the degree to which the spaces narrow as they recede into the distance. However, you use what

you have already drawn as a comparison. For example, compare the width of the nearest building to the width of the furthest one. This will give you an idea of how much the width of the furthest building has narrowed.

One more very important point to remember is to keep your vertical lines vertical. If they slant, even by a small amount, it will give the impression that your building is leaning or falling over.

## Two-Point Perspective

This is the most common form of perspective used by artists to produce a three-dimensional image. It will enable you to draw both sides of a building and to have both of these sides, including the rooftops, doors and windows, receding into the distance.

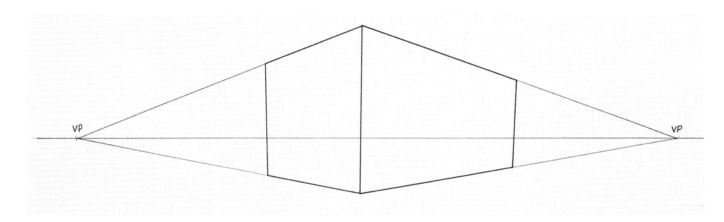

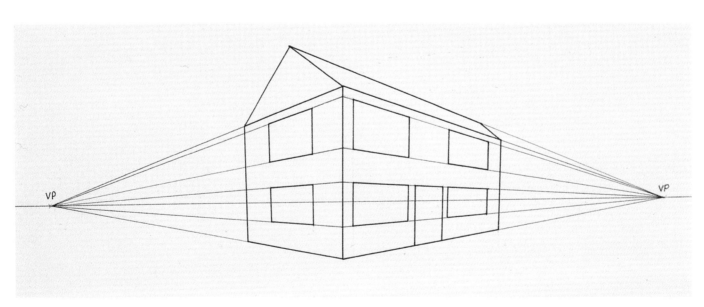

TOP: **Two-point perspective will give the impression of both sides of the building receding to two vanishing points (vp) on the horizon.**

ABOVE: **All doors, windows and roof lines will converge on their corresponding vanishing point.**

As with one-point perspective, begin by drawing a box, starting with the closest vertical, which is usually the corner of the building that is nearest to you. This will indicate the height of the building and the horizon or eyeline will cross this line about one-third of the way up. Once you have established these two lines, put in the two vanishing points, one on each side of the vertical corner line.

Next, take a line from the top of the vertical down to the vanishing points on the horizon, then do the same for the bottom of the vertical line. The next step is to put in two more vertical lines to indicate the far corners of the box. The position of these will depend on how wide each face of the box or building is. You should now have a perfectly drawn box in perspective. Once you are happy with this, proceed to fill in the detail, starting with the windows, doors and rooftops. This is carried out in exactly the same way as in one-point perspective, except that you will need to do it on both sides of the building. As with one-point perspective, do some exercises involving two or more buildings or boxes and vary the heights of the buildings. If the boxes or buildings face the same way, in other words are in the same row, they will have the same vanishing points,

**Because of the angle of the building, the vanishing points may well be beyond the edge of the photograph.**

## Detail

The rules of perspective apply to everything, including smaller details such as chimneys, arches, fences and pathways. If you look at an archway or a door or window with an arched top, the arch is normally a semi-circle, so the best way to create an arch in perspective is to draw the rectangular area that the arch fits into first and then draw in the arch, making sure that it touches the rectangular box in the correct places. The same rules apply to circles. Draw the square box in perspective first, then draw the circle inside the box.

If you are drawing a circular building there will be horizontal circular lines and edges that will be affected by perspective, depending on how far they appear above or below the eyeline. If you are looking at a horizontal circular line above the eyeline, it will curve up. If it is below the eyeline, then it will curve down.

## Shadows

Shadows are just as important as perspective when drawing and painting. They indicate light direction, tone and form and the rules of perspective apply to shadows just as much as they apply to edges and lines. Look carefully at your chosen subject matter and see how the shadows fall.

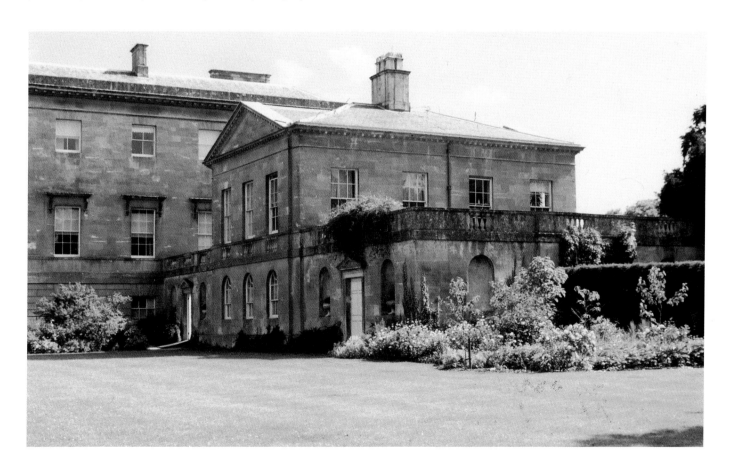

The horizon is just above the top of the small tree in the foreground.

Note how the top of the chimney recedes down to each vanishing point.

Even the lines on the grass in front of the house recede to the vanishing point.

## Three-Point Perspective

Three-point perspective is an element of drawing often over-looked by artists. The third point is used when looking up at a tall building or down when standing on a roof. Tall buildings such as skyscrapers will appear to get narrower at the top if looking up at them. The taller the building, the more the straight sides of the building will appear to converge as they head skywards. Three-point perspective can be used to add impact to your picture.

To start a three-point perspective exercise, begin as you would with a two-point perspective exercise, but before putting in your second and third vertical lines place a third vanishing point above your first vertical. Project your second and third verticals up to this third vanishing point; you will then see the illusion of the lines converging as they head towards the sky. Project the other lines to the vanishing points on the horizon as you did in the two-point exercises. The higher the building, the further up the page the third point will be, so bear this in mind when doing more than one high building.

If looking down on a tall building, the process is the same except that the third point should be placed below the horizon rather than above it.

## Moving the Horizon

So far, we have dealt with the different aspects of perspective, but with the horizon or eyeline positioned in the same place. If you move the horizon, you will change the way the picture looks due to changing the eyeline. In other words, if the horizon is moved to the top of the paper, the impression will be of looking down, whereas if the horizon is moved to the bottom of the page this will result in an exaggerated view looking up. The picture will there-fore need to be drawn using three-point perspective.

## Perspective Drawing Aid

There is a quick, cheap and easy way to check that your draw-ing is correct. There are products on the market called protrac-tor rulers, which are two short pieces of plastic secured at one

**A painting of Bath Abbey using three-point perspective.**

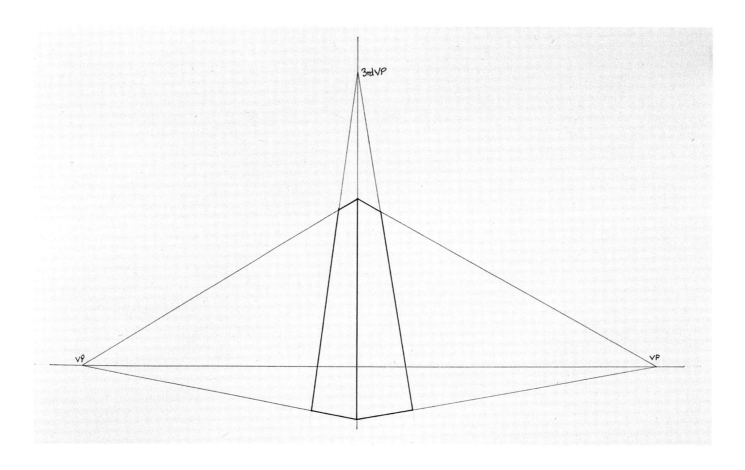

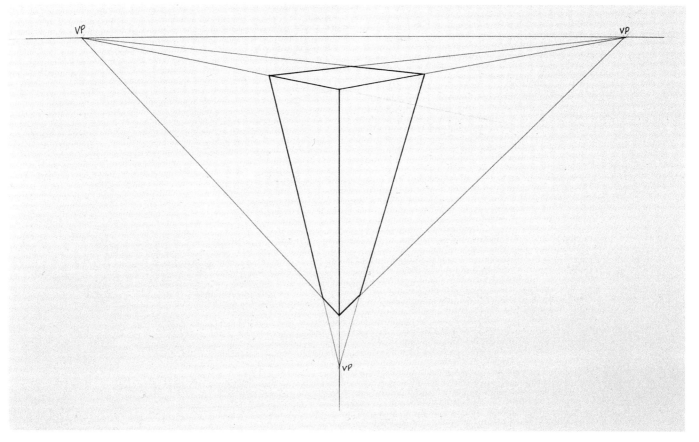

OPPOSITE PAGE:
TOP: Three-point perspective, with the eye level towards the bottom of the picture, will give the illusion of looking up at a building.
BOTTOM: Three-point perspective, with the eye level towards the top of the picture, will give the impression of looking down on a building.

end so that the two pieces swivel to create different angles. Line up one of the pieces of plastic on a vertical line, then move the other piece up or down until it lines up with the sloping line you are checking. Then move the protractor ruler to the same angle you have already drawn on your paper and check to see if the angle is correct. You can also make one of these instruments yourself. Cut two pieces of stiff card, approximately 15cm (6in) in length, and join them together at one end with a split pin so that they can swivel through 180 degrees.

It is important not to become too reliant on drawing aids. If they are used all the time, you will not fully get to grips with the rules of perspective, so aim to keep their use to a minimum.

## Composition

Composition is the technique used by artists to aid the eye of the viewer around the picture and, therefore, help to give a better balance. Artists can use their experience to position certain elements of their subject matter in a particular place on their picture and can include empty spaces as well as strong verticals, doors, windows and brighter colours. One of the surest ways to achieve a strong composition is to follow the rule of thirds. Before commencing your drawing, break up the working surface into thirds, both horizontally and vertically, so that you have nine equal sections. The horizon (if you can see it) can be placed on the bottom horizontal third, which will give you a good place to start. Next, look at the scene you want to reproduce and decide which part of the building you feel is the strongest and place this on one of the vertical thirds. If you are not sure which are the strongest elements to place on the thirds, do a few small sketches on a scrap piece of paper before committing to your proper picture surface.

There are a few other things to consider when creating a good composition. Do not put any strong verticals or horizontals too close to the edge of the working surface, as these will clash with the edge and confuse the eye. Try not to have any diagonals disappearing into a corner and if there are any rows of trees in your picture, vary their size and shape, otherwise they will look too regimental. Finally, if including animals or figures, portray them walking into or towards the centre of the image rather than away.

## Summary

The rules of perspective may seem complicated and mathematical, but if you get them wrong or draw one line at the wrong angle this mistake will unsettle the whole image. Hopefully the information in this chapter will help you to understand the rules of perspective a little more. The most difficult aspect of perspective is that most of the time you will not be able to see the horizon or eyeline and, therefore, may not be sure where to put your vanishing points. Also, the vanishing points may converge off the drawing surface, especially if the angle of the building is less than some of the exercises in this chapter. Use the rules you have learnt here to check that your drawing is correct, so that most of the time you will not need to put in your horizon or vanishing points. The best method is to draw what you are looking at, then check the finished drawing using the rules of perspective. Try to do as many exercises using perspective as possible. The more you do, the more it will become second nature when drawing and painting buildings.

Perspective drawing aids showing a protractor ruler on the left and a homemade drawing aid on the right.

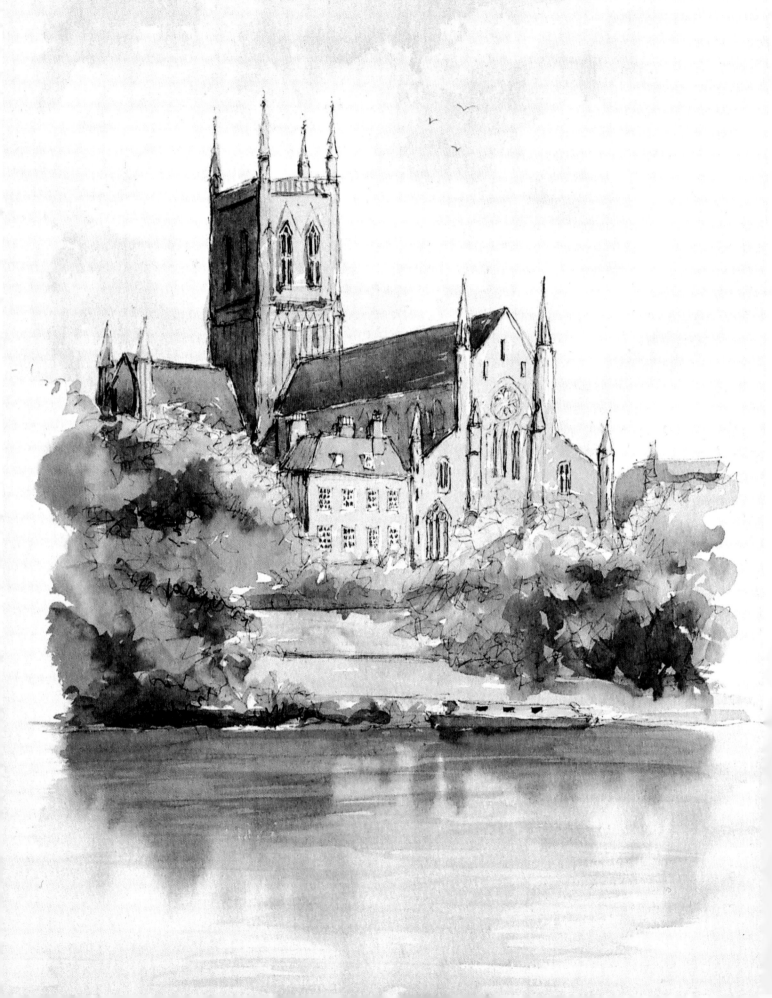

# CREATING THE CHARACTER OF OLD BUILDINGS

When drawing and painting buildings, we look for structure, perspective, composition and, probably most important of all, character, especially with older buildings.

Old buildings have a history. They have a story to tell and it is the character of the old buildings that tells you this story. The architecture or design can indicate the year of construction, but will not reveal the character or what the building has gone through during its life. But how do you define that character and, more importantly, how do you reproduce it? This chapter will show you how to use different mediums and techniques to reproduce the characteristics of old buildings and also how to recognize certain characteristics and how to use them in your drawings and paintings.

A lot of the character of an old building can be attributed to the detail, such as brickwork, masonry, cracked plaster, peeling paint and so on. We will be dealing with this in detail in Chapter Five. In this chapter, we will concentrate on the overall character of an old building and the best way to do this is to look at certain types of buildings and what they have been used for, such as cottages, churches, ruins, farm buildings and castles. Also, the more a building has been exposed to the elements and everything else that Mother Nature and people can throw at it, such as earthquakes, war and so on, the more the character will develop over the years.

There have been houses or dwellings in existence almost as long as there have been people. Humans have lived in everything from a cave to a castle. Most houses these days have no character because they have been mass-produced to be functional, rather than being built by individuals who wanted a

unique place in which to live. Consequently, the older the building, the more likely it is to retain the character of the person who built or commissioned it. A good example would be an old castle. These were often built to specific instructions from the person paying for them and some of these people would have very strange ideas about what sort of castle they were after. Therefore, if you study the detail of such a building it will often reflect the character of the person who commissioned it.

Different countries have different types of houses depending on their size and location within those countries. Some are rural, others in towns and cities. Some buildings have been created for purely functional reasons, such as farm buildings and boat yards. Others have been constructed for defence, protection and practicality. In the following exercise, we will do a graphite drawing of an English thatched cottage that shows the character of the building with the distinctive thatched roof and leaded windows.

## EXERCISE: **DRAWING AN OLD COTTAGE WITH GRAPHITE PENCIL**

— OBJECTIVE: To create a graphite drawing of an old cottage with a thatched roof.

— MATERIALS: Smooth white cartridge paper, 2B and 4B graphite pencils, pencil sharpener, putty eraser.

In Britain, we have cottages with thatched roofs and timber frames. Some of these cottages are extremely old, with crooked windows and walls that bulge out due to the weight of the thatching. Others have slate tiled roofs that sag in the middle or chimneys that look like they are about to fall off the roof in the next storm! All of these unusual aspects come together to create a unique feel to the building. Most cottages are of a simple design, four walls and a roof, and are surrounded by gardens, fences, hedges and rolling countryside. When drawing and

**OPPOSITE PAGE:**
*Worcester Cathedral, England.*
**Pen and watercolour wash.**

painting cottages, it is best to try to make them look as simple and as old as they appear. Some of them may have been renovated, which means aspects of the original character may have been taken away, giving them a 'chocolate box' effect. To avoid this, try some simple black and white sketches in graphite pencil, as in this exercise.

Using a sharp 2B pencil, start by lightly drawing in the basic outline of the cottage. Try not to be too tight with your drawing. Keep the lines fluid and sketchy while maintaining a certain degree of accuracy. Look at where horizontal and vertical lines meet. Keep your pencil lines in the distance lighter, increasing the strength of the lines as they progress towards the front of the drawing.

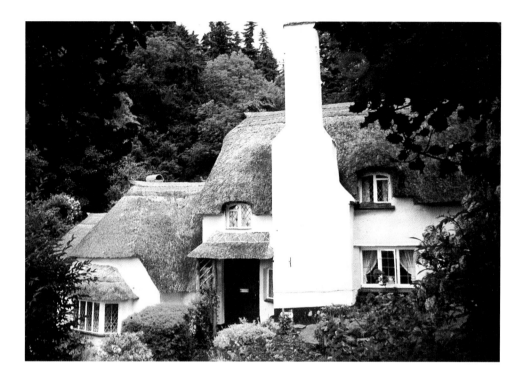

**An old English cottage.**

**Using a sharp 2B pencil, start by lightly drawing in the basic outline of the cottage.**

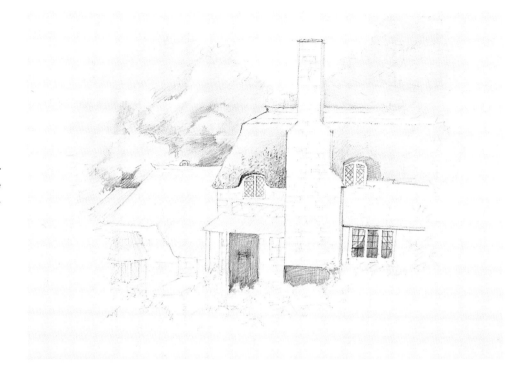

**Start to bring out the character of the building by drawing in the brickwork, thatch and windows.**

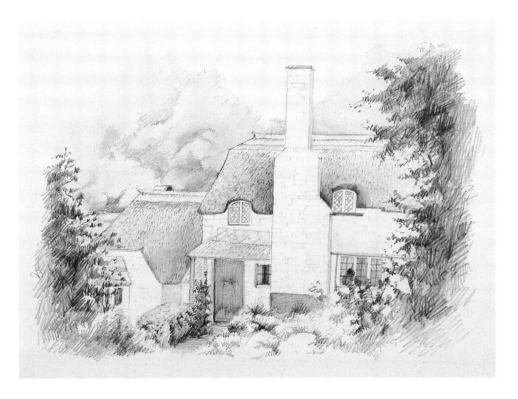

**Using the softer 4B pencil, shade in any surrounding dark vegetation, especially in the foreground and down the sides and strengthen up the detail in the building.**

Once you are happy with the basic drawing, start to add some detail. Look for odd angles and different textures. Sometimes, as in the photograph chosen for this exercise, windows and doors do not line up and the thatch is uneven. Use a variety of lines and scribbles with both pencils to depict the different textures such as stonework, plaster, thatch and foliage. Look at the chimney. Is it crooked? If so, do not be afraid to draw it that way, but be aware that although the photograph is real your drawing of the chimney that leans to the left may look awkward. All of these elements will help with the character of the old cottage.

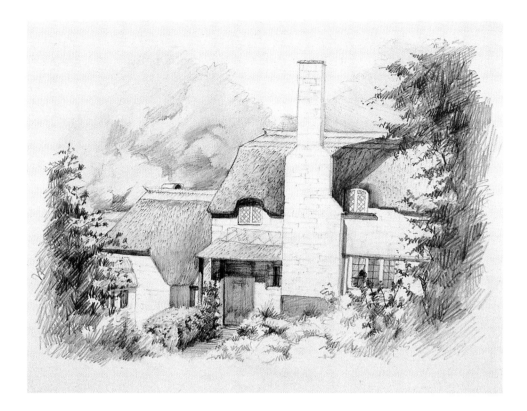

Once you are happy that you have done enough drawing and feel the picture is nearly finished, you can put in the shadows.

The brickwork in this subject is not clear, but if you decide to put some in do not draw every single brick as this would look too fussy. Indicate the brickwork with a few horizontal and vertical lines, especially around the doors and windows. Lightly rub your finger over some of the brickwork to smudge some of the edges. You can also use the eraser to lift out a few lines and make some of the bricks appear lighter. When working on the thatched roof use a mixture of cross-hatching, rubbing with your finger and small flicks with the softer 4B pencil to give the impression of the thatch. Lightly shade in some of the distant trees, using your finger to rub some of the pencil marks.

The next step is to start putting in some of the darker parts of the drawing. Leave out the shadows as these form the next and final step. Using the softer 4B pencil, shade in any surrounding dark vegetation, especially in the foreground and down the sides, as this will help to frame the drawing on the paper. Do not put in too much heavy shading with the 4B in the distance, as the further away something is the lighter it should appear. When you shade the darker areas it will make some of the lighter areas you started with look even lighter, so it may be necessary to go back over these areas to balance the drawing. When doing the foliage, use a cross-hatching technique rather than pencil lines all going in the same direction, as this will create a more natural feel.

When you feel that you have done enough drawing and the picture is nearly finished, it is time to put in the shadows. Pay particular attention to the angles of the surfaces on which the shadows fall. The shadows need to be stronger than they appear in the photograph and all need to fall in the same direction. Keep the shading soft, but maintain nice sharp edges to the shadows. You may find that you will have covered up some of the original detail; if so, redraw the detail over the top of the shadows. Once you have done the shadows, the drawing is complete.

In this exercise, we have dealt with such features as old brickwork and thatched rooftops. These will help to give the impression of an old building that has plenty of character and is immediately recognizable as an old cottage. The graphite pencils enable us to vary the tones and textures and we can also use the eraser as a drawing tool to lift out highlights and easily correct mistakes.

### EXERCISE: **PAINTING A FRENCH CHÂTEAU IN ACRYLIC**

— OBJECTIVE: To reproduce the distinctive architecture of a French château with round towers.

— MATERIALS: Primed canvas board, acrylic paints, brushes, palette, palette knife, water container, tissues or rags, easel (optional).

There are very few buildings as distinctive as a French château. The round towers with their 'witch's hat' rooftops shining in the sun combined with the yellow and grey stonework are easily recognizable. In this exercise, we will use the versatility of acrylic

paint to reproduce the mixture of colour, texture and character of these buildings.

When painting with acrylic or oil onto canvas or canvas board, I prefer to block out the white surface using a wash of yellow ochre acrylic. The resulting yellow surface is a better colour to paint onto and some of this underpainting will show through parts of the picture at the end to give the picture a unified finish.

When this underpainting has dried, start on the drawing of the buildings. Use a size 8 round brush with a good point to paint in the basic outlines of the château with a dark brown paint. If you make a mistake but the lines of paint have dried, cross out the incorrect line and put in the correct ones. The paint you put on later, once the drawing has dried, will cover up any corrections.

Using a palette knife, mix a colour for the sky from white and cobalt blue, then paint this onto the canvas with a number 12 round brush. Don't worry if the brush marks show – this will add to the painterly effect of the picture. Next, block in the rooftops with a mixture of ultramarine blue, burnt umber and white. Lay down brush marks that go in the same direction as the slope of the roof and use a few spots of different colour, such as a darker grey and a bit of yellow ochre. These colours will help to break up the large areas of grey. When the rooftops are finished, start to block in the sides of the buildings with yellow ochre, white and some of the grey you used on the rooftops. If you use a flat brush for the walls it will help to give a suggestion of brick and stonework.

Once you have done the blocking in of the buildings, it is time to put in a bit more detail. Working across the picture, bring out the detail of the bricks and broken plaster. Don't overdo this, as it will look too fussy. The large wall on the left-hand side will have more detail in it than the right-hand side as it is closer to you in the picture. Use a combination of broken colour and rough brush strokes to break up these areas. I use a worn number 8 round brush for this.

At this stage, it is a good idea to sharpen up a few edges, especially after you have done the walls of the buildings. The eye level in this picture is about a quarter of the way up, so any curve

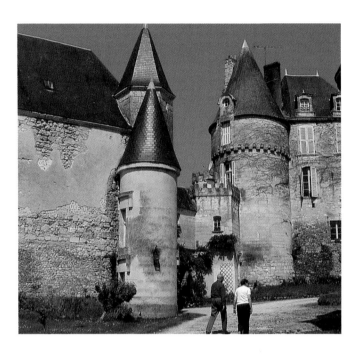

ABOVE: **A French château in the Loire Valley, France.**
LEFT: **After painting the canvas with a yellow ochre wash, paint in the basic outlines of the château with dark brown paint.**

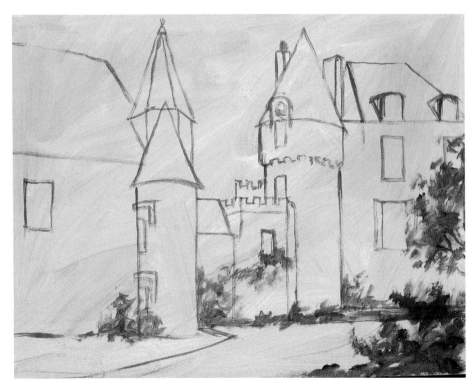

47

above this line will bend upwards, as can be seen at the point on the round towers where the bottom of the roof meets the top of the wall. Put in the windows and the basic colour of the vegetation. The dark windows will make everything else look lighter and, therefore, help you to judge how much more to do on the painting.

Most of the painting is now finished. If you feel that some of the buildings need to have a bit more colour added, you can use a technique called 'glazing'. Mix up a loose wash of colour with a combination of yellow ochre and burnt umber and drag this down your picture using a worn round brush. Before this has a chance to dry, soften some of the wash with your fingers.

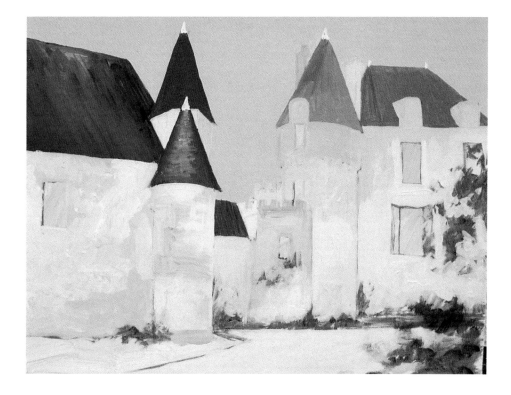

Start to block in the sky, rooftops and main parts of the buildings.

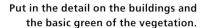

Put in the detail on the buildings and the basic green of the vegetation.

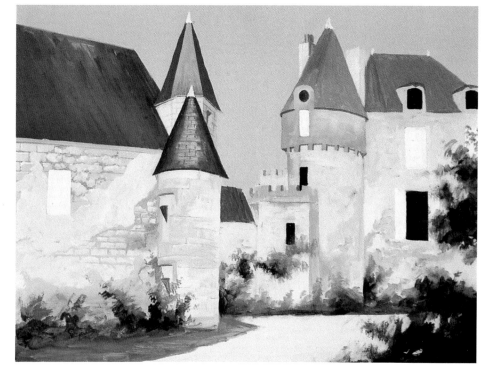

48

This glazing technique using a worn brush will add texture to the walls of the building. To achieve a sense of scale, add in the figures.

The final stage concerns the shadows. The photograph of the château was taken at midday so the shadows are very small. You may want to exaggerate these shadows to give a greater sense of three dimensions. Use a mixture of ultramarine blue and burnt umber for the shadow colour.

The important part of this exercise is to give an impression of strength, solidity and also character using texture and colour. Remember to use broken colour in large areas, but also keep the edges sharp. The figures add a sense of movement and scale.

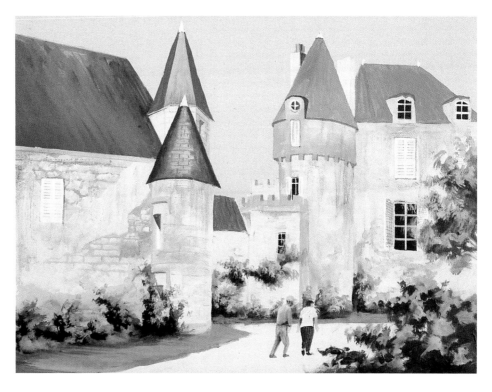

**Glaze a wash of yellow ochre and burnt umber over the sides of the buildings and add the figures for scale.**

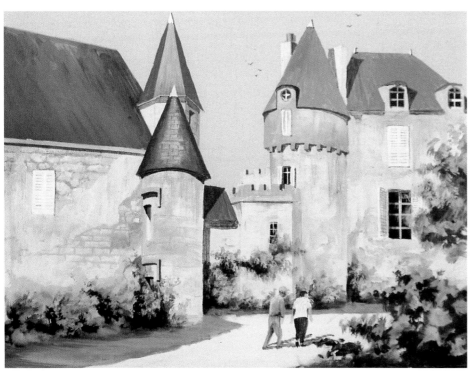

**Finally, add the shadows with a mixture of ultramarine blue and burnt umber.**

EXERCISE: **PAINTING OF A CHURCH USING A LIMITED WATERCOLOUR PALETTE**

— OBJECTIVE: To use a minimum amount of colour to reproduce a painting of an old stone church.

— MATERIALS: White, 'Not' surface, 300gsm (140lb) watercolour paper, watercolour paints, watercolour brush, water container, 2B graphite pencil, pencil sharpener, eraser, tissues.

Most old churches are built from grey or brown stone, usually a local stone, and have an austere and sombre appearance. You can reproduce this by using what is called a limited palette. This means keeping the number of different colours down to a minimum.

When painting with a limited palette I recommend a maximum of four colours, although in this exercise we will be using only three. The colours chosen for a limited palette would depend on the subject matter, but to paint the old church I recommend

**An old English church.**

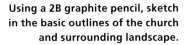

**Using a 2B graphite pencil, sketch in the basic outlines of the church and surrounding landscape.**

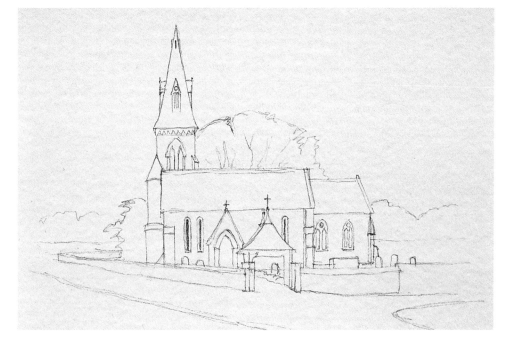

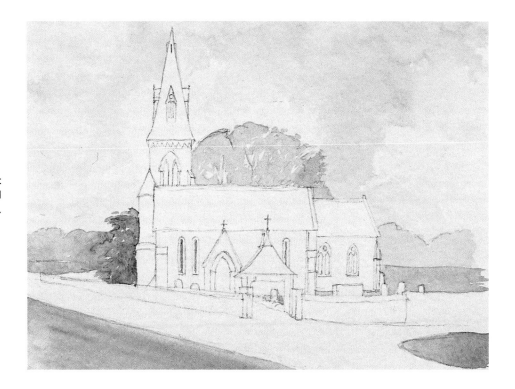

**Paint in the sky and light greens of the foliage and grass in the foreground.**

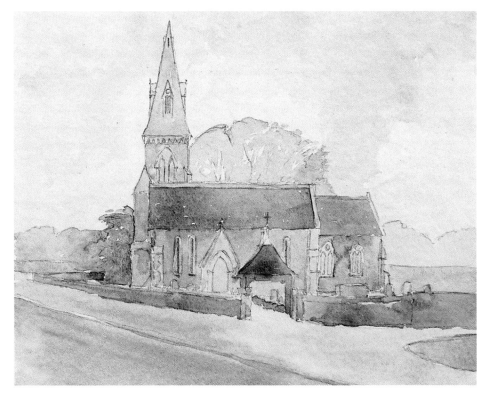

**Start blocking in the rest of the picture using a variety of greys and browns mixed using the ultramarine blue and burnt umber.**

ultramarine blue, burnt umber and cadmium yellow. The blue can be used in the sky and also mixed with the burnt umber to produce different greys and browns. The yellow, mixed with the same blue, will be used for the greens.

Start with a pencil drawing. Using a 2B graphite pencil, sketch the basic outlines of the church and the surrounding landscape. The church itself should be the strongest part of the painting, so use fairly strong pencil lines on the building and softer lines on

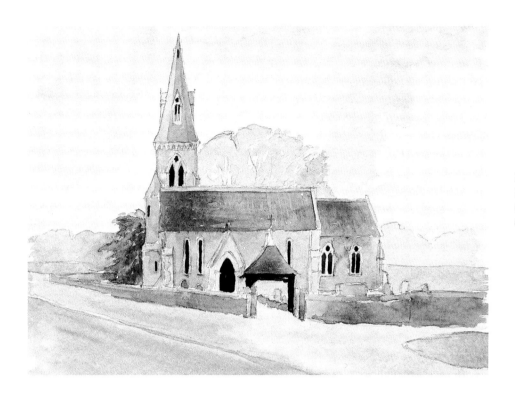

Use a strong mix of ultramarine blue with a little burnt umber and paint in the windows, doors and underneath the gate roof.

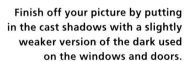

Finish off your picture by putting in the cast shadows with a slightly weaker version of the dark used on the windows and doors.

the trees and surrounding landscape. There is no need to put in any shading as you will do this with the paint. Once you are happy with the drawing, you can commence painting.

As with all watercolours, I always recommend starting with the sky at the top of the picture. Using the ultramarine blue, gently

wash in a pale tint and leave some of the white of the paper for clouds. Next, mix some of the burnt umber into the blue on your palette and apply this pale wash to the underside of the clouds. Finally, use a very pale wash of the cadmium yellow to tint some of the clouds to give an impression of sunlight. Make sure the blue

is dry before adding the yellow. If you touch a wet area of the blue with the yellow, the paint will run together and turn green.

In the next step, start to build up the surrounding landscape using various mixes of ultramarine blue and cadmium yellow. Begin at the back of the picture or with the trees in the distance. The further away something is, the lighter and bluer it will appear, so mix up a light blue-green and use this to paint in the trees in the distance. Make this wash stronger and warmer by adding more of the yellow and blue. Use this to paint in the rest of the grass and trees in your picture. You may need to add more yellow for the grass in the foreground to make it warmer than the other areas of green.

The next stage is to start blocking in the rest of the picture using a variety of greys and browns mixed using different proportions of ultramarine blue and burnt umber. Start at the top (the church spire) and move down the picture, varying the greys with either more brown or more blue. Don't worry if some of the browns bleed into some of the greys as this will help to unify the various aspects of the image. Try to keep within the pencil lines but leave little white spots here and there to add to the 'sparkle' of the picture. You may see some of the blue separate out and settle into the grain of the paper. This is called granulation and is a perfectly natural thing to happen with watercolour, depending on the type of paper you are painting on. I like this effect because it adds to the texture of the walls and rooftops of the building. When you have finished painting the building, walls and road, it is time to start adding your darks.

The darks are the darkest part of the painting, such as windows and doors, but are not the cast shadows. Use a strong mix of

ultramarine blue with a little burnt umber and paint in the windows, doors and underneath the gate roof. These darks may make other areas of the painting look a little light. If they do, strengthen some of them but don't overdo it. Finally, finish off your picture by putting in the cast shadows with a slightly weaker version of the dark used on the windows and doors. Remember to keep all your shadows going in the same direction and don't overwork these areas as you may re-wet the colour you are painting onto.

Hopefully you will have achieved a feeling of solidity, cohesion and unity with the use of just the three colours. A painting done with a limited palette such as this will always look much better than a similar painting done with too many colours. Try a few more exercises using this technique.

### EXERCISE: **A CHARCOAL AND CHALK DRAWING OF A CASTLE**

— OBJECTIVE: To create the drama, power and majesty of a castle using charcoal and chalk on grey paper.

— MATERIALS: Grey pastel paper, drawing board, charcoal sticks, chalk sticks, fixative, tissues, easel (optional).

There is no escaping the power and majesty of a castle. They were built for defence and for showing off. They were intended as a statement of power and affluence in an age where the ruling classes needed to maintain a presence in the landscape and remind the locals who was in charge. To reproduce this presence, we need to pick a medium that can portray a sense of drama

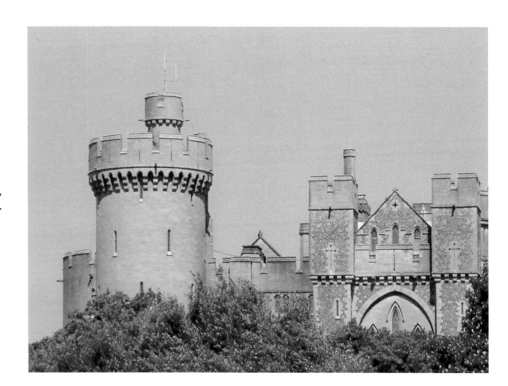

**Arundel Castle, England.**

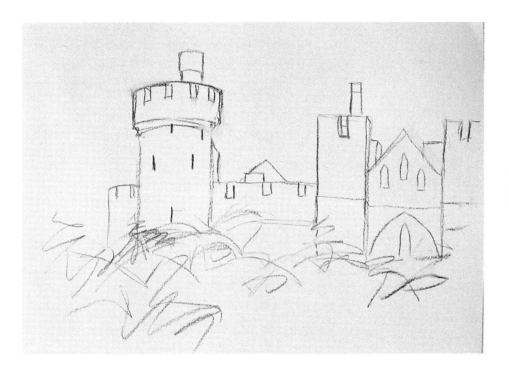

**With the charcoal, start by quickly sketching in the basic outlines of the castle and trees.**

**Start to block in the sky and buildings with the white chalk and strengthen the outlines with the charcoal stick.**

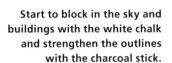

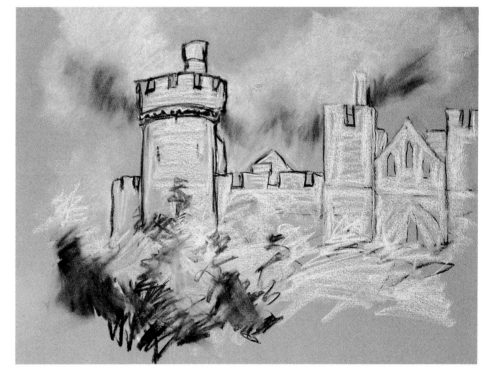

and there is nothing more dramatic than the expressive drawing medium of charcoal.

In this exercise, we will be using the charcoal with chalk on grey paper. This gives us the three tones, light, middle and dark, and by blending these tones together we will be able to produce a three-dimensional drawing as well as an emotional and vibrant sketch.

With the charcoal, start by quickly sketching in the basic outlines of the castle and trees. You need to keep the lines loose and sketchy but also maintain a certain amount of accuracy. I find that the best way to maintain the loose charcoal lines is to have your drawing surface on an upright easel and to stand up when drawing.

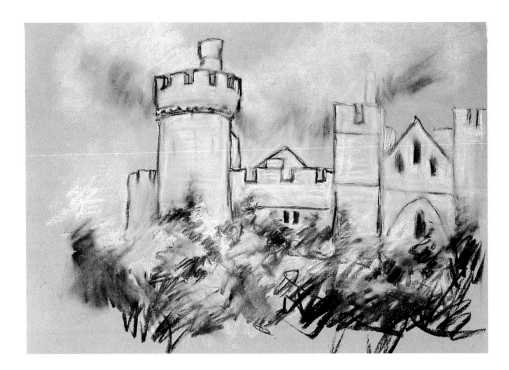

Strengthen the foreground with the charcoal and chalk and blend some of this together with your finger.

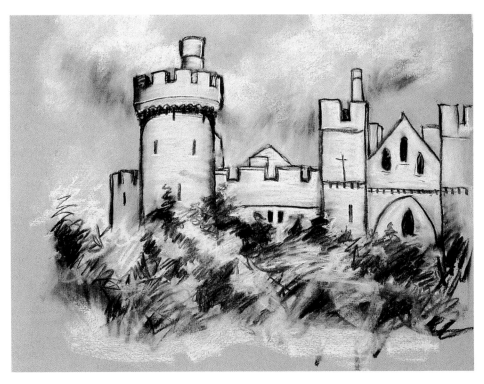

The final stage is to use the charcoal and chalk to re-emphasize the light and dark areas and to put in the shadows.

When this initial charcoal drawing is done, use the white chalk to shade in the clouds and also the castle and trees in the foreground. Use the side of the chalk for larger areas and the end of the chalk for the stronger highlights. Use your finger to soften the clouds and some of the trees in the foreground. Next, use the charcoal stick to sharpen some of the edges that may have been lost when using the chalk. You will need to put in the shadows under the clouds with the charcoal and smudge this into the white. Do not press too hard with the charcoal as this may produce a hard line that cannot be smudged away. Put in some of the darker areas of the foreground and smudge this into the white, but do not get rid of all the charcoal lines. Before moving

onto the next stage with the charcoal and chalk use your finger to soften the drawing. I find this pulls the picture together and gives a more three-dimensional appearance. But do not rub your finger over the outline drawing as this may make the drawing disappear altogether!

The final stage is to use the charcoal and chalk to re-emphasize the light and dark areas, strengthen the stronger outlines and develop a larger tonal range by smudging with your fingers. Use the sharp edge of the charcoal stick to put in the detail such as the windows and wall edges and finish off with a few strong white highlights with the chalk.

You should now have a strong and lively drawing that uses the combination of charcoal and chalk to produce the power of the castle as it appears over the trees in the foreground. Artists have used this medium for centuries to create an emotional response to the subject matter in portraits, landscapes and life drawing.

### EXERCISE: **AN OIL SKETCH OF OLD FARM BUILDINGS**

— OBJECTIVE: To paint the worn and faded wood of an old farm building using oil paint as a sketching medium.

— MATERIALS: Primed canvas board, oil paints, brushes, palette, palette knife, turpentine, linseed oil, rag or tissues.

Scattered around the countryside are old, run-down farm buildings, huts and barns, which, because of their basic construction and years of neglect, have a wonderful character all of their own. These buildings were intended to be purely functional, so their character can be affected solely by exposure to the elements and their suffering at the hands of their owners. They come in a variety of shapes and sizes and can be constructed from all sorts of materials, in some cases from material that has been found lying around the area – anything from wood, metal and plastic to brick, stone and flint. Even though these buildings look like they are about to fall down, most of them are still being used, adding to their character and atmosphere.

The type of medium you choose may depend on the type of building you intend to draw or paint. Watercolour is an excellent medium to reproduce the texture of wood, but would struggle with the larger, darker textures. Pencils are a good medium to sketch with, but for this particular exercise we will be doing an oil sketch onto a canvas panel.

Oil enables us to push paint around using brushes, fingers and palette knives to create texture and is sufficiently opaque for us to produce large darker areas for contrast. Because we are going to do a sketch rather than a finished painting and because of the slow drying time of oils, we will be doing this painting in a single sitting and therefore painting onto wet paint. Do not make your oil paint too thick as this will increase the chance of the paint mixing on the board, creating a muddy effect. Keep the brush strokes as vigorous as possible to maintain a fresh, sketchy feel.

Start by painting a wash of raw sienna onto the board to get rid of the white. Next, using a burnt umber, draw in the building and the edges of the trees with a small flat brush. You can also fill in the dark areas with the same paint to give you an idea of how these dark areas work in the overall picture. Paint in the sky with a mixture of white and a little ultramarine blue, painting

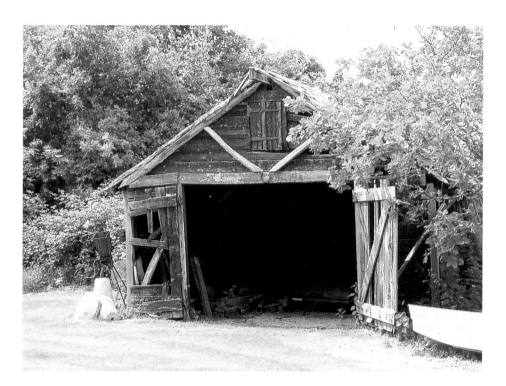

**An old farm building.**

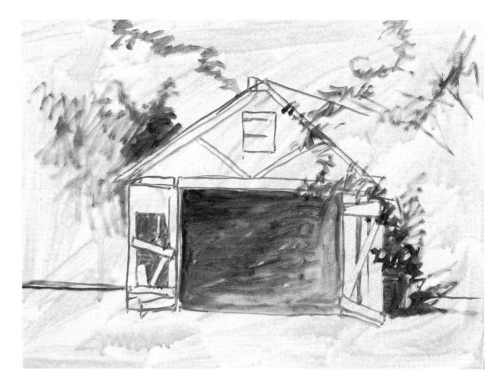

After washing raw sienna onto the canvas, draw in the picture with burnt umber.

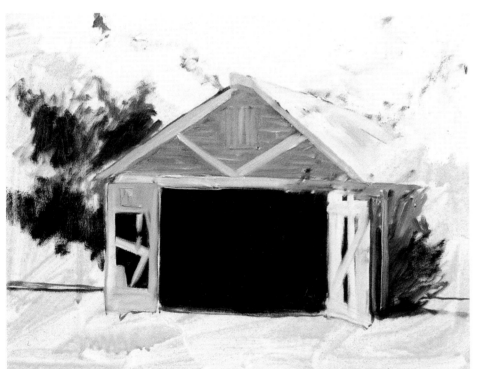

After painting the sky, use a small flat brush to paint the planks of wood on the building.

over the tree area in places for the dappled light that is shining through the tops of the trees. At this stage, I have decided to put in the darks, using a mixture of burnt umber and ultramarine blue paint in the dark interior of the building plus the other dark areas of the trees and bushes.

Add some of this dark paint to white and use this grey colour to start to paint in the building. The advantage of oil paint is that even at this stage we can start to reproduce the structure of the building, especially the planks of wood, by using a small flat brush and the brush strokes that show up in the paint. Use a variety of

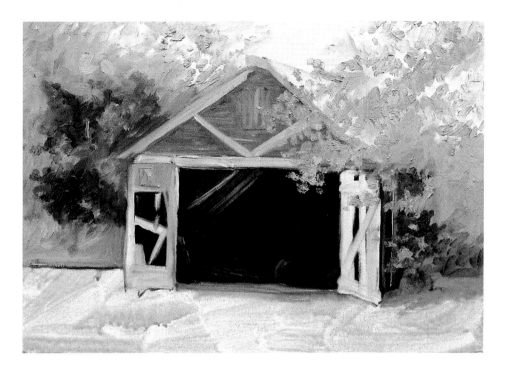

Paint in the trees using a mixture of cadmium yellow, white and ultramarine blue.

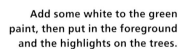

Add some white to the green paint, then put in the foreground and the highlights on the trees.

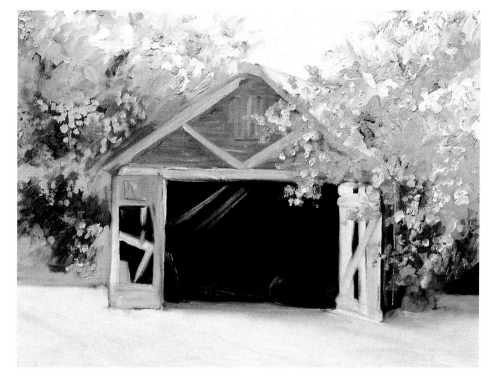

light and dark greys by varying the amount of white mixed in. Also add a little yellow ochre for some of the warmer areas. Do not use the same shade of grey over the whole building as it will make it look boring and unimaginative.

Use the lighter grey to put in some of the detail inside the building in the dark areas. Try to use single brush strokes with the small flat brush as constant brushing in the same area will cause the paint to mix on the canvas. Once you have done this, start to put in the trees using a mixture of cadmium yellow, white and ultramarine blue. Vary this mixture by increasing or decreasing the amount of blue and yellow to get a variety of different greens. Use different brush strokes as well as the side and

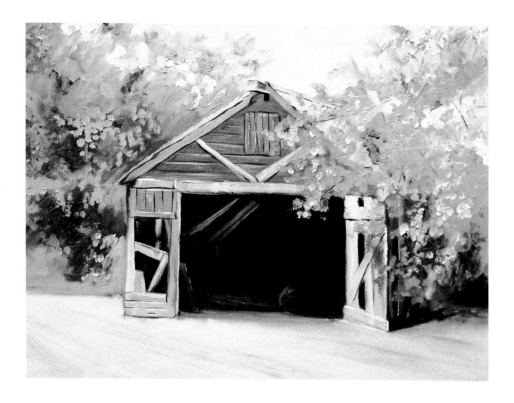

**The final stage is to put in more detail, highlights and the dark shadows.**

tip of the brush. This will give a more natural look to the foliage. Add a small amount of black to the green for the darker areas.

The foreground area contains a lot more sunlight, so use more white in the green mixture and horizontal brush strokes to give the impression of a level grass lawn.

Also use this light green to paint in some of the highlights on the trees. I have pushed the tree on the left back a bit to create distance. To do this, soften some of your brush strokes and add some yellow to the highlight colour for the tree on the right to bring it forwards.

Using a black, darken the interior of the building to give a subtle indication of its rear. It is up to you how much detail to put in this dark area. It may be a good idea to leave this until the end, when you will be able to judge how much detail is needed.

The final stages involve the detail and shadows. Using a small flat nylon brush, put in the highlights with some white and the darker edges with dark grey or black. Using a nylon brush will give you a thinner, sharper line than a hog or bristle brush. The light direction in this picture is coming from left to right but hitting the front of the building, so the only shadows visible are to the right of the building under the tree. I have left out the white object that is visible on the right, but the problem with leaving something out is that you do not know what is behind it. So use the black to put in some shadows of the leaves and the door. Finally, paint a few more brush strokes on the grass to lead the eye into the picture.

What we have learnt in this exercise is how oil paint can be used to paint a sketch of an old farm building. The wet paint on the canvas can be pushed and pulled with the brush to achieve contrast and softness and the brush strokes that can be seen in the paint indicate the wooden planking and the overall structure of the building. Perhaps the most important part of the picture is the dark interior of the building. This draws the viewer in and hints at a few objects lying around inside, indicating a run-down farm building that is still in use.

## Summary

The exercises in this chapter have given us an idea of how to create the character of a building using different techniques and mediums. The precise line of the graphite pencil can help delineate bricks, windows and doors and also the texture of a thatched roof. Charcoal is an excellent way to create an expressive and invigorating drawing and is a wonderful medium for depicting the size and power of a castle. Using a limited palette of watercolours helped us to reproduce the sombre and austere look of an old church, while oil paint allowed us to explore the contrast of old woodwork with the soft greens of the surrounding countryside.

There are many types of old buildings, each with their own style and character. Next time you are on holiday take a look around and see how many different types you can find. Make a few sketches or take a few photographs for future reference, then experiment with as many different mediums as you can.

# NEW BUILDINGS

Throughout this book we have been drawing and painting buildings whose age creates their style, character and history. The look of these old buildings can make it easy for us when trying to produce a drawing and painting with charm and character. In contrast, the buildings of today tend not to have the same charm and character, so in this chapter we will be dealing with the difficult subject of new buildings and how to portray them with different mediums without making them look too new and 'architectural'.

When drawing and painting new buildings there is a danger that we will end up with a picture that looks too tight and does not have the appeal of older buildings. The last thing we want to do is to produce something that looks like an architect's illustration. We therefore need to use the qualities of a particular medium to produce something that is more exciting and, hopefully, inject some character of our own into the finished picture.

New buildings have strong, sharp edges and bright, shiny surfaces. The brickwork is clean and unstained by pollution. They tend to have larger windows than older buildings and, because of the more advanced building materials and methods available today, they also come in all shapes and sizes. Throughout this chapter we will be experimenting with different types of mediums, both drawing and painting, while striving, as always, to keep the drawing and painting as loose as possible.

## EXERCISE: **WET-IN-WET WATERCOLOUR**

— OBJECTIVE: To use the flow of wet-in-wet watercolour to produce a loose painting.

— MATERIALS: White, Not surface, 300gsm (140lb) watercolour paper, watercolour paints, watercolour brush, water container, 2B graphite pencil, pencil sharpener, eraser, tissues.

**OPPOSITE PAGE:**
**Detail of wet-in-wet watercolour.**

**THIS PAGE:**
**Example of a new building.**

Begin by loosely sketching
in your drawing using the
2B graphite pencil.

After wetting the
paper thoroughly, drop
in your basic colours.

Most architects' illustrations are done with watercolour paint but in a particular style. Their job is to give an accurate impression of what the new building will look like when completed. We, on the other hand, want to produce a painting that gives an impression of character and style, but without the tight lines of an architect's drawing. Watercolour used wet-in-wet is an excellent way of achieving a loose, watery effect and, combined with a loose pencil drawing, should give us the impression we are hoping for.

The subject picked for this exercise has a good combination of strong vertical lines on the building and soft vegetation in the

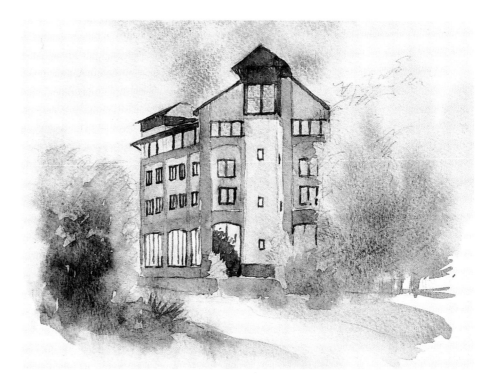

**Paint in the building and the trees with the same colours used for the initial wet-in-wet wash.**

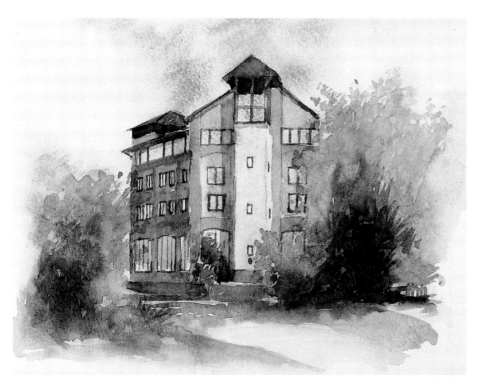

**For the final stage, paint in the shadows with a cool grey wash.**

form of the trees on both sides. Begin by loosely sketching in your drawing with the 2B graphite pencil, then wet the paper thoroughly with clean water and start to drop in the basic colours, such as the blue sky, green for the trees and the browns and greys of the building itself. Put some of the blue into the window areas too. Because the paper is wet, the colours will run into each other and into areas where they would not normally be wanted, such as green into the sky and building. Do not worry about this. Just let the paint go where it wants to. The shapes will be filled in properly once the painting has dried.

Before commencing the next stage, make sure that your initial wet-in-wet painting has dried completely. Start to paint in the building using the same greys and browns you used for the initial stage. If possible, use a larger brush than normal as this will help maintain a looser style of painting. Paint each section separately and be careful not to let the painted areas run into each other too much. Do the same for the trees on the left and some of the foreground too, but soften the darker tree colours in places to vary the strength of colour and help to give a more natural feel.

Once this stage has dried, it is time to finish off with the shadows. In the photograph chosen for this exercise there is not a lot of light and shadow on the building so, using a mixture of blue and dark brown, paint in the left side of the building, working around the windows and, with a stronger grey, paint in the cast shadows down the side of the building facing you and in other areas, for example under the roof and trees. The trees to the right have a particularly dark area underneath, so you may need to mix a stronger shadow colour for this. Soften some of the shadows under the trees to avoid too many hard edges and drag some of this dark across the pathway. The picture is now finished.

An architect's illustration would contain a lot more detail, including bricks and roof tiles, and would almost certainly have lighter trees and stronger colour on the building. In this exercise, we have used the wet-in-wet technique to pull the picture together, but also to soften a lot of the edges to give an impression rather than achieve an accurate representation of a new building.

## EXERCISE: **SKETCHING A NEW BUILDING WITH GRAPHITE PENCIL**

— OBJECTIVE: To create a loose sketch of a new building.

— MATERIALS: White cartridge paper, 2B and 4B graphite pencils, pencil sharpener, putty eraser.

New buildings can be made up of a variety of materials, from wood and brick through to metal and lots of glass. This means that there can be a lot of different colours in a series of new buildings, possibly leading to a confused and overworked painting. If faced with a subject such as the one chosen for this exercise, the best way to deal with it is to do a single colour or graphite drawing of the scene. Another aspect of new buildings is the straight edges. We have already dealt with loosening up in the previous exercise, but in this exercise we can loosen up our drawing even further by doing a quick sketch using the graphite pencil.

In this particular subject the best place to start is at the back of the picture. The bridge that cuts across the picture can be put in later. Using the 2B pencil very lightly, quickly sketch in the outlines of the distant buildings. Do not draw them in too dark as they are in the distance and too much pencil work at this stage could cause them to jump forwards in the finished drawing. Next, start on the bridge and figures in the foreground. Once the foreground has been completed, go back over this to strengthen the bridge and figures. This will help to pull the foreground forwards and give a greater sense of distance in your drawing.

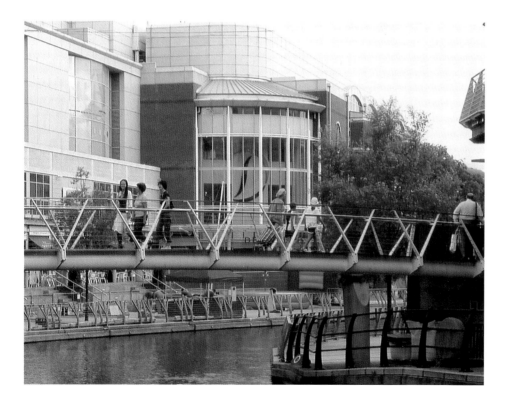

**Kennet and Avon Canal at the Oracle shopping centre, Reading, England.**

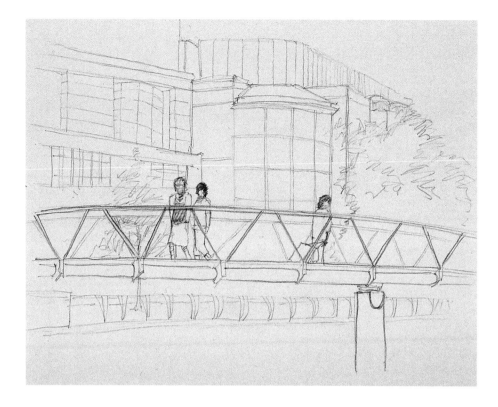

**Use the 2B pencil lightly and quickly sketch in the outlines.**

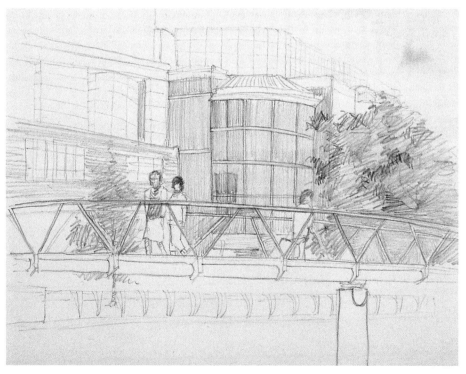

**Start to shade in the distant buildings and the trees on the left and right.**

Start to shade in the distant buildings using the 2B pencil. You may need to re-establish some of the outlines during the shading-in process. Use vertical lines to shade so as to emphasize the structure of the buildings. If the shading becomes too dark, use the eraser to lighten the areas. You may also find that some of the shading lines are too hard, in which case gently soften some of the areas with your finger to maintain the feeling of distant buildings. Use a random scribble line to put in the trees on the

**65**

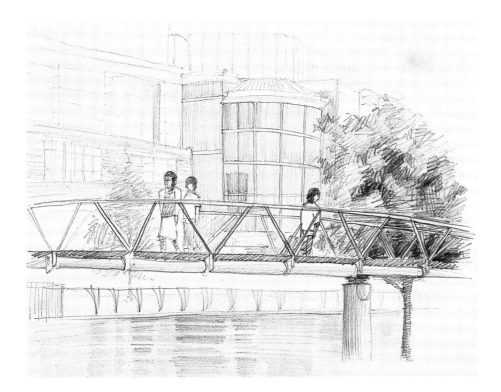

**Use the 4B pencil to strengthen the bridge and the shadows in the trees.**

left and right. If you lose some of the lines of the bridge, especially where the trees show through the railings, put these back in with a sharp pencil. The figures need to be put in at this stage. Just concentrate on the general figure shape rather than too much detail. There is no need to put in the facial features.

Shading in the background buildings will make them look too dark in comparison with the rest of the picture so use the 4B pencil to strengthen the bridge and the shadows in the trees. Use your finger to smudge some of the foliage and the eraser to create highlights on the trees and the lighter parts of the bridge. Finally, fill in the water under the bridge with horizontal shading. Smudge this with your finger and use the eraser to pick out some horizontal highlights in the water.

This exercise has shown us how to produce a quick sketch of a new building and therefore make the straight lines and sharp edges of the buildings look looser. A lot of the detail in the photograph has been left out, especially on the distant buildings. Too much detail would have made these buildings jump forwards and hover over the bridge in the foreground. Using both the 2B and 4B pencils and varying the pressure has helped us to maintain a sense of distance.

We have started this chapter by looking at new buildings in a landscape. A lot of new buildings have larger windows and more reflective surfaces than their older counterparts and the reflections in these windows and surfaces are a good subject for a more detailed painting. In the next exercise we will be dealing with reflections in windows using acrylic paint.

## EXERCISE: **REFLECTIONS IN GLASS**

— OBJECTIVE: To reproduce a reflection of the sky in windows.

— MATERIALS: Primed canvas board, acrylic paints, brushes, palette, palette knife, palette, water container, tissues or rags.

When painting new buildings in detail there is a danger that the end result will look tight and uninteresting. A good way of getting round this is to focus on a particular aspect of the subject. In this exercise, we will be concentrating on reproducing the

**Example of the sky reflected in glass windows.**

effect of reflections in a large window and also some of the other surfaces, such as wood and brickwork. The photograph chosen for this exercise has a large area of the building showing, but also has some foliage on the edges. These will give a soft and subtle contrast to the hardness of the new building.

After painting a wash of raw sienna over the canvas board, draw the outlines of the windows and trees with a dark brown. Next, use a mixture of white and ultramarine blue to paint the windows. It is important to establish these at this stage because they are the lightest parts of the painting and it will make it easier to judge the darker parts later. Whilst the blue paint is wet,

paint in the clouds on the larger windows. Do not worry about overlapping the edge of the windows as these lines can be tidied up later with the wall colour.

Next, using a mixture of white, lemon yellow and a little black, paint the window surrounds at the top and the central parts of the building. To keep the window edges sharp, you may need to use a straight edge to guide your brush stroke. Paint the rest of the building in a warmer version of the same colour, replacing the lemon yellow with a raw sienna. When painting on this colour, vary it in places with more white to break up the wall area. Allow these wall areas to dry before moving on to the next stage.

Draw in the outlines of the windows and trees with a dark brown and use a mixture of white and ultramarine blue to paint in the windows.

The next stage is to start blocking in the wall colours and the sharp edges of the windows.

Mix up a light green and a dark green from lemon yellow, ultramarine blue and white and paint in the trees on the left and right.

Mix up a loose wash of ultramarine blue and burnt umber for the shadows.

Now it is time to put in the detail on the walls and around the windows. Use a dark brown, such as burnt umber mixed with a little ultramarine blue, and paint the window frames and lines on the walls with a small round brush and a straight edge. Try to keep the lines straight and level and make the horizontal lines on the wall line up on either side of the central wall. These sharp lines and edges help to create the contrast we need to show up the reflections in the glass of the windows.

Mix up a light green and a dark green from lemon yellow, ultramarine blue and white and paint in the trees on the left and right. Use a vigorous brush action to scrub in the colour. This will give a good textural contrast to the rest of the picture. Start with the light green and work in with the dark green on top. When this has dried, it is time to finish the painting with the shadows.

Mix up a loose wash of ultramarine blue and burnt umber and, using a soft round brush, paint the shadows down the side of the central wall, along the bottom and down the sides of a few of the window frames. Scrub in some of the tree shadow onto the central wall and smudge this with your finger to soften some of the edges. When you have finished painting the shadows, the picture is complete.

This exercise has showed us how to reproduce the reflections of the sky in the large windows of a new building. The hard, sharp lines of the walls and window frames give an excellent contrast to the softness of the reflected clouds in the sky. The trees have added to this contrast and helped to frame the building on the canvas.

As mentioned before, new buildings can be made from all sorts of materials and, therefore, have many different coloured surfaces built into them. Sometimes, however, a new building can be made from similar materials, for example metal and concrete, and can therefore look the same colour all over. The best way to reproduce this is to work on a coloured background that is close to the overall colour of the building. In the next exercise, we will experiment with coloured pencil on a grey board that is similar in colour to the chosen subject.

### EXERCISE: **A GREY BUILDING IN COLOURED PENCIL**

— OBJECTIVE: To use a coloured background to produce a drawing of a grey building

— MATERIALS: Grey mount board, a selection of coloured pencils, pencil sharpener, eraser.

Most of the exercises in this book have been carried out on a white surface. Sometimes we need a coloured background to help with the overall feel of the picture and to pull it together. With acrylic or oils we can colour the surface prior to painting; with watercolour we can tint the paper with an initial wash. When using pencils, however, we have to use a surface that will not affect the way the pencil makes its marks, so for this exercise we will be using a grey tinted mount board.

Using a black pencil, lightly draw the basic outline of the building. In the photograph chosen for this exercise there are a lot of road signs and fences in the foreground. The building is the important part, so leave out any unnecessary detail.

**The Oracle shopping centre, Reading, England.**

Use the same black pencil to put in the very dark parts of the picture. Shading in the darker areas first will assist you in deciding how much needs to be done on the rest of the picture. Keep the edges crisp and work around any lighter areas with a sharp pencil. With a mid-tone blue-grey, shade in the grey areas of the building, pressing down harder with the pencil to achieve a stronger darker grey on the left side of the building.

Next, using a white pencil, lightly shade back over the blue-grey of the building. This will soften some of the pencil marks and also lighten the grey slightly. If it lightens too much, repeat the blue-grey and white process until you have achieved the correct shade. Use a light brown, green and grey to shade in the right-hand side of the building. Do not overlap your colours too much as you will lose the sharp edges. Block in the sky with a light blue and the foreground with greys and greens.

For the final stage. use the white to shade in the clouds with a cross-hatching technique. This will give a good contrast to the solidity of the building. Draw in the detail on the building, such

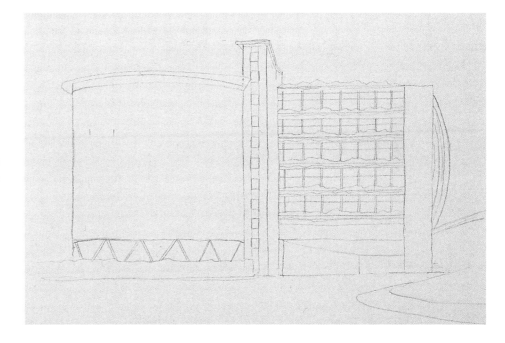

**Using a black pencil, lightly draw the basic outline of the building.**

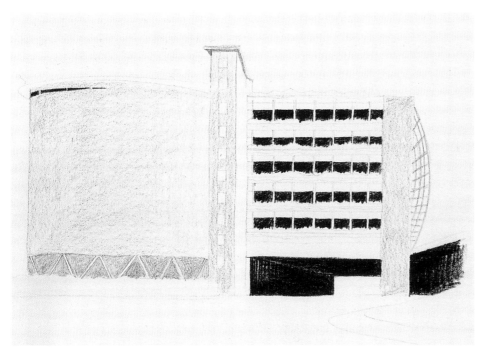

**With a mid-tone blue-grey, shade in the grey areas of the building, then put in the darker areas with black.**

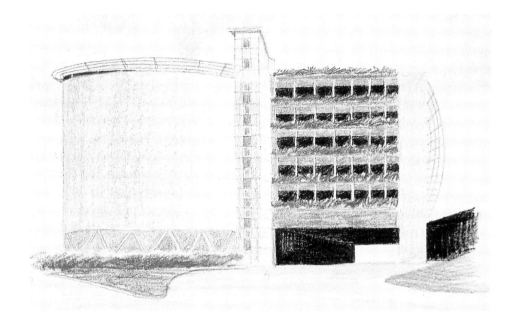

Use a light brown, green and grey to shade in the right-hand side of the building and a light blue for the sky.

Draw in the detail on the building, such as the vertical and horizontal panels, and finish the drawing off with the shadows.

as the vertical and horizontal panels, and finish off the drawing by putting in the cast shadows with a mid-tone grey.

The grey of the mount board chosen for this exercise has not only helped with the overall feel of the picture, but by allowing some of this grey to show through it has actually done a lot of the work for us. When choosing a paper colour, it is important not to choose a colour that is too dark, as of course this will make the finished picture look too dark as well.

One of the most difficult subjects to paint is new buildings built from bricks. In the final exercise in this chapter, we will deal with how to paint a new brick building in pen and watercolour wash.

EXERCISE: **NEW BRICK-BUILT BUILDING IN PEN AND WASH**

— OBJECTIVE: To show how to reproduce a brick effect without making the building look too fussy.

— MATERIALS: White, 'Not' surface, 300gsm (140lb) water-colour paper, watercolour paints, waterproof ink pen, water-colour brush, water container, tissues. A 2B graphite pencil, pencil sharpener and eraser are optional.

We will now turn to painting a new building that has been con-structed almost entirely from red bricks. The problem we face is

that we need to give the impression of bricks without putting in every single brick, as this would look too fussy. I have suggested the use of waterproof ink pen and watercolour paint because we can use this medium quickly to sketch in the outlines of the buildings and then concentrate on the painting of the brickwork.

Start with your pen drawing, concentrating solely on the outlines at this stage. There is no need to put in the brickwork as this can be done easily and more effectively with the paint. If you are not confident of getting the pen lines right first time, do an initial light pencil drawing as a guide for the pen drawing.

Start your painting with a wash of ultramarine blue in the sky. Next, using mixtures of the same blue plus burnt sienna and raw umber, block in the basic colour of the building. Be careful not to use paint that is too strong. Going in too dark at this stage will create a dark painting. It is easy enough to darken watercolour but a lot more difficult to try to make it lighter once it is

on the paper. To avoid the colours looking flat and boring, drop some lighter and darker versions of the same colours onto the wet areas of the paper to create a broken colour effect. Let all of this dry before moving onto the next stage.

Using the same colours as in the initial wash, start painting in a few bricks. Whilst these are still wet, take a damp brush and gently soften some of the edges. Do not scrub too hard with the damp brush as this could loosen the initial wash underneath, resulting in an overworked and muddy appearance as the colours inadvertently mix on the paper. Continue with this technique, changing colour when painting the yellow building on the right. We are not trying to achieve a definite brick texture, just an indication of broken colour and red bricks. If you overdo this, there is a danger that the building will appear older, so keep a tissue handy to dab out some of the broken colour in places. When this stage has dried, it is time to put in the final touches, such as the shadows.

**An example of a new brick-built building.**

Start with your pen drawing, concentrating solely on the outlines at this stage.

Using mixtures of ultramarine blue plus burnt sienna and raw umber, block in the basic colour of the building.

Use a mixture of ultramarine blue and burnt sienna for the shadows. Try to keep the brush damp rather than wet and apply the shadows in a single brush stroke rather than scrubbing too hard or going back over as this may overwork the shadow. Test the colour first down the side of your paper before committing to your painting. Once the shadows have been done, the painting is finished.

This broken colour effect is an excellent way of reproducing the qualities of brickwork, but be aware that it is easy to overdo it. There is no need to use the pen here for the bricks as the buildings are too far away for this amount of detail. If doing a brick building close up, the pen could be used after the painting is finished in order to accentuate the brickwork.

Using the same colours as in the initial wash, start painting in a few bricks.

Finally, use a dark grey to paint the shadows.

## Summary

Throughout this chapter we have experimented with a number of different mediums and techniques in order to create drawings and paintings of new buildings. You may find that new buildings are more difficult than older buildings because they do not have as much character. Modern building materials can create a few problems too. Older buildings have been around longer and, therefore, subjected to more exposure to environmental conditions. The best way to draw and paint new buildings is to apply character of your own, while being careful not to overwork your pictures as this could age the buildings prematurely.

# ARCHITECTURAL DETAIL

The character of a building is often determined by the architectural detail as much as by its overall look. In this chapter, we will study different aspects of architectural detail, such as walls, doors, windows and rooftops. All of these come together to form the particular character of a building, but the individual details can often make an interesting study in themselves. The style and condition of the detail may denote a building's history and may also reveal a little about the people who originally designed and constructed it. There are different ways of reproducing the detail, depending on which medium you choose, and in this chapter we will be doing a number of exercises using different mediums and techniques that will help you to recreate the character and history of architectural detail.

## EXERCISE: **STONEWORK AND MASONRY**

— OBJECTIVE: To create classical carved masonry and stonework using hard pastel or Conté crayon on brown paper.

— MATERIALS: Light brown pastel paper, drawing board, hard pastels in stick and pencil form, torchon (for blending), fixative, tissues, easel (optional).

Pastels are an excellent drawing medium as they can be used to produce both energetic sketches and, if blended together with your fingers, very highly finished drawings. In this exercise, we will be using this blending characteristic to produce a drawing of classical carved architecture. We will use a limited number of

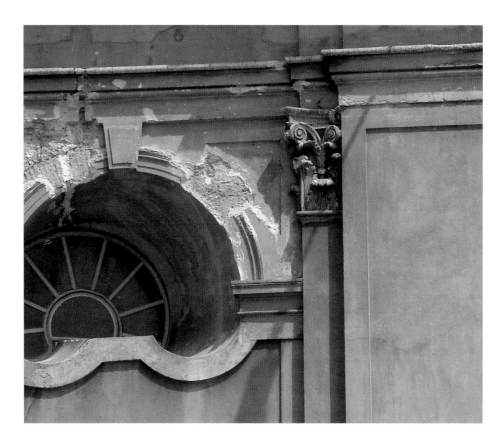

**OPPOSITE PAGE:**
*Old Blue Door.*
Acrylic.

**THIS PAGE:**
Carved stone architectural
detail from Nice, France.

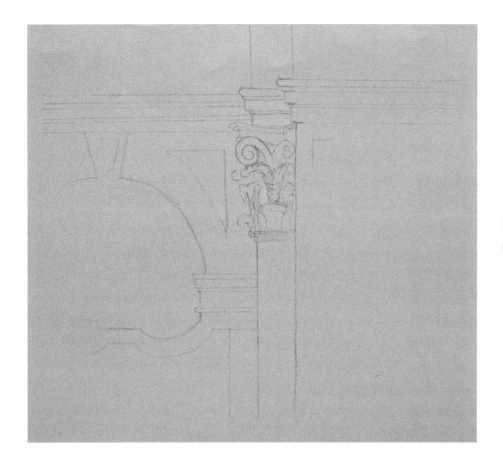

Start your picture using a sharp,
light brown pastel pencil to put in the
straight edges and carved masonry.

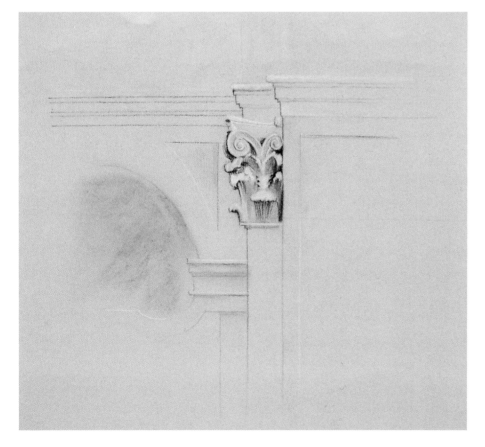

Use a yellow to shade in
the walls and put in some
detail with black and white.

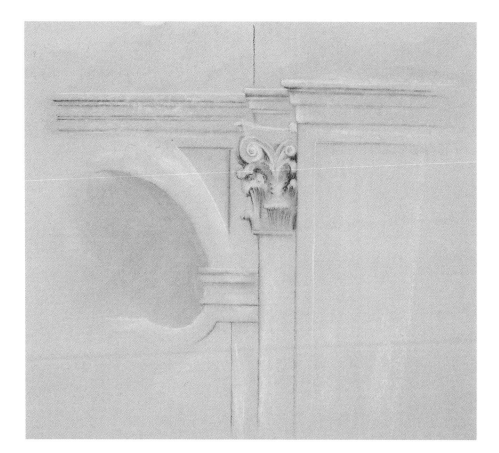

Using the side of a hard pastel stick, block in some stronger colour onto the walls.

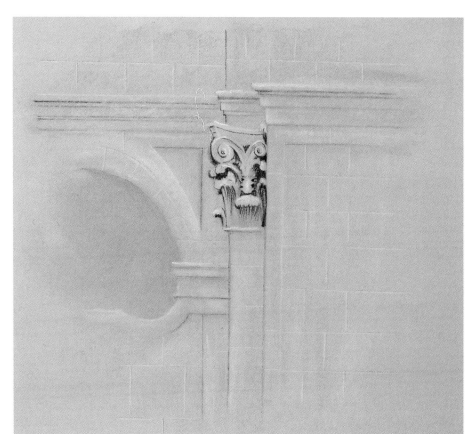

To bring out the stone blocks, use grey and white to draw in the edges.

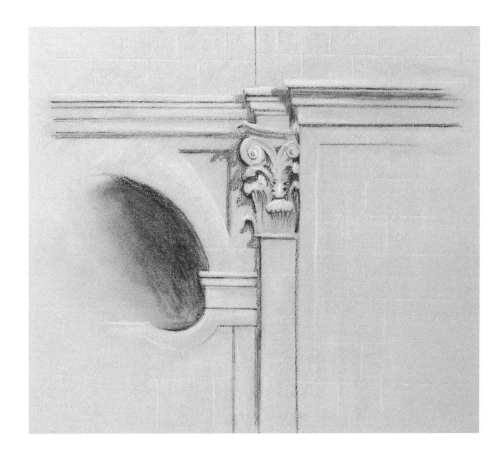

Finally, use a grey or brown
pastel to put in the shadows.

browns and blacks, as well as chalk white, onto brown paper. This limited palette of colours will add to the overall feel and look of the drawing and help us to reproduce the character of the architectural detail.

Start your picture using a sharp, light brown pastel pencil to put in the straight edges and carved masonry. Due to the soft, powdery nature of the pastels, some of these lines may disappear later when applying the larger areas of colour. However, putting these lines in early will make it easier to plan ahead and they can always be redrawn later.

Once you have done the initial drawing, block in some of the stone colour on the walls using a hard pastel. Use two or three colours, then blend these colours together on the paper using your fingers. Next, using black and white pastel pencils, draw in the dark and light areas of the carved masonry, then gently dust the picture with a tissue to knock back some of the black. This will enable you to develop grey areas by blending the white and black areas with a torchon, or the corner of a stiff piece of paper. If you do not gently dust the picture before blending, the black may spread too much and make your picture look dirty. Some of your original lines may have disappeared by now, so, using the same light brown pastel pencil you started with, redefine these lines and also use the pencil to shade in some of the areas in-between the white and black.

At this stage, the overall colour is looking a little weak. To counteract this, use the side of a hard pastel stick to block in some stronger colour onto the walls. The tooth of the paper can give a good textured effect to the drawing, but you do not want this over the entire picture so blend some areas in with your fingers. After doing this, re-establish some of the dark areas, especially the sharp edges, then add some highlights with the white pastel pencil.

Even with the stronger colour on the walls the picture is looking a little plain, so I have decided to put in the edges of the stone blocks to break up the large areas of colour. To do this, use grey or light blue pastel pencil to draw in the horizontal and vertical edges of the stones. Make sure that where they meet the vertical edges of the walls, they are offset by the protruding columns. Next, using a sharp white pastel pencil, draw in the highlighted edges across the top of each block and down one edge. In this picture the light is coming from right to left, so put the highlight in to the left of each vertical edge. Finally, using a grey or brown pastel put in the shadows and fix it to prevent smudging.

The versatility of the pastel, in both stick and pencil form, has enabled us to reproduce both the texture of the stonework and the carving of the masonry. Using the white pencil has given us the opportunity to show the stonework on the walls (which was a bit of artistic licence!) and produce a picture using a limited number of colours on a coloured background.

## EXERCISE: **A WINDOW IN A BRICK WALL**

— OBJECTIVE: To produce a watercolour painting of a window surrounded by a brick wall.

— MATERIALS: White, Not surface, 300gsm (140lb) watercolour paper, watercolour paints, watercolour brush, water container, 2B graphite pencil, pencil sharpener, eraser, tissues.

One of the most difficult things to do is to produce a drawing or painting of a brick building without making it look too fussy or too detailed. There is a temptation to put in every single brick. Not only would this take a very long time to do, it would also make the picture look overdone and complicated. The secret is to produce a picture where the bricks have been 'suggested'. The way this is done depends on which medium you use. In

**An example of a window in a brick wall.**

**Use the 2B graphite pencil to do the initial drawing.**

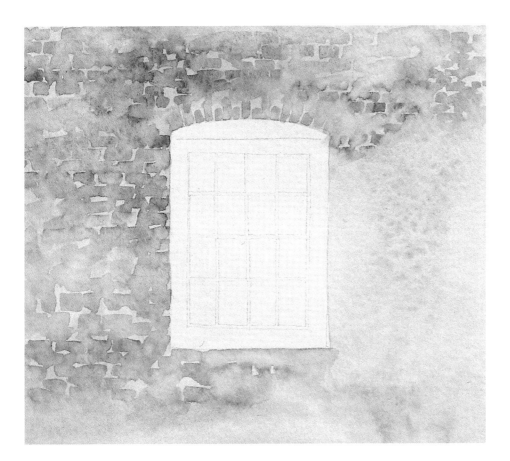

With a mixture of raw umber, burnt sienna and a little ultramarine blue, do a wet-in-wet wash over the wall and around the window.

Paint in the bricks and soften some of the edges to merge them with the background. Put in the windows to finish the picture.

drawing you can use your fingers to smudge the brickwork or use an eraser to remove some of the bricks. When using thick paint such as oil or acrylic you can, again, smudge with your finger or brush, or use a more impressionistic style of painting to depict the bricks. In this exercise, we will be using watercolour to produce a painting of a window surrounded by a brick wall. Watercolour has been described as the most difficult medium to work with, so we will use the flow of the watercolour and the transparency of the colours to our advantage.

Use the 2B graphite pencil to do the initial drawing. Because this is an exercise on how to do a brick wall and a window I have left out the vegetation that is growing up the wall and over the window.

Once you have drawn in the window, use a mixture of raw umber, burnt sienna and a little ultramarine blue to do a wet-in-wet wash over the wall and around the window. It is essential that this first wash of colour is not too dark, otherwise, because of the transparent nature of watercolour, the picture will be too dark when finished. Allow this first step to dry before proceeding.

The next step is to start putting in the bricks, but do this by suggesting the brickwork rather than painting every single one. Using the same three colours as the initial wash, paint between six and twelve bricks horizontally around the window. Before these bricks dry, use a damp brush to soften some of the hard edges to blend the bricks into the background. Use different colours and different strengths of paint, and vary the hard and soft edges to give a more realistic broken pattern of bricks. Your aim is to achieve the suggestion of bricks and any detail that needs to be put in can be done later. Use these techniques to cover the whole wall around the window. Once this is dry we can start on the window.

The window in this exercise has a reflection running across it. We can do this by using the transparency of the watercolour to do two dark grey washes, one on top of the other, leaving the space with the second grey wash to create the lighter reflection. Also, when painting the two grey washes, leave the spaces for the window frames as white paper. When painting the second grey wash on top of the first, be careful not to loosen the dry first wash as this will overwork the area on which you are painting.

After this has dried, use the same grey wash to put in the shadows of the window frames. Some of the shadows will need to be lightened with more water.

It is at this stage that I often stop a watercolour painting. Take a step back and look at your painting. This was an exercise in how to reproduce the brick effect without overdoing it, so to fiddle around with the painting at this stage may not be a good idea. I like the balance between the light brickwork and the dark window panes. We could easily go back and put in stronger bricks using the same technique as before, but there is always the risk that we will go too far and make a mess. Watercolour is easily overworked. If you feel that more detail is necessary, then perhaps you could emphasize some of the brick detail with

coloured pencil or use a smaller paint brush to pick out some individual bricks. If doing a smaller picture or painting a brick building from further away, obviously the bricks would be smaller and there would be less detail, so care should be taken not to make the bricks too big in comparison to the size of the building.

## EXERCISE: **BROKEN PLASTER AND PEELING PAINT**

— OBJECTIVE: To learn how to reproduce broken plaster and peeling paint using thick and thin acrylic.

— MATERIALS: Primed canvas board, acrylic paints, brushes, palette, palette knife, water container, 2B graphite pencil, pencil sharpener, eraser, tissues or rag.

One of the most endearing things about buildings is the effect the environment and human habitation has on them. Hot sun,

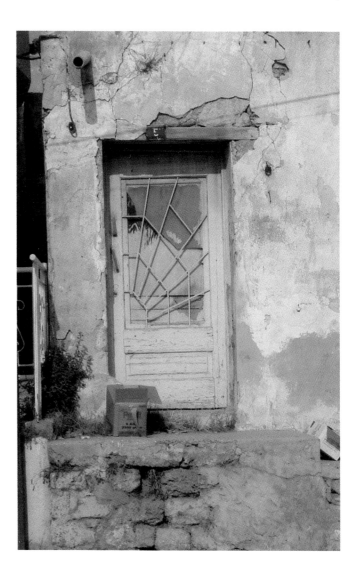

**An old Mediterranean door.**

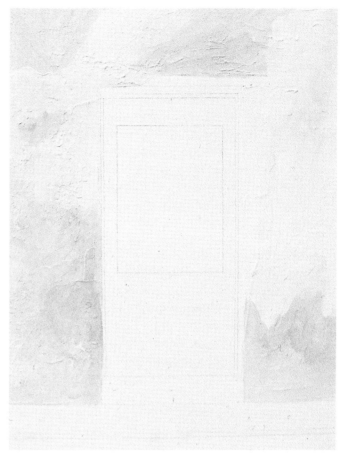

After drawing in the outline of the door, use thick white paint and a palette knife to apply the texture to the wall.

Using white, black and yellow ochre, paint in the variations of colour on the wall.

pouring rain, freezing temperatures, earthquakes, fire damage, graffiti and neglect all take their toll and can reduce a building to a pile of rubble. During the many years of a building's life, the people who live within its walls will endeavour to patch up the damage as much as they can, mending broken windows with pieces of wood or cardboard, filling in holes in the wall and patching up paintwork with whatever they can lay their hands on. All this adds to the character of a building and although it gives the impression of being neglected and run down, this provides the artist with wonderful subject matter.

In this exercise, we will learn how to reproduce this neglected look using acrylic paint in both a thick and thin consistency, palette knives for thick, broken plaster and a dry brush technique for reproducing the effect of peeling paint.

Start by drawing in the outline of the doorway in the wall. We will just concentrate on the door and surrounding wall, so there is no need to put in the edge of the wall on the left and the foreground can be kept to a simple pathway. At this point, there is no

need to draw in any detail on the door as we will block in the basic colour first before doing any drawing; however, it would be a good idea to draw in the window space before painting the door.

Next, using thick white paint put in the texture of the wall using a palette knife. Leave areas of canvas showing through and vary the thickness of the paint in places. Use the edge of the knife to work up to the sharp edges of the door, but do not put any of the thick white paint on the door itself. Whilst the thick paint is wet, work into it with the knife, but don't overdo it as we will be adding coloured paint when the white has dried.

The next stage is to start blocking in the basic colour of the wall. Using white, black and yellow ochre, paint in the variations of colour on the wall using a stiff size 8 round brush. Vary the brush strokes and thickness of paint. You are creating the feeling of patchy, broken plaster so do not make the paint too even. Vary the colour as well. Use the white and black for the grey patches and the yellow ochre for the warmer parts of the wall. When this stage is dry we can start to bring out the texture of the broken plaster.

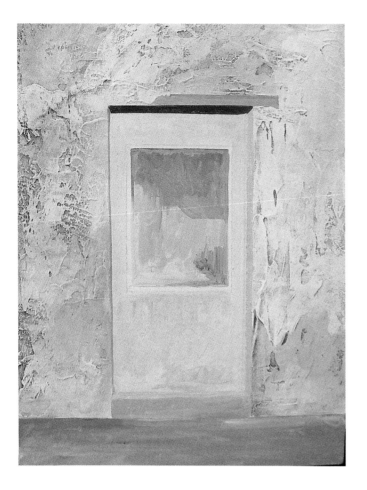

**Using a mixture of black, yellow ochre and a small amount of white, scrub the paint onto a small area of the wall and immediately wipe off with a damp tissue.**

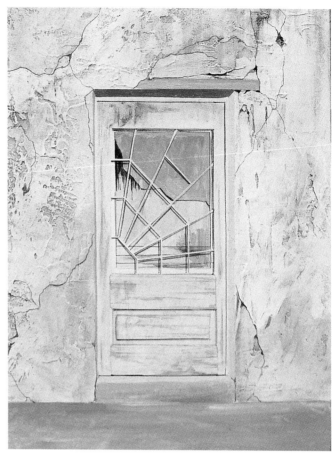

**Paint in the cracks on the wall and start to put in the detail on the door.**

Using a mixture of black, yellow ochre and a small amount of white, scrub the paint onto a small area of the wall and immediately wipe off with a damp tissue. This dark mixture of paint will fill in the deeper areas of the thick dry paint and will bring out the texture in the walls, giving the impression of broken and dirty plaster. Do this to the whole wall area of your picture. Don't worry about overlapping onto the door and foreground. We can cover those areas up in the next stage when applying the grey pavement and yellow door. So far, we have only used a mixture of white, black and yellow ochre. However, the door is a slightly different colour so I suggest adding a small amount of lemon yellow to the mixture. Do not make this mix of paint too dark as we will be painting over it later. Finally, block in the grey areas of the foreground, varying the mixture in places so that you end up with a broken grey coloured pavement.

Now it is time to start putting in the detail on the walls and door. Using a small brush (I used a size 1 round), paint in the cracks on the wall with a mixture of yellow ochre and black. Do

not use a paint that is too black as this will create too much contrast and give a cartoon effect. Vary the thickness of the cracks and paint in some holes in places to break up the large areas of colour. Next, use a larger brush such as a size 6 round and, with the side of the brush, drag some warm grey paint down the door. Whilst this is still wet rub your finger over parts of it to smudge some of the harder lines. This is a method called 'dry brushing' and is an excellent way to reproduce the effect of peeling and flaking paint. Do not use too much paint when doing this as it will change the colour of the door. You are trying to achieve a hint of peeling paint rather than too much.

Next, with the same warm grey, paint in the edges of the panels of the door and use this to strengthen some of the darker areas of the peeling paint. Some of the panels will need to have highlights added to the upper areas, so use the white paint to do this. When this has dried, paint in the bars on the windows using a small brush and the same colour you originally used to block in the door.

**The final stage is to finish off the painting with a bit more detail and to put in the shadows.**

The final stage is to finish off the painting with a bit more detail and to put in the shadows. I have added door handles to the door and some vegetation to the foreground, which helps to break up the continuous line where the bottom of the wall meets the pavement. For the shadows, use a mixture of dark blue and black and apply this to the left-hand side of the door recess and along the top just below the grey lintel. Finally, put in a few cracks in the pavement and the picture is finished.

Acrylic paint is an ideal medium to use to achieve the effect of crumbling and broken plaster. The quick drying time allows us to apply wet paint onto the thick texture and then wipe it off without having to wait days or even weeks for the paint to dry as you would with oil paint. Try using additives such as sand, marble dust or fibres. These will give a different texture to the wall. The use of such techniques as dry brushing and glazing help us to reproduce the effect that the building has been subjected to years of neglect and exposed to everything that its environment can throw at it.

## EXERCISES: **ROOFTOPS IN WATERCOLOUR**

— OBJECTIVE: To learn how to do three different types of roofing in watercolour.

— MATERIALS: White, 'Not' surface, 300gsm (140lb) watercolour paper, watercolour paints, 2B graphite pencil, pencil sharpener, eraser, watercolour brush, water container, tissues.

There are many different types of buildings but generally they all have one thing in common: they all have a roof of some sort. As with the rest of the building, the rooftops come in all types of construction, such as tiles, pantiles and thatch. The problem with rooftops is that we rarely see them unless we have a high vantage point where we can look down at them. However, there are circumstances where a single building has a sloping roof that gives us a good view of the type of roof on the building.

In the exercises below, we will be dealing with three different types of rooftops: tiles, pantiles and thatch. The type of medium you choose would be dictated either by the overall building or by your preferred medium. However, in these exercises we will be using watercolour for all three types of roof. Using the same medium for all three will give us a good idea of the differences between the types of rooftops and how to get the best out of our chosen medium.

## Tiles

Flat tiles are common in most countries but are normally seen on sloping rooftops in the northern parts of Europe, especially the UK where they are used on the majority of buildings. They can vary in colour enormously depending on what the individual tile is made from, while the age and condition of the tiles will also have an effect on the colour and texture.

For this exercise we are painting a rooftop on a building which has a roof covered in red tiles. This building is approximately one hundred years old, so some of the tiles have faded while others have moss and vegetation growing on them. One of the obvious things that can be seen in this picture is the lines that the overlapping tiles create on the roof. These need to be done in such a way as to give the correct slope of the roof yet not look too complicated and fussy. If you look closely at the tiles there are a lot of different colours, so we will need to reproduce this effect while also maintaining a common colour balance, otherwise the roof will appear disjointed and uncomfortable to look at.

We are not concerned with the whole building as this is just an exercise concerned with the roof, so we will concentrate on the two sloping rooftops on the right just below the chimney.

Use your 2B pencil to put in the outlines of the roof and part of the building. There is no need to put in the lines of the tiles as we will do this later with some paint.

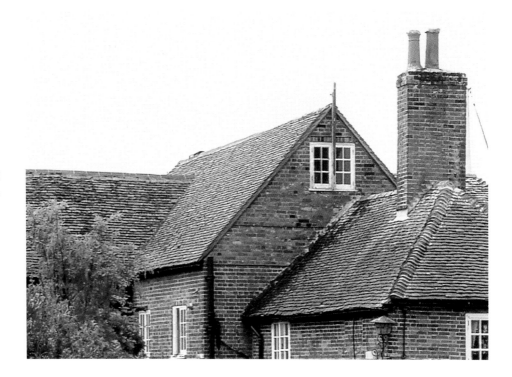

**An example of old English roof tiles.**

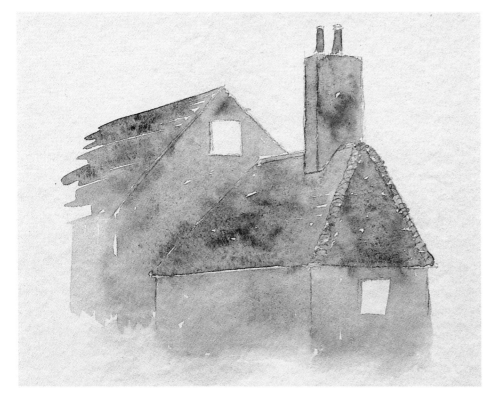

**After the initial drawing, paint in a variety of browns, blues and greys.**

The next stage is to paint in the general colour of the tiles. Mix up three variations of brown and grey using burnt sienna, ultramarine blue and burnt umber. Paint these colours onto your drawing, varying the strength and colour as you paint across the picture. This will give a broken colour effect and, therefore, a more natural and interesting look to your picture. There is an area at the end of the roof on the left which has some vegetation or moss growing on it, so whilst the paint is wet in this area

**85**

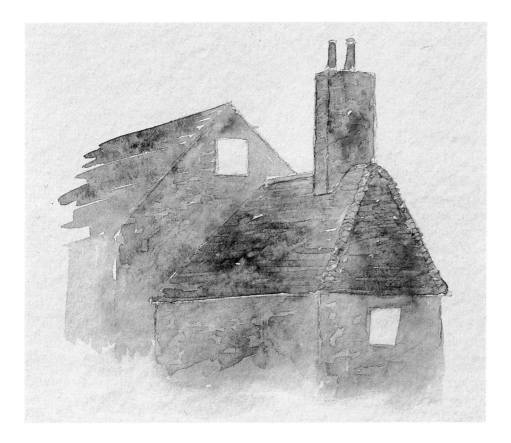

Using the same colours you started with, paint some horizontal lines along the rooftops parallel with the top and bottom of the roof itself.

Finish off with the moss on the roof and the shadows.

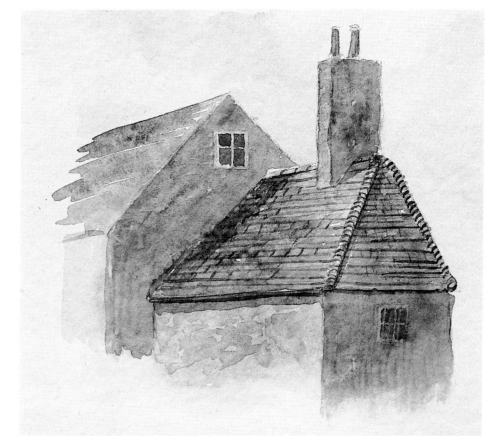

drop a small amount of sap green into this and let it merge into the brown of the tiles. Let all of this paint dry before moving on to the next stage.

Using the same colours you started with, paint some horizontal lines along the rooftops parallel with the top and bottom of the roof. Vary the colours as you did with the initial wash. Before this dries, take a damp clean brush and lightly blend in some of the lines in order to create a more natural look.

Once this is dry, use a small number four round brush to put in some vertical lines to indicate the edges of individual tiles. Use a fairly strong grey mixed from ultramarine blue and burnt sienna and make sure that the lines slope in the same direction as the roof. Finally, put in some more of the moss on the roof and finish off by using the same grey mix to put in the shadows.

## Pantiles

Pantiles are different from ordinary tiles in that they are curved rather than straight. This gives the artist more to do in order to reproduce the pantile effect whilst still trying to keep the end result simple and uncluttered. The colour of these tiles is invariably red or terracotta, so the selection and mix of the initial colour is important.

As with the previous exercise, start with your drawing. Pantiles have a more complicated shape, so in this exercise it is important to put in the edges of the roof to help with the overall look of the picture and to save you from having to put in the edge of every single tile.

Once you are happy with the drawing, start to put in the basic colour of the roof itself. For this, you will need to mix up a basic terracotta colour from burnt sienna and cadmium red, then from this colour mix up a grey by adding ultramarine blue. Use these colours in various places to produce a broken colour effect on the roof. Leaving little white areas can also help to break up the flat area of the roof. Don't go too dark at this stage; the stronger colour can be added later.

Use the same colours to go back over the roof and start to put in the edges of some of the tiles. You may need to use a smaller brush for this, such as size four round. Before these lines have dried, soften some of the edges with a damp brush. Do not make these lines too dark as this will lead to too much contrast in your picture and an overly fussy end result.

Use some of these colours and a larger brush to break up the surrounding walls and also to put in some stronger, darker areas on the roof near to the wall on the left. Keep varying the colours and softening some of the edges. Once this has dried, put in some strong dark shadows under the eaves to give the tiles more shape. Do the same under the ridge tiles on the top of the roof. Re-establish some of the tiles on the roof with a lighter version of the grey and terracotta red before finishing the picture with the shadows.

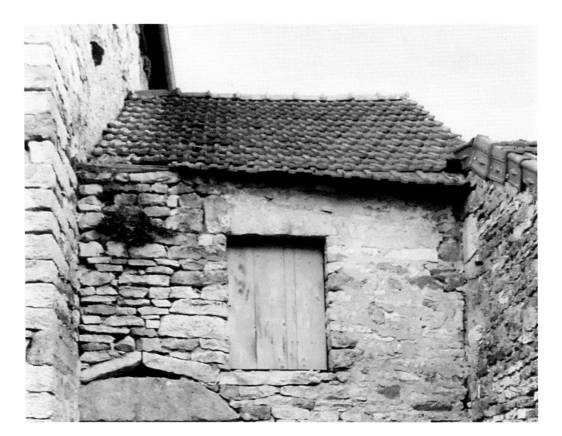

**An example of old French pantiles.**

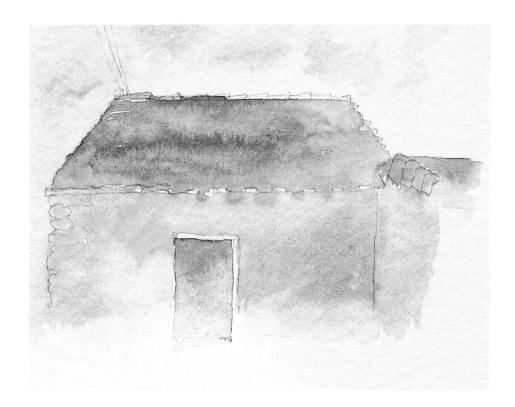

**Paint the roof with a mixture of terracotta and grey.**

**Use the same colours to go back over the roof and put in the edges of some of the tiles.**

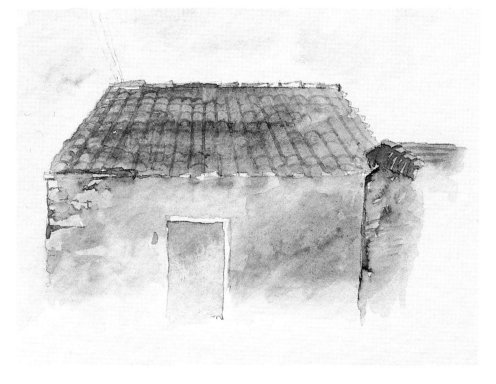

## Thatched Roof

Thatched roofs are one of the most difficult styles of rooftops to do. The best way to explain the process is to look at the colours and shadows rather than the texture. There are some mediums which you could use to reproduce the texture, such as acrylic and oils, but you would need to do a time-consuming and highly representational picture to get the texture right. As with the other exercises and indeed all watercolour paintings, simplicity is the key.

Put in some of the strong, dark shadows under the eaves of the roof to give the tiles more shape.

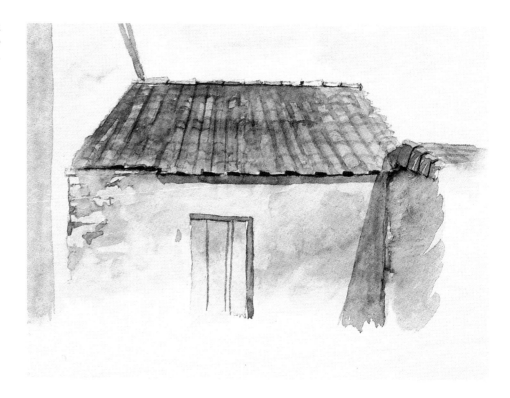

BELOW: **A typical old English thatched roof.**

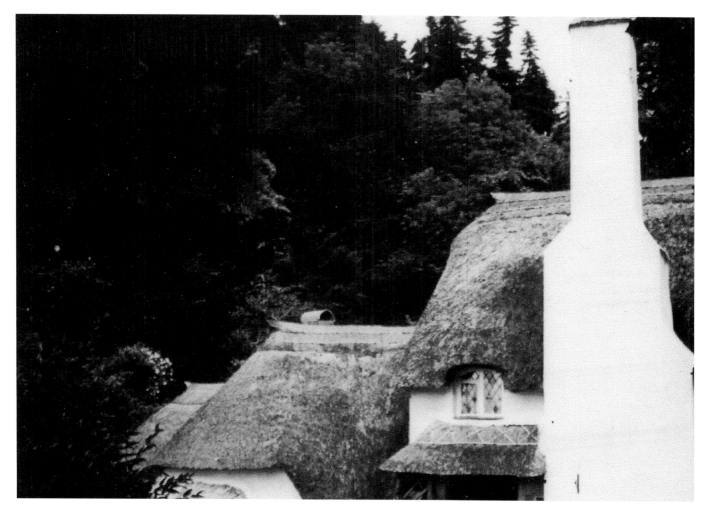

After your initial drawing,
paint the roof with a mixture
of browns and greys.

Paint in the darker areas
of the roof, but use a spotty
brush mark around the edges
of the area you are painting.

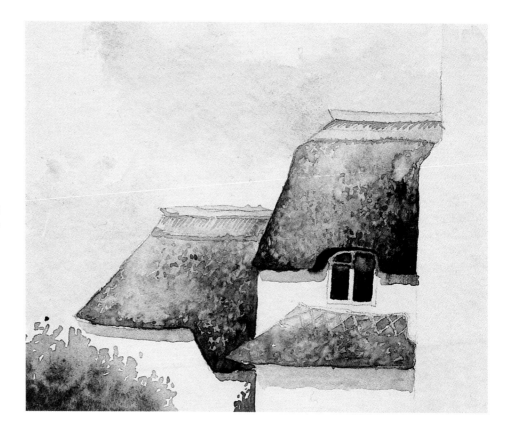

**Finish the painting by putting in the windows and shadows.**

Start your drawing, but when doing the roof look at the corners of the thatch. They are round, not square or sharp. Drawing these edges and corners round will help with the overall appearance of a thatched roof. When beginning the painting, do not go in too dark with your initial wash, as we will be working over this with other colours later on. Using a mix of burnt sienna and ultramarine blue, start painting the thatched roof. Begin at the top with a pale wash of the brown, slowly moving down the paper and adding stronger paint as you get to the bottom of the roof. Wait for this to dry before moving onto the next step.

This next step is very important as it will be the last wash on the thatch and will also be the one that will depict the texture of the thatch in all its glory. Using a number 4 round brush and the same browns as before, fill in the darker areas of the roof but use a spotty brush mark around the edges of the area you are painting. Do a small area at a time and before this area dries, soften a few of the spots – this effect should hopefully start to look like thatch. Work around the roof in the same manner, especially the areas that are darker. The lighter areas will require fewer and, in some places, no spots at all. Be careful not to overdo this 'spotting' effect and when softening some of the spots do not scrub too hard with the brush as this will loosen the paint underneath and overwork the area.

Finally, put in the shadows under the eaves and any other detail you feel the painting needs.

## Summary

In this chapter, we dealt with the character of buildings in more detail. It is these small details which, when grouped together, give the overall character and feel of a building and which, when done properly, can contribute to a successful drawing and painting.

The hard pastel enabled us to use a combination of hard and soft lines to reproduce the carved detail of masonry on a yellow stone building. The versatility of the pastel helped with the overall finish and feel of the drawing. Using a combination of pastel stick and pencil gave us the variation of sharp detail and texture.

The next exercise taught us how to use thick acrylic paint to create the texture of broken and cracked plaster. The quick drying time enabled us to finish the picture quickly; something not achievable with the slow drying time of oils. In the final exercises we used watercolour to reproduce details such as windows and different styles of roofing. The transparency of watercolour allows us to build up the correct colour and tone to achieve the feel of bricks and roof tiles.

All of the mediums can be used to create all kinds of detail, so why not try experimenting by drawing and painting the same subject but with different mediums to see which one works best for you?

# BUILDINGS IN THE LANDSCAPE

In this chapter, we will turn to considering the places and landscapes in which buildings are contained. The best way to depict buildings as part of an overall image will depend on what you are trying to achieve, or, more importantly, what your picture represents. We have already dealt with buildings close up, face on, as in two dimensions, and also in three dimensions where we have just hinted at a surrounding town or landscape.

Buildings can be used as a focal point in a larger picture. Their structure can lure the eye into a picture so where you place them in that picture is very important. They can be used to complement the surroundings, used as a dominating feature to give a sense of scale or used as a contrast to the landscape such as rolling fields and hillsides or reflections in water. The exercises in this chapter will deal with buildings in different positions, in conjunction with other elements of towns and landscapes and using different media. Hopefully this will give you an insight into the many uses of buildings in the overall picture.

**OPPOSITE PAGE:**
*Tuscany, Italy.*
**Pen and watercolour wash.**

**THIS PAGE:**
**Cadiz, Spain.**

### EXERCISE: **DOMINATING A SKYLINE**

— OBJECTIVE: To show how a building can be used as a strong focal point on a skyline.

— MATERIALS: Light blue mount board, drawing board, coloured pencils, pencil sharpener, eraser.

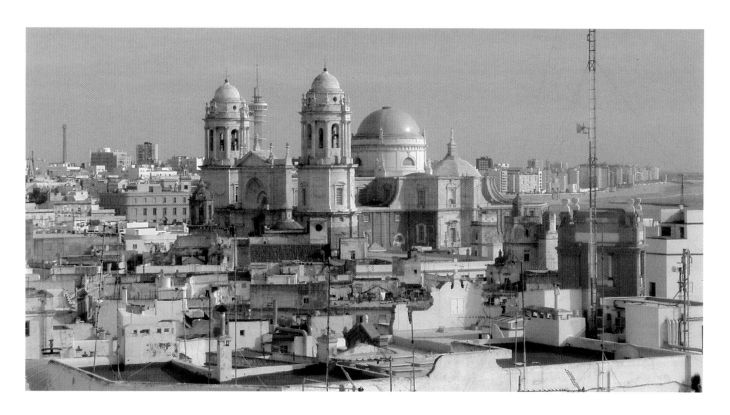

Starting with a dark grey, draw the cathedral and the surrounding buildings,
fading off the smaller buildings as they recede into the distance.

Start shading in the basic colours of the buildings but do not shade in too dark.

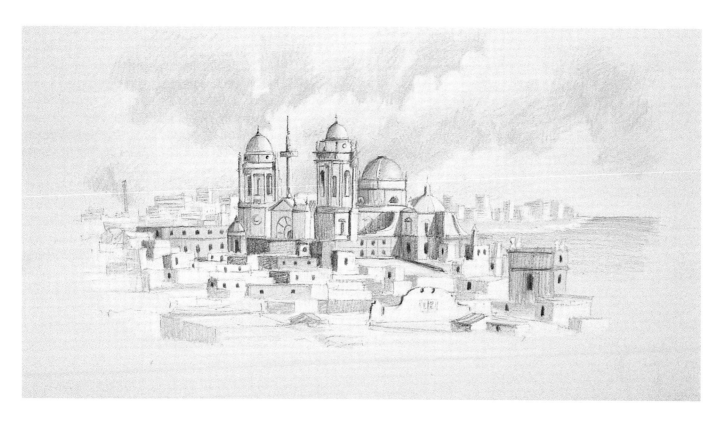

Using a sharp darker grey, start putting in the darker shadows
on the buildings, especially the cathedral in the centre.

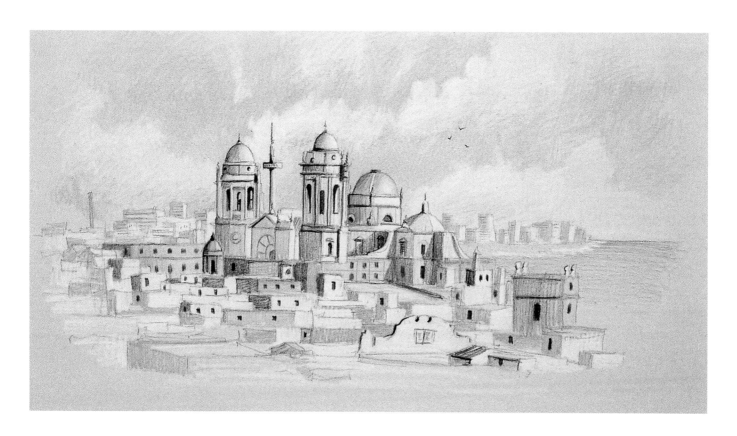

Finally, use a sharp black pencil to put in the last bits of detail and shadow.

The subject for this exercise is a photo of Cadiz in Spain. As you can see from the photograph there is a lot going on, but we will concentrate on the cathedral in the centre and use our pencils to sketch in lightly the surrounding townscape so that the cathedral itself will be the centre of attention.

Starting with a dark grey, draw in the cathedral and the surrounding buildings, fading off the smaller buildings as they recede into the distance. There is no need to do any shading at this stage as we need to get all the drawing correct before starting to colour in. Once you are happy that the drawing is correct, start shading in the sky using a light blue and white. Use a cross-hatching technique to overlap your pencil marks. This will look better than having all the pencil marks going in the same direction. Next, shade in the buildings, starting with the cathedral and using the same dark grey as for the initial drawing. Do not go too dark, as you will need to be able to use a darker grey for the shadows later.

Use the white pencil for the highlighted areas of the building and also shade over the grey with the white to soften the pencil marks and give a more graduated effect on the buildings. Use a yellow ochre and raw sienna for the brown buildings and the dome, again shading over these colours with white to soften the pencil marks. Because the cathedral is the dominant part of the picture, the surrounding buildings in the foreground need to have a lighter touch of colour, so do not apply too much of the grey and brown. For the buildings in the distance use a lighter blue-grey to give the impression of them being further away.

The next step is to put in some of the detail. Using a sharp darker grey, start putting in the darker shadows on the buildings, especially the cathedral in the centre. Do not work up the surrounding buildings too much as this will detract from the centre of the picture. Also put in the windows using the same dark grey and strengthen some of the darker edges of the buildings. For the windows in the distance use the same grey but do not make them too dark. Finally, use a sharp black pencil to put in the last bits of detail such as doors and arches.

What this exercise has taught you is how to use a large building as a focal point in a larger picture. The secret is to make it look like it belongs in the town or landscape. In this picture you were shown how to use the same colours on the main building and the surrounding buildings but to fade off and lighten the colours as you moved towards the horizon and edges of the picture.

EXERCISE: **USING TREES AND FOLIAGE TO FRAME THE BUILDING**

— OBJECTIVE: To show how elements in the landscape such as trees and foliage can be used to frame the building.

— MATERIALS: Primed canvas board, acrylic paints, brushes, palette, palette knife, water container, 2B graphite pencil, pencil sharperner, eraser, tissues or rags.

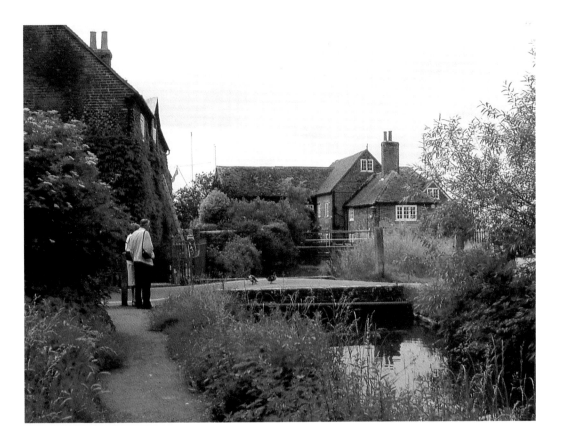

Bosham, England.

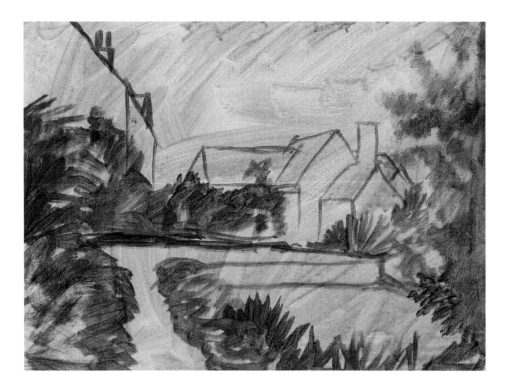

After putting a raw sienna wash over your canvas, use a dark brown such as burnt umber to draw in the main elements of the picture.

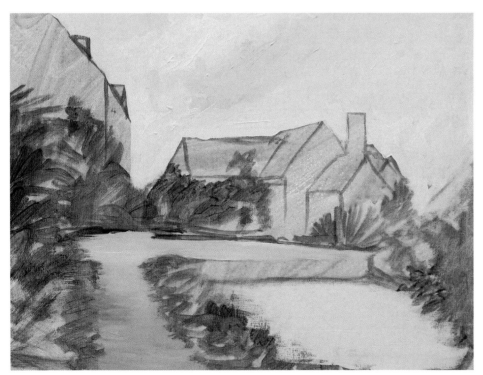

Start to block in the sky using a mix of titanium white and cobalt blue. Use the same colour for the water in the foreground.

When painting a picture of a building there is a danger that the building can be the main focal point at the expense of the rest of the image. The viewer may look at the building but ignore the rest. To compensate for this, we can use other elements of a landscape to produce a picture with a more interesting composition.

One of the favourite elements an artist likes to use for this are trees and other foliage such as grass and bushes. In this exercise, we will produce a painting using trees to frame the building plus grass and bushes to lead the eye of the viewer into the picture and also to balance the painting. In the photograph I have chosen

there are a couple of figures on the left. We will use these to give a sense of scale and also a focal point other than the buildings themselves.

After putting a raw sienna wash over your canvas, use a dark brown such as burnt umber to draw the main elements of the picture. There is no need to put in any detail at this point. Just concentrate on the basic shapes and outlines. We will put in the figures at a later date.

Start to block in the sky using a mix of titanium white and cobalt blue. Use random brush marks with a round brush to put

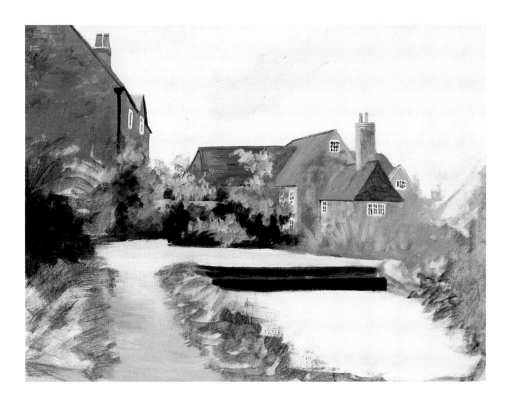

**Use a mixture of browns and greys to paint in the buildings and greens for the distant trees.**

**Paint the rest of the trees using a mixture of light and dark greens**

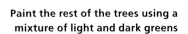
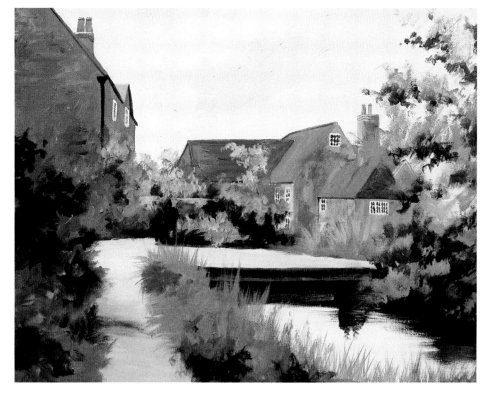

**Add the final touches, such as the highlights on the trees, the figures and the ducks.**

some movement and life into the clouds. The sky is important but is not the main part of the picture, so just suggest a few fluffy clouds. You can always return to the sky at a later point if you feel it needs more detail. While you have the sky colour on your brush, paint in the small area of water in the foreground. Mix a grey colour using burnt umber, ultramarine blue and white and paint in the pathway that leads from the bottom of the picture up and into the middle. Make the path in the middle slightly lighter than the foreground to give the impression of distance.

The next step is to start blocking in the buildings. Use a mixture of colours for this, such as burnt sienna, burnt umber, yellow ochre and white. Try to use the brush in such a way as to give the impression of brickwork, especially on the closer building to the left of the picture. The light in this photograph is not particularly good, so have the left-hand sides of the buildings catching the light and the right-hand sides in shadow. The only detail that needs to be put in is the edges of the rooftops and the windows. Keep this to a minimum, especially on the distant buildings, as too much detail will bring the buildings forwards and make their focal point too strong.

Start to paint the trees in the distance and just in front of the building in the middle. Use a mixture of ultramarine blue, cadmium yellow and a little white. Do not make the trees too yellow or warm as the warmer colours need to be in the foreground. Use different brush strokes to create the feeling of natural foliage and add some black to the green mix for the darker areas.

Before painting the rest of the trees, put in the reflections on the water by using horizontal brush strokes. Brush in one direction only and lift the brush off the canvas to create the ripple effect in the middle. Use some of the left-over sky colour to adjust the reflections if you overdo it.

Next, start painting a middle tone of green onto the rest of the trees. As with the middle ground trees, use a variety of brush marks and also warm up the green in places with a little cadmium yellow. Add black to this mixture, then paint in the darker areas of the foliage.

Add a little white to the green and put in some of the lighter greens. These will add movement and life to the trees, while also helping to pull the viewer's eye into the picture. Dab on the final highlights to the trees with a mixture of white, green and yellow. This will break up the darker areas and add more contrast. Finally, add the figures and any other details you think the picture needs.

What we have learnt in this exercise is that even though the buildings may be the important part of a picture, the use of trees as a framing device aids the composition and the soft greens of the foliage provide a good contrast to the hard edges of the buildings. The addition of the figures gives a sense of scale and a good focal point which allows the eye to move on to the rest of the picture. We will deal with more figures in the next exercise.

## EXERCISE: **USING FIGURES AND OTHER ELEMENTS FOR SCALE**

— OBJECTIVE: To show how placing figures and other elements in the picture can help with scale and composition.

— MATERIALS: White, 'Not' surface, 300gsm (140lb) watercolour paper, watercolour paints, waterproof ink pen, watercolour brush, water container, tissues. A 2B pencil, pencil sharpener and eraser are optional.

There are many things we can do to aid composition and give a sense of scale in our pictures, one of which is the addition of figures. Adding figures will also give a sense of life to the picture and, depending on where they are placed, can make or break a drawing or painting. There are a number of things to consider when putting figures into a picture. The first is where they are to be placed. Figures will automatically draw the eye of the viewer into the picture, so it is best to position them on or near one of the thirds and where they will aid the balance or design of the picture. The exact placement of your figures will depend on the specific picture you are doing. If the figures are in the foreground and, therefore, highly visible, make sure they are not in the middle and draw them so that they face into the picture.

Another important thing to remember is that figures are affected by perspective just like anything else, but in a specific way. If you are putting in a number of figures in different places, then make sure that their heads are on or close to the eye level or horizon. Even figures in the background will have their heads on or near the horizon. It is their foot level that will vary depending on how close or how far away they appear to be.

In this particular exercise we will do a pen and watercolour wash of a street scene with figures in. The photograph shows a few figures in the foreground, but they need to be moved. The large figures in the foreground are too close to the bottom of the picture and overlap the building. Move them over to the right, placing them on the right-hand vertical third and have them facing into the picture. You can keep one of the figures on the left, but we need to put in some figures in the distance. Remember to keep the heads on the horizon and do not put in too much detail on the figures in the distance.

If you are not too sure where to place the figures, do a few small sketches on a scrap piece of paper just to get the composition right before committing to your watercolour paper. When you are happy with your composition, start the pen drawing on the watercolour paper.

The best way to do the pen drawing is to go straight in with the pen, but if you make a mistake of course you cannot rub the pen line out. You may be able to hide the mistake with more pen work, but if not you will have to start again. If you are not confident about your drawing skills, do a light pencil sketch first and use this as a guide for the pen.

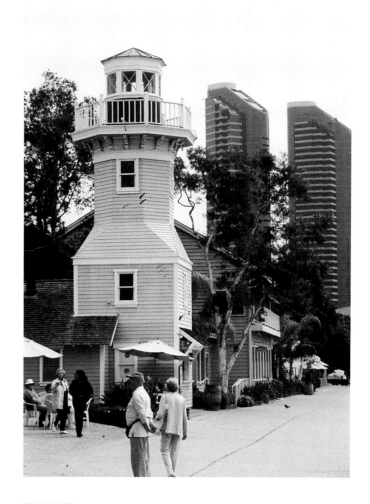

**THIS PAGE:**
**San Diego, California, USA.**

**OPPOSITE PAGE:**
TOP LEFT: **Start with your pen drawing, keeping the lines loose but accurate.**
TOP RIGHT: **Paint the sky and buildings with a light wash of colour.**
BOTTOM LEFT: **Using stronger colour, paint in the trees and red building.**
BOTTOM RIGHT: **Use a mixture of ultramarine blue and burnt sienna to paint the shadows on the tower and the figures.**

When you have finished your pen drawing, paint the sky using an ultramarine blue wash. Mix a couple of greys using the blue and burnt sienna and paint the distant buildings and the road. When this is dry, use a stronger version of the greys to paint the main building on the left. Leave the white paper showing for the white areas of the building and use a bluer, darker grey for the shadow areas.

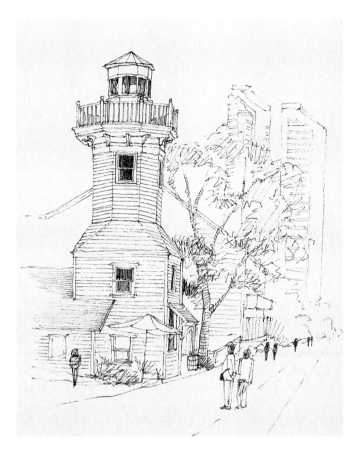

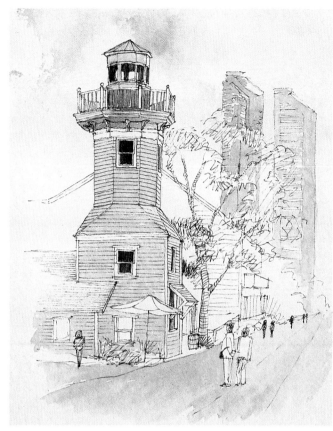

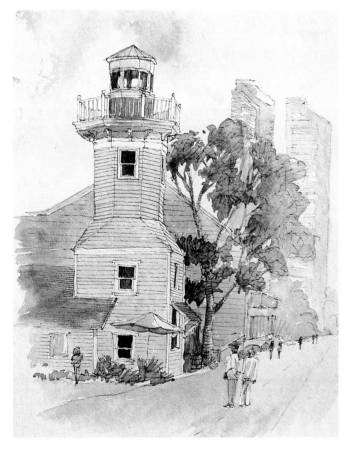

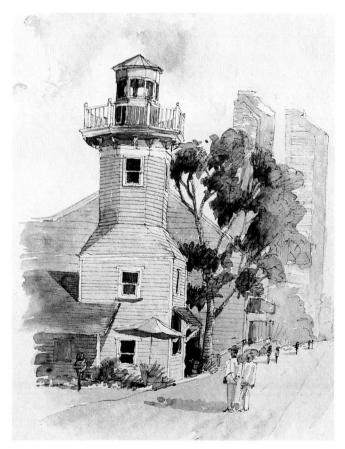

Mix sap green with some ultramarine blue and paint in the trees and bushes. Start with more green and less blue on the large tree in the middle and use a bluer, lighter green for the trees in the distance. Use a burnt umber for the roof of the building on the left and a thinner version of the same brown for the tree trunk in the middle. When the tree in the middle has dried, paint the red house using a mixture of burnt sienna and crimson. Finally, add a few touches of colour to the figures.

The last act is to add the shadows. With a mixture of ultramarine blue and burnt sienna, paint in the shadows on the left-hand building. The light is coming from the right, so the left of the building needs to be in shadow and the figures should have their shadows going towards the left of the picture. Finally, use a lighter grey for the side of the larger building and put some of the shadow colour on the green of the tree.

This was an exercise that taught you how to use figures effectively to enhance the composition and design of a painting. Other things can also be used but they have to be put in the right place and be at the right size in order to be effective.

### EXERCISE: **USING THE FOREGROUND IN A PAINTING**

— OBJECTIVE: To use the foreground as an important part of the painting.

— MATERIALS: Primed canvas board, oil paints, brushes, palette knife, palette, turpentine, linseed oil, rags or tissues.

Sometimes the building is not enough to lead the viewer's eye into and around the picture, so we have to use the foreground to do this for us. In some cases we have to use the foreground as the main part of the painting and the building as a middle or distant background focal point. In order to increase the amount of foreground, it is necessary to raise the horizon. This will correspondingly reduce the amount of sky in the picture.

The photograph chosen for this exercise has a strong foreground, but it is a bit empty and the horizon needs to be lifted slightly to allow more foreground. You could jump straight into the painting and make these corrections on your canvas, but I prefer to do a quick, small, or what is called 'thumbnail', sketch to establish the main elements and get the composition right. The thumbnail sketch can be done in any drawing medium such as graphite pencil on any piece of scrap paper. Try different compositions or moving things around before deciding on the final one you are going to paint.

After doing the basic drawing with a dark brown, start to paint the sky with a mixture of white and ultramarine blue. Use the paint thickly to give the impression of billowing clouds and movement. With a smaller brush, show some of the reflected sky in the water. Work on the background trees using a light blue-green mixed from sap green, ultramarine blue and white. This is in the distance, so you do not need to put in too much detail. Keep your brush strokes small and varied. Add a little cadmium yellow to the green and paint in some of the green parts of the estuary around the sky colour you put in earlier. Do this down to the same level as the buildings on the right. We will do the rest later. The next stage is to paint in the buildings.

Use a combination of burnt umber, light red and a touch of white to paint the buildings. A small flat brush is the best for this as the straight sides of the brush will make it easier to

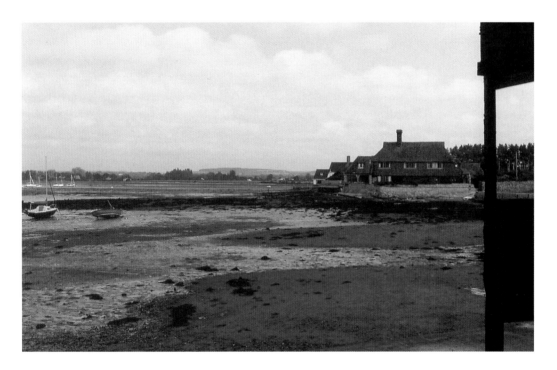

Estuary,
Bosham,
England.

**This shows the thumbnail sketches done prior to starting the painting.**

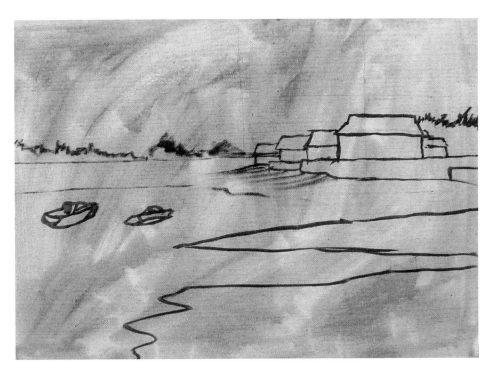

**Do the basic drawing on the canvas with a dark brown paint.**

paint the hard edges of the buildings. Just block in the basic colours of the buildings and the sea wall. There is no need to put in the final detail yet. The middle ground of the estuary is a mix of sap green, ultramarine blue and white. For the lighter areas mix in more white and a touch of yellow. For the darker areas mix in some burnt umber to the blue to create a dark brown and add this to the green. Use horizontal brush marks, but do not scrub too hard as the paint will mix in with the sky

colour and look too soft. In places, use the side of the brush to dab on some hard, broken colour. Work your way around the boats and to the front of the picture. Use a brighter, warmer green for the areas on the right below the sea wall and to the bottom of the canvas.

Now is the time to use the foreground to lead the eye of the viewer into the picture. Using a dark green, place some small rocks in the water and the green areas, leading from the bottom

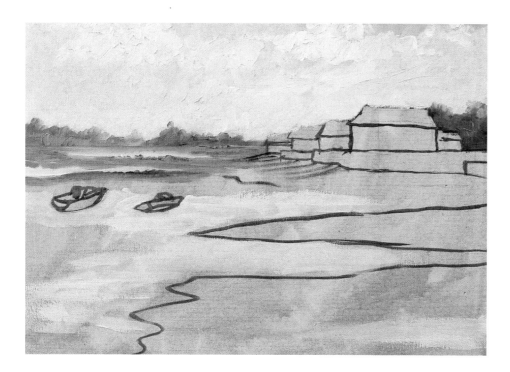

**Paint the sky using thick paint and start putting in the distant trees with light blue-greens.**

**Block in the buildings and some of the middle ground.**

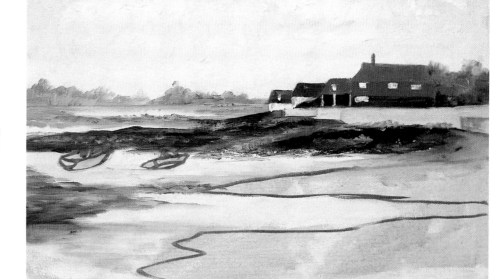

left-hand corner into the centre of the picture, just to the right of the boats. Use your finger or a small brush to soften the bottom of the rocks to give the impression of a reflection. The last thing to do is the detail on the houses and boats. For the mast of the boat take a piece of card or folded paper and dip the edge of the card into some white paint, then use this to place the mast onto the canvas. If you try to put the mast in with a small brush

your hand could shake and leave a wobbly line. Using the card gives you a nice straight line.

What you should have achieved in this exercise is to use the foreground to lead the eye into the picture. This is common practice amongst artists, especially when doing a scene such as this. Next time you are visiting a gallery have a look at similar paintings and see how the artists have dealt with the foreground.

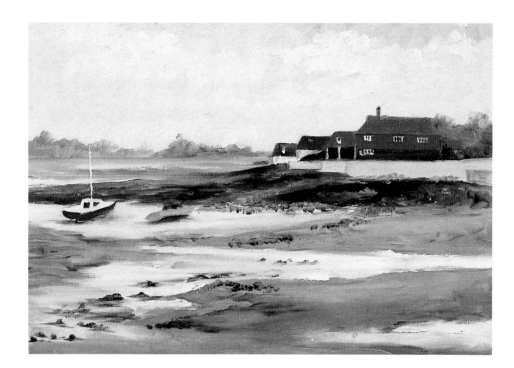

Paint in the foreground with warmer greens and use the rocks to lead the eye into the picture.

BELOW: An example of a reflection in water.

## EXERCISE: **REFLECTIONS IN WATER**

— OBJECTIVE: To use watercolour to produce the reflection of a building in water.

— MATERIALS: White, 'Not' surface, 300gsm (140lb) watercolour paper, watercolour paints, watercolour brush, water container, 2B graphite pencil, pencil sharpener, eraser, tissues.

Artists get asked many times how they produce reflections in water in their drawings and paintings. There are many ways to do this depending on what medium you are using. Students commonly make the mistake of thinking that areas of water such as seas and rivers are a particular colour and, therefore, this is the colour that the reflection should be, which is not the case. The best way to think of a reflection is that it is reflecting the colours of the objects around it, but upside-down.

There are also ripples to take into account, as well as floating vegetation and sparkle, but to begin with the best approach is to take a photograph of the particular reflection you want to paint, then turn it upside-down. This will give you a better idea of how to paint the reflection.

For this exercise, we are going to use watercolour. Watercolour paint has a characteristic flow quality and transparency that we can utilize to achieve the best result.

After doing your drawing, start by painting the main parts of the picture, which are the buildings and foliage. I will not go into great detail here about this particular part as we have dealt with this type of subject matter in previous exercises. The reason we

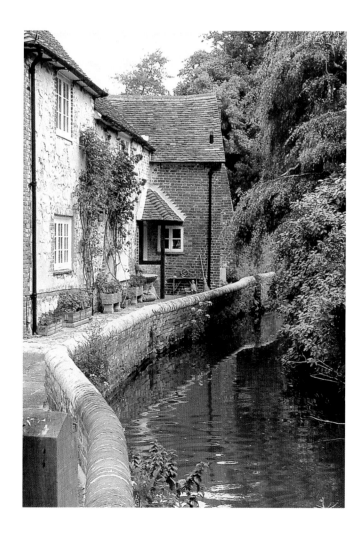

**Use the 2B graphite pencil to put in your drawing.**

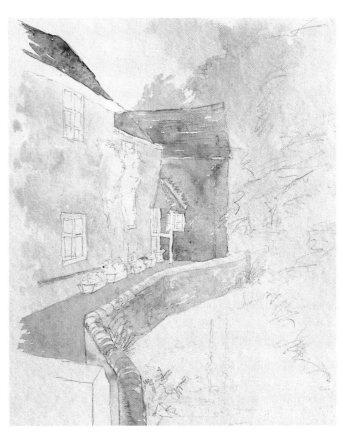

**Paint the initial washes on the buildings and trees.**

are doing this first is that it is easier to have something to reflect rather than doing the reflection first.

When painting a watercolour picture it is always preferable to start at the top of the picture and work your way down. Try to limit the number of colours you use to about four or five, as this limited palette will help to pull the picture together. Too many different colours will make the painting look disjointed. Try to get a good tonal balance. The further away something is, the lighter it appears, so when starting your painting do not make the distant buildings and trees too dark as you will need to darken the paint as you move down the picture. Do not worry if some of the paint bleeds into other colours as this will also help to pull the picture together. In order to break up the larger areas of colour, such as the sides of the buildings and the trees on the right, vary the colours slightly in places by adding a touch of grey or blue.

Do all of the painting, except the reflection in the water, including the darker shadows. When this is finished, it is time to tackle the reflections.

Reflections tend to be darker than the object they are reflecting and the image in the reflection will be influenced by the amount of movement in the water. In this picture there is a slight ripple to the water, especially where the top of the wall meets

the building behind it. The ripples will get larger and the gaps between them bigger as they come towards you.

Start at the back of the picture by painting in the wall with horizontal brush strokes and lifting the brush off the paper to create the rippled edge of the area you are painting. As you progress towards the front of the paper, start to lighten the colours by adding a small amount of water. Do each area separately and wait for it to dry before moving on to the next one. If you start painting an area next to a wet one, the edges will bleed into each other and you will lose the ripples. When you get to the bottom of the picture put in a bit of blue sky.

After painting the reflection of the building, wait for the whole area to dry thoroughly before putting in the detail such as the black drainpipe. Notice how the reflections give the drainpipe a 'wobble' and how this wobble increases as it comes towards you. If you wish to darken some of the reflections, such as the green area on the right, then now is the time to do it. Keep within the reflected area. If you overlap the ripples you will create a double edge and the area will look confused and overworked. Once you have done this, the picture should be finished.

In this exercise, we have learnt how to reproduce a rippled reflection using watercolour. Other mediums such as oil or

acrylic have the added benefit of being able to use white, but the brush marks should be the same as with the watercolour paint, that is, horizontal to achieve a rippled effect. Even when using a pencil to draw reflections in water, the pencil marks should be kept horizontal.

## Summary

This chapter showed us how to use a building as a focal point in a landscape and also how other elements of the landscape, such as trees, foreground, figures and reflections, can help to lead the eye into the picture and give contrast to the solidity and structure of the buildings. There are many other parts of a landscape that can be used in a similar way, for example fences, roads, vehicles and boats. Use these elements sparingly and place them in the picture in such a way as to enhance the composition, while being careful not to overcrowd the picture. If you are not sure what to put where, do a few small sketches before committing to your drawing or painting.

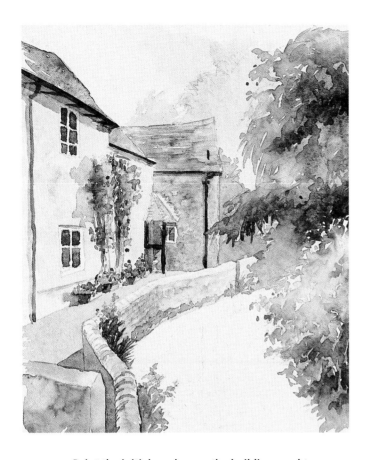

ABOVE: **Paint the initial washes on the buildings and trees.**

BELOW LEFT: **Paint the reflections on the water with darker versions of the colours used at the start.**
BELOW : **Paint in the rest of the reflection including the 'wobble' of the drain pipe.**

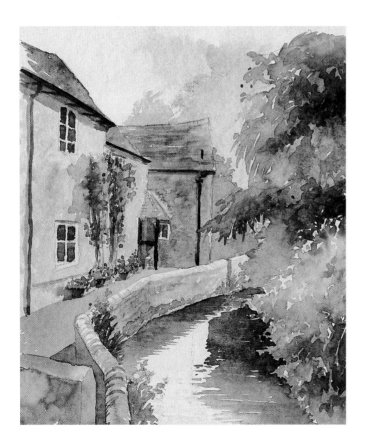

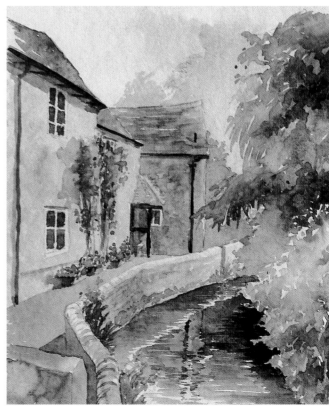

# SKETCHING BUILDINGS OUTSIDE

Any artist will tell you that there is no substitute for sketching outside. The enjoyment comes from the variety of subjects available and, to a certain extent, the feeling of freedom and how the weather and environmental conditions can have an effect, not just on yourself, but on your sketches too.

When sketching buildings for the first time, we tend to be daunted by the huge choice of subject matter. Everything from small huts and barns to skyscrapers and street scenes, churches, cottages, industrial buildings, shops, castles, ruins, even bridges and monuments, they all provide something for the budding artist to think about. But what is a sketch? What do you choose to do? Do you put everything in or just concentrate on detail? Which medium do you use? All of these questions and more will be answered in this chapter.

## What is a Sketch?

A sketch can be a number of things, but the two main reasons for doing a sketch are gathering information for a possible future painting to be done in the studio and doing a sketch purely for the fun and enjoyment. There is no other form of reference material that could come close to replacing drawing and painting from life. Photographs can give us an indication as to what the subject looks like, but the colours are artificial, your eyes see more than the camera lens and, unless you are an accomplished photographer, the light and dark areas tend to get exaggerated so that the shadows appear too dark and the highlights too bright.

Sketches can be used as a form of note-taking for things such as colours, shadows, light direction and proportion. They can

also be used to gather information, such as small sketches of figures, animals, reflections and architectural detail, all of which can be used in future drawings and paintings.

For most artists, however, sketching is one of the most enjoyable forms of self-expression and there is nothing better than sitting out, in all weathers, and passing the time of day by doing a few sketches. What better way to remind you of a particular day out, or a holiday, than to look back at your sketches? It is quite surprising how much you can remember when looking at old sketches done a few years earlier. So much better than buying a postcard!

## What to Choose

One of the biggest problems students have when venturing out to sketch is 'What do I choose to do?' Even more accomplished artists have this problem, although their experience can help them to overcome the amount of visual information in front of them and so they can be more selective. There is no specific way of choosing the right thing to do. You are the artist and the person who is going to do the sketch, so it is up to you to choose what to do. But how can you be more selective? First thing of all is to find somewhere to sit. If you are a bit nervous about people coming up to have a look at what you are doing, sit with your back against a wall or large tree.

Next, you have to choose what and how much you are going to sketch. A useful piece of equipment to have is called a viewfinder. This is basically a rectangular piece of card with a rectangular hole cut into the middle. Use this by holding it up to your chosen subject, then move your arm backwards and forwards. This will cut out the unnecessary detail surrounding the subject you wish to sketch. Eventually, you will find that your eyes will automatically cut out the unnecessary detail, making it unnecessary to use a viewfinder, but this will only come with plenty of experience and practice.

The final thing you need to establish before starting a sketch is how long you are going to spend on it. This, obviously, will

**OPPOSITE PAGE:**
*Hotel Calif, Spain.*
**Pen and watercolour wash.**

The black box on the photograph shows how a viewfinder can help with the selection of a scene to sketch.

depend on what you are sketching and, to a certain extent, the size of the sketch and the medium you are using. Other factors could include the weather, the place where you are sketching and how comfortable you feel.

## Which Medium to Use

As you have already discovered in this book, there are many mediums available to the artist, which is wonderful if you have a large studio in which to experiment. But when out sketching, what you take with you in terms of equipment will depend on the medium you choose. Let's start with the minimum.

Drawing is a great way to sketch because you do not need much in the way of tools and materials. All you need is paper, a pencil, a sharpener and an eraser. The paper can be a single sheet, in which case you need a drawing board to support the paper, otherwise use a sketch pad or book. There is a huge variety of pads and books available in different sizes and with different types of paper inside. If you have not sketched before, choose a sketchbook or pad with white cartridge paper inside and no bigger than A4 for the book and A3 for the pad. To draw with, you can choose from ink pen, biro, graphite, charcoal and pastel, or a combination of some of these. If using charcoal and pastel, remember that they are a dusty medium and would need to be fixed or carried home safely to prevent smudging.

When choosing a paint, most artists go for watercolour because it is small and easy to carry around. You can use any of the car-

tridge pads mentioned above, or a pad or book that contains watercolour paper. To keep what you are carrying to a minimum, take only a couple of brushes, one larger and one small, and use a set of watercolour pans which are designed for sketching outdoors. Don't forget to take water and a container to put it in.

Oil paint is a wonderfully expressive medium to work with, especially when sketching, but it has one major drawback. It takes a very long time to dry, which means you will have a wet oil painting to take home with you. Bear this in mind when sketching outdoors with oil. There are several products on the market that can help you with transporting a wet oil painting, but they tend to be expensive so unless you are going to take up oil sketching in a serious way, it is probably wise to stick to one of the other mediums, such as watercolour or acrylic.

As mentioned in Chapter One, acrylic paint is a very versatile medium. It can be used as a watercolour or oil paint and therefore the equipment you take with you would depend on how you are going to use it. It is an ideal substitute if you do not want to bring home a wet oil painting, as it can be used in the same way as oil and even fairly thick acrylic paint will be touch dry after a couple of hours. Just make sure that you do not store an acrylic painting where it will come into contact with another one in the same material, as acrylic paint will stick to itself even when dry.

With all of these mediums, should you decide to be seated when sketching you will need to take along a seat. Also, if sketching with paint you may decide to take an easel with you. But whatever you take, remember that you will have to transport it and then most likely carry it somewhere else, so do not take too much.

There is a huge range of sketch pads available for the artist.

The exercises in this chapter will deal with sketching with different mediums and will concentrate on what you can achieve with the medium when sketching buildings. As with the other chapters, there will be a list of tools and materials that will be used for each particular exercise. Each exercise contains a photograph chosen to get the best result from the particular medium and in some cases shows a specific area of the photograph indicated by a superimposed black box.

### EXERCISE: **SKETCHING WITH GRAPHITE PENCIL**

— OBJECTIVE: To learn how to use graphite pencil to sketch a building.

— MATERIALS: Smooth, white cartridge paper in pad or sheet form, 2B and 4B graphite pencils, pencil sharpener, smooth sandpaper, eraser, drawing board (optional).

Graphite, or lead pencil is one of the most readily available mediums to sketch with. It is cheap, small and easy to correct when things go wrong. It can be used on most dry, matt surfaces, although the rougher the surface, the more work involved in the sketch, so the list above recommends a smooth cartridge paper in either pad or sheet form. If doing the sketch on a single sheet, you will need a hard surface such as a drawing board to lean on. The photograph for this exercise has a box which indicates the area that will be the subject for this sketch and shows how much extraneous detail has been omitted.

BELOW: **Florence, Italy.**

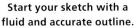

**Start your sketch with a
fluid and accurate outline.**

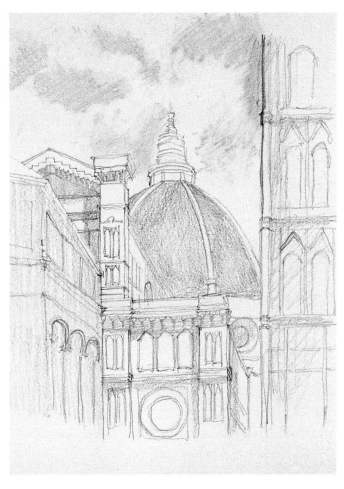

**Start to shade in the lighter areas
with the 2B pencil, including the sky.**

When starting a sketch, the important thing to remember is that you do not have to fill the whole page; in fact, it is better not to. The best place to start is somewhere in the middle, so make a few marks with your pencil to indicate the size of the sketch and where certain elements will appear so that your sketch does not fall off the edge of the paper. Then start your outline sketch.

Try to be as accurate as possible but maintain a fluid and lively pencil line. If you are too straight and solid with your pencil, the drawing will look too tight. Get all the outlines done and correct before beginning your shading.

Start to shade in the lighter areas with the 2B pencil, including the sky. Use your finger to blend some of the pencil marks in the sky and use your eraser to rub out some of the clouds from the grey shaded area. When shading the buildings, use a vertical shading technique to emphasize the vertical sides. Use a scrap piece of paper or tissue to protect the bottom half of the drawing from being smudged by your hand. Next, use the 4B

pencil to put in the darkest parts of the drawing. Keep a sharp point to your pencil by rotating the pencil through ninety degrees every so often, or use a piece of sandpaper to sharpen the pencil. Just concentrate on the very dark areas of your picture, such as windows, arches and under ledges. The 2B pencil could be used for this, but you would have to press harder to achieve the same result as the 4B pencil. When this is done, it is time for the next and final stage, which is to put in the shadows.

To do the shadows, use your 2B pencil and shade in the areas underneath the ledges and the sides of the buildings. Try to maintain a softness to the shading. If you lose some of the original outlines, put these back in with a sharp pencil to finish off your picture.

What you should have is a sketch with accurate but loose pencil lines and a good tonal range, in other words, a graduated range of greys from light to dark. If you do not have this tonal range, use your eraser to lift out some highlights and your 4B pencil to strengthen some of the very dark areas.

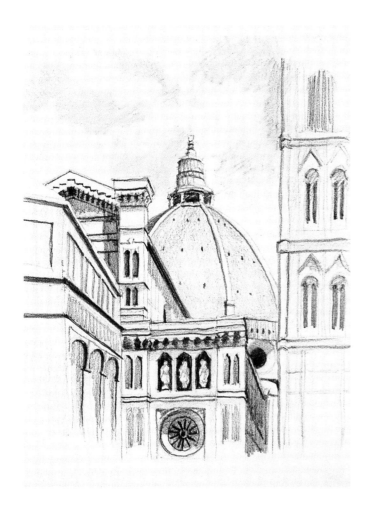

ABOVE: **Use a combination of the 2B and 4B pencils to shade in the rest of the sketch.**

RIGHT: **San Diego, California, USA.**

## EXERCISE: **SKETCHING WITH WATERCOLOUR PENCILS**

— OBJECTIVE: To use watercolour pencil to sketch a light-coloured building.

— MATERIALS: White, 'Not' surface, 300gsm (140lb) watercolour paper, watercolour pencils, watercolour brush, water container, tissues or small piece of natural sponge. A 2B pencil, pencil sharpener and eraser are optional.

Watercolour pencils are an excellent medium for sketching. They can be used dry on a smooth, dry surface, or, when wetted with a brush, can be used as a watercolour on watercolour paper. They are not as strong as watercolour paint when used over a large area, but can produce subtle colours and when combined with their dry characteristics can produce a variety of textures and colours. You only need a handful of the pencils when sketching outside, which makes them convenient to carry around. The photograph that we will do the sketch from has been selected for its subtle range of warm greys and blues, which is achievable with the watercolour pencils. The strong sky colour, however, is too strong so we will change that to a blue sky with clouds.

Start your sketch by drawing in the outlines using a warm grey colour for the building and a dark green for the palm trees. The watercolour pencils are a bit more difficult to erase should you make a mistake, so you could use a 2B graphite pencil, but make sure that the lines are not too dark as otherwise they will show through the watered-down pencil colour. There is a lot of detail

**113**

Start your sketch by drawing in the outlines using a warm grey colour for the building and a dark green for the palm trees.

Once you have shaded in the sky and building, wash over this with a damp brush.

in some parts of the architecture, especially the patterns on the dome. There is no need to put in the pattern at this stage. The detail in the small parts of the architecture is too elaborate for a sketch, so simply put in a few loose pencil lines to hint at the complexity of these parts of the building. When we do the shadows later, we can emphasize this detail a little more.

One of the problems with watercolour pencil is knowing how the colour will appear when wet, so if you are not sure do a test

**Shade in the darker parts of the building and more of the detail on the palm trees.**

**Finally, using a dark blue-grey put in some of the darker shadows.**

piece on the side of the paper before committing to your sketch. The blue of the sky in the photograph is very strong and would overpower the rest of the picture, so instead use a light blue to shade in some of the sky, leaving white areas for the clouds.

Next, shade in the grey architecture with the same light grey that you used for the initial drawing. Follow the direction of the surfaces; for example, the wall in the foreground is vertical so use vertical pencil strokes. When you have done the sky and grey

of the architecture, loosen the colour with a wet brush. The sky needs to be a varied shade of blue, so use wet and damp brush strokes in different places. If you push the blue around too much, use a damp tissue or sponge to blot the clouds out. Clean your brush and wet some of the grey on the building. Do not use a brush that is too wet, otherwise you will lose some of your initial outlines. Run a damp brush over the green of the palm trees to loosen them slightly.

When the paper has dried, start to strengthen some of the outlines with a dark grey. The texture of the paper will cause the pencil to lose its point quickly, so make sure that you maintain a sharp point; you can use a piece of sandpaper to do this. Put in some of the shadows but leave the darker ones until the end. When you have done this, use a light green to put in the leaves on the palm tree. Indicate the fronds on the leaves with your pencil strokes.

Next, use a sharp blue and yellow to put in the detail of the pattern on the dome. Don't forget that we are sketching, so there is no need to put in too much detail; just indicate the pattern with general shapes and shading. Use a damp brush to soften the shadows and the leaves on the palm trees. Do not wet the pattern on the dome as this is too detailed to be loosened with the brush. We can leave this bit dry. When this stage has dried, it is time to do the final step and put in the dark parts of the building and palm trees.

Use a sharp dark green to put in the darker parts of the leaves on the palm tree. Loosen this with a damp brush, being careful not to have too much water in the brush as we need to keep the detail of the fronds on the leaves. Finally, using a dark blue-grey, put in some of the darker shadows. You can wet these areas to make them darker, or leave them as a more subtle shadow.

This exercise has shown you how versatile and easy watercolour pencils are to use. If you are going out sketching and know the basic colours of the building you intend to sketch, then you only need to take a certain range of coloured pencils with you. If you do not have the exact colour, you can mix the pencils together on the side of the paper then brush this mix on with a damp brush. Make sure that the paper is dry before using the pencil, because if the paper is wet the pencil may damage it if used too hard. One more tip is not to make the picture or sketch too big. Watercolour pencils are a soft and delicate medium and are not strong enough, when used wet, to hold a large picture together.

### EXERCISE: **SKETCHING WITH CHARCOAL**

— OBJECTIVE: To learn how to sketch a building with charcoal.

— MATERIALS: Smooth, white cartridge paper, drawing board, charcoal sticks, tissues, easel (optional).

Charcoal has to be the cheapest yet most expressive form of drawing and sketching available to the artist. It has been used for hundreds and possibly thousands of years by artists as an expressive way of gathering information. It can be used as a medium in life classes, for preparatory drawings prior to painting and on a canvas before starting to paint, as well as for sketching. The best way to use charcoal is on a large sheet of paper that is pinned or taped with masking tape to a drawing board and the board placed on an upright easel. Obviously an upright easel is heavy and difficult to carry around, so there are alterna-

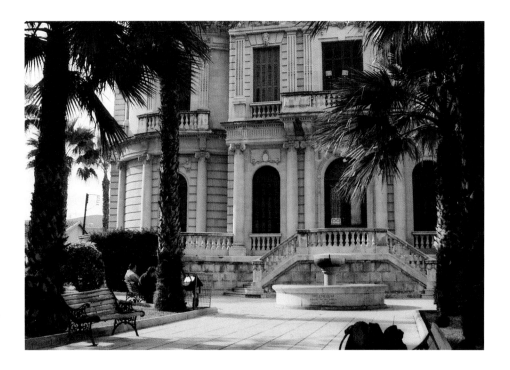

**Municipal Library,
Limassol, Cyprus.**

**Start your drawing by putting in the outlines of the building with quick broad marks.**

tives on the market called field easels, which are light, fairly easy to put up and can hold a drawing board up to A2 or A1 size. The only drawback is that because of their lightness a sudden gust of wind could blow the easel over, so, if you do not want the hassle of carrying one around and putting it up, or do not want to go to the expense of buying an easel, then you will have to work smaller and either stand up or sit down to do your sketch.

As mentioned above, charcoal is an excellent drawing medium for expressive and vigorous sketching, so the subject matter may be an important factor in the outcome of the drawing. The photograph in this exercise has a combination of strong vertical and horizontal lines in the architecture, but also has trees and foliage that frame the picture.

If using an easel, stand up at your drawing surface and use the charcoal almost at arm's length. If you stand too close, your work will end up too tight and detailed. If you do not have an easel, try not to move your wrist too much. Use sweeping movements of your whole arm from the shoulder and the elbow. This should generate a more expressive form of sketching and will stop you from becoming bogged down with detail.

In this exercise, the building is at the back of the picture with the trees framing it in front, so start your drawing by putting in the outlines of the building with quick, broad marks. Do not worry if you cannot get a straight line. If the lines are too straight they will appear rigid and lifeless. The best place to start is with a strong vertical line somewhere in the middle and to work out-

wards in both directions from this line. You will be working over an area that has already been drawn and because of the softness of charcoal you may smudge a few areas. If any lines become too smudged, go back in afterwards and re-establish them. Try to get everything in proportion and, most importantly, your vertical lines must be vertical, or the building will take on a slant. Do not put in any detail at this stage; just keep to the basic outlines.

The next stage is to put in the palm trees. These need to be expressed by vigorous strokes of the charcoal and the best approach is to 'flick' with the charcoal stick. Vary the length, strength and direction of the fronds, but keep most of them pointing down and towards the middle of the picture. This will help to frame the picture. To maintain a sharp edge on your charcoal stick, keep turning the stick every half a dozen strokes or so and you can also use both ends of the stick. The trunks of the palm trees will help to frame the sides of the picture, so be big and bold when drawing these in. Remember that this is a sketch, so if you find yourself getting too close to your picture it probably means you are putting in too much detail. Step back and have a look at what you have done so far. This will give you a good idea of the overall progress of the work.

The final stage is to put some detail and soft tone into the building at the back of the picture. Shade in the doors and windows, rubbing your finger over this to darken the drawing. Re-establish any hard outlines you may have lost when smudging

Put in the palm trees
with vigorous, expressive
strokes of the charcoal.

The final stage is to put some
detail and soft tone into the
building at the back of the picture.

and also run your finger over the building to soften some of the lines in places. This will help to push the building back slightly, giving an impression of distance between the trees and the building. The smudging of the charcoal will give you a mid-tone grey, which will link the black of the charcoal lines with the white of the paper. Use the side of the charcoal stick to put in some shadow in the foreground, then soften this with your finger. When this is done, your picture should be finished.

This exercise has shown you how to achieve a quick and expressive sketch using charcoal on white paper. The strong black lines of the charcoal, if done in a quick and fluid way, give a sense of movement to the picture. Do not get tied up with detail. Use the charcoal sticks to their potential by concentrating on the basic outlines, especially the palm trees, which help to frame the picture whilst also giving scale and movement.

You can also try using charcoal in conjunction with chalk on grey paper, but use the chalk in the same way as the charcoal. If you do a charcoal sketch outside, you will need to bear in mind that, when you have finished, the charcoal will smudge, so the best thing is to roll the paper up and either put an elastic band around it, or put it into a cardboard or plastic tube for easy transportation home.

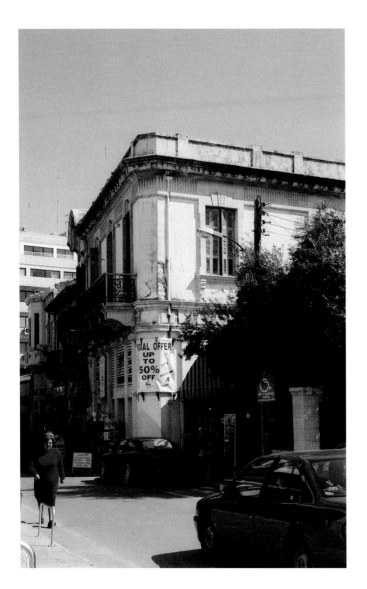

**St Andrew's Street,
Limassol, Cyprus.**

## EXERCISE: **SKETCHING WITH INK PEN**

— OBJECTIVE: To sketch a building with nib pen and bottled ink.

— MATERIALS: Smooth, white cartridge paper or Hot Pressed watercolour paper, fine point nib and nib holder, bottle of black drawing ink, drawing board (optional).

In previous exercises, we have done pen drawings and pen and wash paintings using disposable ink pens. Here, we will do a sketch of a building using an old-fashioned dip pen and a bottle of drawing ink. There is nothing wrong with using the disposable pens – in fact, they are easier to use and transport around than the conventional nib and bottle of ink – but they do not give the same crisp, expressive line that is achievable with the traditional dip pen. If you decide to sketch outside using the pen and bottle of ink, ensure that the bottle of ink will not get broken in transit and also secure it safely when using it so that it doesn't tip over. For transportation, I suggest making sure the lid is tight, then wrap the bottle in bubble wrap and insert this into a waterproof plastic container. You can also use the plastic container as something to put the open bottle of ink into when using it, perhaps putting a small amount of tissue in the bottom of the container to soak up any spillages and drips.

The 'Materials' list above suggests two types of paper, both of which are ideal for use with a pen. The first is cartridge paper, which is easy to get hold of in both sheet and pad form and is also economical. The alternative is smooth or Hot Pressed watercolour paper. This should be available in sheet form from your local art shop, but is not readily available in a pad. The advantage of the watercolour paper is that it is thicker, smoother and takes the ink better. Some cheaper cartridge papers may act like blotting paper, so get a good quality paper specifically manufactured for the art market. Loose sheets of paper will need to be fixed to a drawing board when you are working.

When sketching with a pen we would normally go straight in with it, but should you be a little apprehensive about this do a few light marks with a pencil first to put in the basic proportions and angles and then proceed with the ink drawing.

As with other drawings, start somewhere in the middle with a strong vertical line and work out towards the left and right of the picture. Use the pen as you would any other drawing implement, with the exception of 'pushing' the pen against the grain of the paper. Because of the fine point of the nib, pushing the pen against the grain of the paper will cause the pen to jump and may splatter ink onto the paper. Also, the more pressure you apply to the nib, the stronger the resulting ink line, so when doing the background apply only a little pressure, increasing it gradually as you move towards the front of the picture. Try to keep a fluid, sketchy line. Speed and accuracy are the key to sketching with a pen, so do not worry if your lines wobble or are

**Start sketching the building and the tree
on the right with quick, fluid pen marks.**

**Move across the picture, putting in more detail on
the right and less detail as you move towards the left.**

not completely straight. The important thing is that they should be in the right place.

The tree on the left needs to be done in a particular way. Use a doodling, scribbling line for the foliage, moving the pen in different directions and with a variety of marks. The nib may catch on the fibres of the paper now and again, so when dipping the nib into the ink make sure there is not too much ink on the nib, otherwise it will splatter.

Start to move across the picture using stronger lines for the foreground, the figure, the foliage and the right-hand side of the building. The distance needs to be looser and lighter than the foreground.

When you are confident that you have completed the outlines of the sketch, now is the time to start the shading. Begin with the darkest parts, such as the foliage, under the tree and in the windows. When shading under the tree, use vertical lines rather

than scribbling in the dark, otherwise it will look like part of the foliage. The light is on the side of the building facing you, so put some vertical lines on the left-hand side of the building to indicate the shade. To create a darker area you either apply more pressure with the pen, or do the ink lines closer together. Another technique you can employ is cross-hatching, but be careful not to overdo it as you will lose the vertical lines that give your building solidity and structure. Do not put anything dark in the distance. Remember that the further away something is, the lighter it should appear and this applies to pen drawing as much as anything else. As you are working up close to the sketch, step back and take a look to judge if there is enough contrast in the picture. If you are happy with the picture, then the final stage is to put in the foreground.

Most of this sketch has been shaded using vertical strokes of the pen, but the foreground, being horizontal, has to be shad-

**When you are happy that you have completed the outlines of the sketch, now is the time to start the shading.**

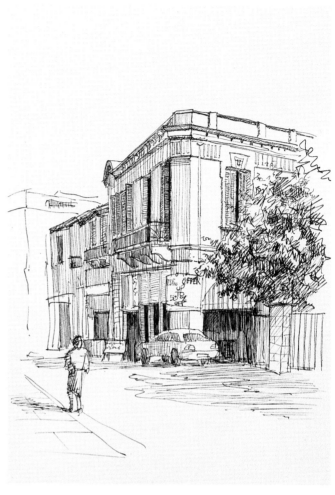

**Use vertical lines on the building and horizontal lines on the road for the shadows.**

ed using horizontal pen lines. Keep the actual road itself free of any ink so as to give the impression of sunlight and do the shadow of the tree using horizontal lines moving from right to left. Finally, shade in the left-hand side of the figure and the shadow thrown by the figure on the pavement. Do not worry about the facial features of the figure. The important part of the sketch is the building.

The traditional ink pen is an excellent tool with which to sketch buildings. You can vary the pen line depending on how much pressure you apply and therefore give the drawing a much more expressive feel. In this exercise, we have dealt solely with the ink pen without putting any colour or tint onto the drawing. This means that we needed to do a lot more shading than if we were doing a pen and wash sketch. In the next exercise we will use the pen again, but this time in conjunction with a monotone wash of watercolour paint.

### EXERCISE: **A MONOTONE SKETCH WITH PEN AND WASH**

— OBJECTIVE: To learn how to use the ink pen in combination with a single grey watercolour wash.

— MATERIALS: Smooth, white, Hot Pressed 300gsm (140lb) watercolour paper, watercolour paints, watercolour brush, water container, dip pen and bottle of drawing ink, tissues.

Most of the exercises in this book have dealt with the use of colour and how using only certain groups of colour, or what is called a limited palette, can help to 'pull' the picture together. In this exercise, we will deal with a technique that does the same as a limited palette, but we will be using the ink pen in conjunction with a single colour or what is called monotone. In Chapter One, we did a similar exercise using brown ink and paint called sepia tint. This exercise uses a grey paint with black

A French gatehouse in the Loire Valley.

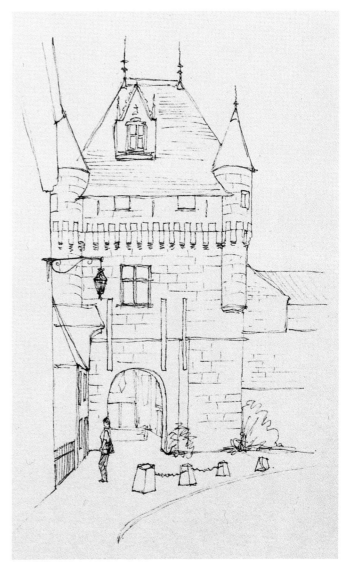

Sketch in the outlines of the building only.
There is no need to do any shading with the pen.

ink and a sketchier technique than that used in the Chapter One exercise.

Monotone sketching is an ideal technique to use because you only need an ink pen, a bottle of ink, grey paint, a brush and water. It is a wonderfully quick and easy medium to gather information or produce small sketches for use later in the studio. It will also teach you how to judge the light and dark areas of a subject, or what is called the tonal range. People often have problems with creating a three-dimensional feel to their painting because of a lack of shadows or light and dark. The only problem you may have is getting used to converting colours to black and white. One way of doing this is to squint at the sub-

ject. This will exaggerate the light and dark areas and cut back some of the colours. If you are doing your sketch from a photograph and have access to a computer, you can scan in the photo and convert it to black and white.

The photograph for this exercise has been chosen because of its overall grey colour, as this will make life easier for us when converting to a monotone colour.

Start with your pen drawing. This is exactly the same technique as in the previous exercise, so we will not be going into any great detail about this part of the sketch, except that because we are putting paint on afterwards we do not need to do any shading in with the pen. Do all of the shading with the

**Begin painting with a light grey but, whilst this is still wet, drop in some darker grey to break up the colour.**

**The next stage is to put in the darkest parts of the painting which are the windows and under the archway.**

paint, then put some on with the pen after the paint has dried if you feel the sketch needs it.

As with all watercolours, start at the top by painting in the sky. For this exercise, I have mixed a grey from ultramarine blue and burnt sienna. You could use any combination of brown and blue depending on what sort of grey you want or you could use a grey, such as Payne's grey, straight from the tube. Mix up a dark grey and, with a bit more water, a lighter grey so that you do not paint the same strength of grey all over the picture. Start light and slowly work towards dark. To begin with, paint a fairly light grey over the building but vary it in places by dropping some of the darker grey into the wet paint on the paper. This will break up the larger areas. Next, put

in the dark grey building on the left and the shadow that falls across the foreground. This will frame the left and bottom of the picture.

The next stage is to put in the darkest parts of the painting, which are the windows and under the archway. Use a stronger mix of grey and a smaller round brush to paint the windows, some of the dark shadows and under the archway. This will make everything else look lighter and, therefore, easier to know when to finish.

Indicate some of the brickwork by painting a few of the bricks here and there using a light grey and, before the paint dries, soften some of the edges of the bricks to make them merge in with the wall.

Finally, once all the paint is dry, put in the lighter cast shadows, such as under the eaves and window recesses.

In this exercise, we have learnt how to produce a monotone sketch using pen, ink and watercolour paint. Another way of doing this is to use water-soluble ink when doing the drawing. This is a drawing ink which can be loosened, like watercolour pencils, with a damp brush and saves the need to take any paint with you when sketching outside. If using the disposable water-soluble pens, then you may find that the ink has a blue or purple tint to it and is very strong when wetted. This is not really a problem but can be a bit of a shock if you are not used to it.

**Finally, put in the lighter cast shadows such as under the eaves and window recesses.**

RIGHT: **A narrow street in Tuscany, Italy.**

## EXERCISE: **SKETCHING WITH GRAPHITE AND WATERCOLOUR PAINT**

— OBJECTIVE: To sketch buildings with graphite pencil and watercolour paint.

— MATERIALS: White, 'Not' surface, 300gsm (140lb) watercolour paper, watercolour paints, watercolour brush, water container, 2B and 4B graphite pencils, pencil sharpener, eraser, tissues.

One of the more traditional ways of sketching is using graphite pencils to do the sketch and watercolour paint to tint the drawing. The advantage of this method is that the pencil does most of the work; in other words, it will create the main structure of the sketch and can be used to indicate the light and dark areas with a variety of different shades. The pencil line is a useful tool to indicate brickwork, plaster, rooftops and foliage. The photograph chosen for this exercise has all of these elements.

If doing a normal watercolour painting of this scene, we would do a careful drawing of the buildings, just by drawing in the outline. When we sketch with the pencil we can put in as little or as much as we like. Here, we will put in most of what can be seen in the photograph including texture, foliage and the shadows.

Start sketching outlines with the 2B pencil somewhere in the middle of the picture and work your way out from here. Use quick and gestural marks, but try to keep angles, proportions and vertical lines accurate. Vary the pressure on the pencil to achieve light and dark lines and scribble the texture of brickwork rather than drawing in every single brick. For the rooftops use pencil lines that run parallel with the slope of the roof. For the distance you will need to use lighter pencil marks and less detail in the texture. As you move towards the front and bottom of the picture apply more pressure with the pencil and start to put in more detail in the walls and rooftops.

Next, use your 4B pencil to put in some of the darker areas, such as under the bridge, the foliage on the left and some of the wall texture and windows. Do not put anything too dark in the distance as this will make it jump forwards. There is not much light in the photograph, so have the light in your sketch coming from left to right. Shade in the sides of the buildings facing away from the light direction using vertical strokes of the pencil. These vertical pencil lines will help to express the structure of the building. Some of the buildings in the distance may look a little too light, so shade in gently on the front of a few of the buildings in the middle ground to get rid of some of the white paper. Vary the direction and pressure of the pencil to give the impression of rough and broken plaster.

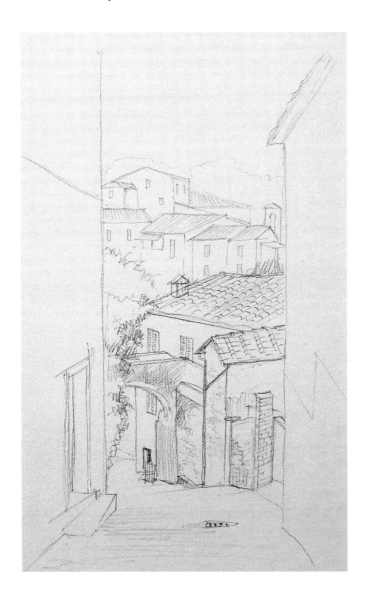

**Start sketching the outlines of the buildings using lighter pencil marks for the distance.**

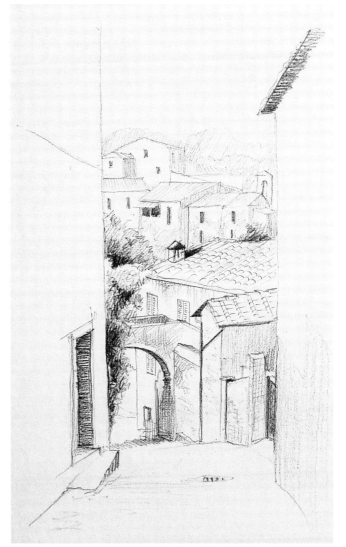

**Using your softer 4B pencil, shade in some of the darker areas.**

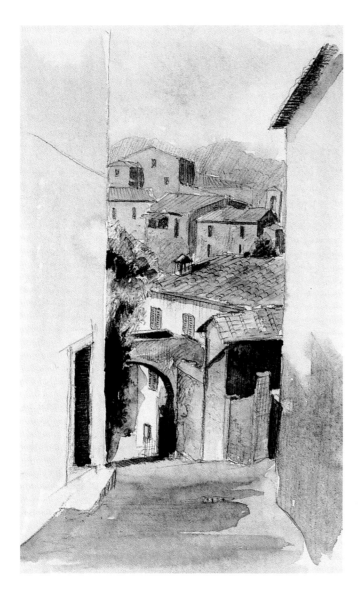

**Start painting at the top and back of your sketch, moving down the picture to the foreground.**

into the paper in the normal way. This is because the graphite is greasy. Work your brush into these areas to push the paint past the graphite and into the paper. Where there is a larger area, such as the roof in the middle of the picture, use a mixture of red, brown and grey in order to break up the picture. Do not fill each space with one flat colour as this will look boring. Keep moving down the picture towards the front, getting stronger and warmer as you go, finally finishing off with strong, warm colours for the vertical buildings on the left and right that frame the picture.

The final stage is to put in the darker areas and the shadows. Using a mixture of ultramarine blue and burnt sienna, paint in all the areas where there is dark shadow, such as under the bridge and in the dark parts of the foliage on the left. These already have a lot of graphite on them, so you may have to work the paint into the paper with the brush. If putting some shadow into the distance, add more water to your grey mix to lighten it. When the shadows have been done then the sketch is finished.

What we have explored in this exercise is the more traditional method of sketching with pencil and watercolour. We have used watercolour paper, but the sketch could easily be done on heavyweight cartridge paper so long as the watercolour paint is not made too wet. If too much water is used, cartridge paper will buckle and wrinkle, making it more difficult to work on.

### EXERCISE: SMALL SKETCHES WITH GRAPHITE PENCIL, PEN AND WATERCOLOUR WASH

— OBJECTIVE: To create a series of thumbnail sketches using graphite pencil, pen and watercolour wash.

— MATERIALS: White, 'Not' surface, 300gsm (140lb) watercolour paper, watercolour paints, watercolour brush, water container, ink pen, 2B graphite pencil, pencil sharpener, eraser, tissues.

All of the sketches in this chapter so far have been done as single pictures and roughly the same size. They are sketches in their own right, most of which, once framed, could stand on their own as a finished picture. In this exercise, we will learn how to use the sketching process as a tool for gathering information such as shadows and colour. These sketches will be quicker and smaller and may have notes written by the side of them for future reference. Because of its size, this type of sketch is sometimes referred to as a thumbnail sketch. If you have a large pad or sheet of paper, you can fit a few sketches onto the same sheet, but obviously the number of sketches on a piece of paper would depend on the size of the sketches and the size of the paper.

Thumbnail sketches are best done in a sketchbook, the size of which would be up to the individual artist, but normally does not exceed A4. Thumbnail sketches can be done in any medium, but are usually carried out using pencil and pen, with colour

When you are happy that you have done enough with the pencil, you can start painting. It may be a good idea to premix some of the colours, such as the greys and terracotta colour of the rooftops. Start with the sky area using ultramarine blue, then begin to move down the picture, changing to a blue-green for the distant trees and a blue-grey for the distant buildings. Paint as quickly as possible to maintain the sketchiness of the picture. Don't worry if the painted areas bleed into each other, as this will add to the feel of the overall sketch.

As you move down and to the front of the picture, start to use stronger paint and warmer greys. What you may find on the areas that have a lot of graphite on them is that the paint may not soak

The bridge over the river at Arundel, England.

BELOW: Three examples of thumbnail sketches.

being added with either coloured pencil or watercolour paint. What medium is used is entirely up to the individual artist, but if working in a sketchbook then you would need to use a medium that dries quickly.

For this exercise, we will do a thumbnail sketch from the photograph above, but you could also do a few from some of the other photographs used in the previous exercises. Some could be done with graphite pencil and watercolour and others with the pen. For the main exercise, we will use pen and watercolour wash.

As mentioned in the introduction to this chapter, one of the most difficult things is to select what to do. Use the viewfinder method or try to ask yourself which part of the scene interests you. Another deciding factor could be the reason you are sketching in the first place. Some artists have a specific subject in mind when they go out sketching, like windows or doors for instance. This will narrow down the subject matter for you. In the photograph chosen for this particular exercise there are a couple of buildings on the right with the sunlight on them and the bridge and water in the middle and foreground. This could make an interesting sketch in its own right, or we could do one small sketch of the buildings and one of the bridge and the reflection. The choice is yours but for this exercise do both the buildings and part of the bridge together.

Use the pen to start sketching the bridge and buildings. Remember this is a small thumbnail sketch, so do not worry about accurate drawing. We are gathering information about

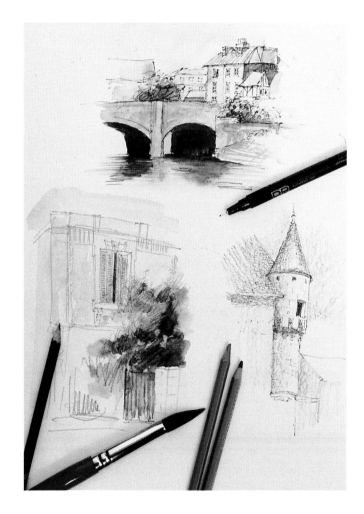

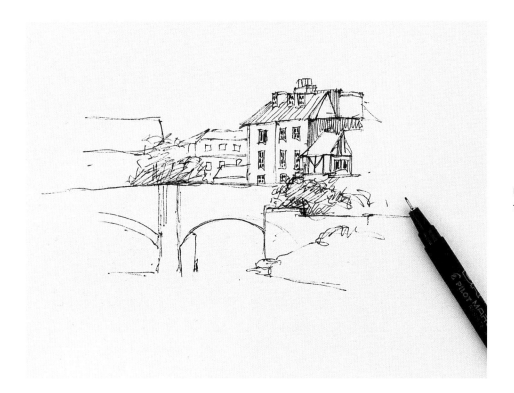

**Use the pen to start sketching the bridge and buildings.**

**Use the watercolour paint to put in the basic colours of the sky and buildings.**

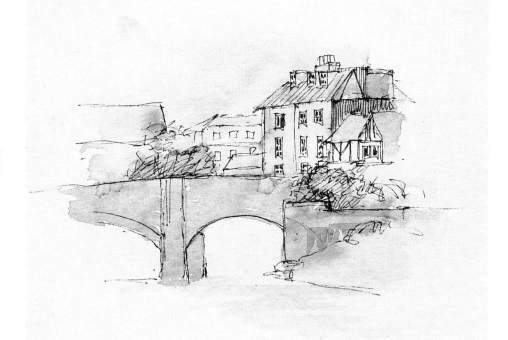

colour and shadow. Once the drawing has been done (this should not take any longer than fifteen minutes), we can start painting. Use the watercolour paint to put in the basic colours of the sky and buildings. Start with light paint and work quickly from the top to the bottom. Some of the painted areas may run into each other, but don't worry about that as it will add to the sketchy feel of the picture. Try to keep the colours fresh and light and use a limited palette such as a green and grey mixed with

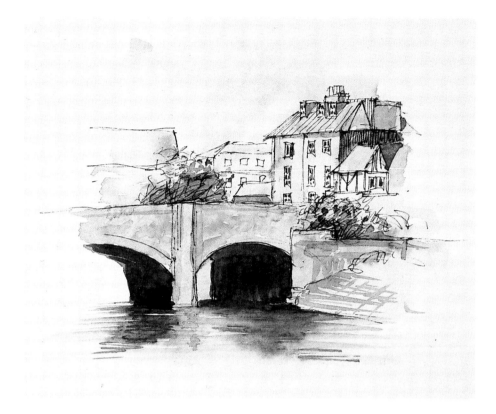

**The final stage is to do the dark shadows and water.**

the same blue as the sky. Whilst you have the blue sky colour on your brush, put some of this into the water under the bridge.

The final stage is to do the dark shadows and water. Use a strong mixture of ultramarine and burnt sienna and paint the shadow under the bridge. Use this same grey to put in the sides of the buildings and the trees that are in shadow.

This is a very quick way of sketching and is used to gather information for such things as light direction, shadows, colour and other useful subjects such as trees, bushes and people. Try a few little exercises using pencil, pen, watercolour or a combination of all three. Use the photographs from the exercises in this chapter to fill an A4 page with little sketches. Try using coloured pencil with pen or graphite with watercolour. Each one of these thumbnail sketches should not take any longer than thirty minutes to produce. The skill in producing quick sketches is to let the drawing part do most of the structural work for you and the colour, whether it be paint or pencil, is just used to tint the drawing.

So far, we have dealt with large-scale buildings without concentrating on detail. The speed of the pencil, pen and watercolour lends itself to doing quick sketches without the need to worry too much about detail. However, some artists prefer to sketch details of buildings and if a lot of detail is to be put in we need to use a medium that will allow us to do this. So in the next exercise we will use acrylic paint to do a detailed sketch of a window.

EXERCISE: **A DETAILED SKETCH OF A WINDOW**

— OBJECTIVE: To create a detailed sketch of a building feature using acrylic paint.

— MATERIALS: White acrylic painting paper, drawing board, acrylic paints, brushes, palette knife, palette, water container, tissues, easel (optional).

Acrylic paint is a wonderful substitute for oil paint when sketching outside because of its quick drying time. It can be used to produce the same result as you would get with oil paint without the problem of taking home a wet painting. In this exercise, we will be doing a sketch of a window. Acrylic paint is ideal for this sort of subject. The paint dries quickly and is opaque, so you can paint light on top of dark and therefore paint out any mistakes.

Compared to other sketching mediums, such as drawing and watercolour painting, there are a lot more tools and materials required, so you may need to limit the amount of stuff used for sketching outside. The list for this exercise suggests a specially made acrylic paper. This is a paper that has a slight canvas texture to it. It is not essential to have this paper as acrylic paint can be used on any matt surface including cardboard and wood, but the textured surface gives the sketch a bit more 'life' to it. You can use a sketch pad to paint into, but most artists will use a single sheet of paper or a canvas board. If you decide to do the

same, you will need a field easel to work on and a board to pin your paper to.

After doing a quick outline drawing in pencil, block in the wall colour using vigorous brush strokes that show up the texture of the paper. In this photograph, the wall colour is a mixture of white, yellow ochre and a small amount of crimson. Try to vary the thickness of the paint and change the colour slightly in places to give a rougher, more natural feel to the wall. Do not fill in the whole of your painting surface with the wall colour. We are just doing a sketch of the window and a small area of the wall around it.

Next, block in the general colour of the window and shutters. Because acrylic paint is opaque we can adjust the colour, once it has dried, with either light or dark paint, so paint the window with a mid-tone colour. We will add highlights and shadows at the next stage.

Using black and a small brush, paint in the louvres on the shutters. Do not worry about getting them straight or the same thickness – we are sketching and, therefore, aiming for an impression of the louvres. Use the same black to put in some shadows on the window frames and down the edge of the shutters. There is a small highlight on the light brown window frame. This can be put in with a small brush using a mixture of white and yellow ochre. When this has dried, put in the highlights on the louvres with white paint.

The final stage is to put in the shadows. Using a soft-haired brush, paint on a thin mixture of ultramarine blue and burnt umber. Look carefully at the direction in which the shadows are falling and the shapes they make. An accurate representation of the shadows will finish the picture off nicely.

This exercise has introduced us to sketching with a medium that allows us greater flexibility in the use of light over dark and vice versa. Acrylic can be used in a number of different ways, including using thick paint like oils or thin washes as with watercolour. It is also a useful medium to sketch larger pictures such as townscapes and landscapes.

## Summary

Throughout this chapter we have dealt with the exciting and rewarding technique of sketching. There is a huge variety of skills, techniques and mediums that can be used when sketching; far too many to cover in a single chapter. So the best advice is to try the basic pencil or charcoal sketching first and then move on to the colour sketching with paint when you are more confident with your drawing skills. Remember that the secret of sketching is speed and accuracy without being too tight, especially when sketching buildings, so try to achieve an accurate but loose feel to your sketch. The more you do, the better you

THIS PAGE:
**An open window with shutters, Nice, France.**

OPPOSITE PAGE:
TOP LEFT: **After doing a quick outline drawing in pencil, block in the wall colour using vigorous brush strokes that show up the texture of the paper.**
TOP RIGHT: **Next, block in the general colour of the window and shutters.**
BOTTOM LEFT: **With a smaller brush, start to put in more detail on the shutters and window.**
BOTTOM RIGHT: **Paint the washing and finish off with the shadows.**

will become, so whenever you plan a day trip out take a small sketchbook and a pencil, plus some watercolour paint or a few coloured pencils, and whenever you get a spare moment do a small sketch. It does not have to be a finished picture or anything too detailed. Just enjoy the moment and keep the sketchbook for future reference.

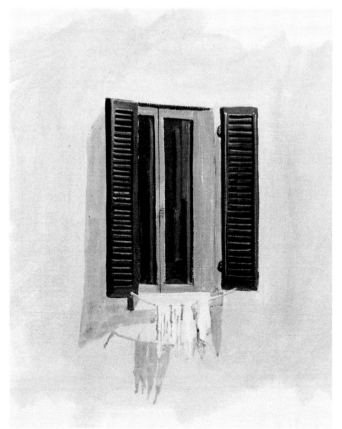

# ALTERNATIVE TECHNIQUES

Throughout this book we have dealt with drawing and painting buildings in a variety of mediums and using various techniques to achieve a mostly realistic result. Art is not just about faithful reproduction of a particular subject. It is also about personal expression, pushing the boundaries of your knowledge of a particular medium and experimentation. In this chapter, we will deal with these aspects of art in a number of exciting and challenging exercises. We will learn how to combine different types of drawing and painting materials and how to apply those mediums to different drawing and painting surfaces.

In previous chapters we learnt how to give a precise and accurate rendition of a building, staying faithful to the subject and, therefore, allowing the viewer to see exactly what is going on in the finished picture. Throughout this chapter we will learn how to give an impression of a building and how to use the impression to engage the viewer in a conversation and to take them on a journey of discovery that will enhance their reaction and enjoyment of looking at our finished pictures. Included in this chapter will be the use of mixed media, thick paint, strong and vibrant colour and how to achieve different textures and layers of paint. There will be the opportunity to experiment with different mediums, but the ultimate goal is to free our creativity and to produce works of art full of excitement, atmosphere and surprise.

## EXERCISE: **CREATING ATMOSPHERE WITH WET-IN-WET WATERCOLOUR WASHES**

— OBJECTIVE: To create atmosphere using wet-in-wet watercolour washes.

— MATERIALS: White, 'Not' surface, 300gsm (140lb) watercolour paper, drawing board, watercolour paints, watercolour

brush, water container, 2B graphite pencil, pencil sharpener, eraser, tissues.

Atmosphere in a painting can be created in a number of ways, including strong contrast and colour or more subtle tonal

**OPPOSITE PAGE:**
Detail from *Creating
a Textured Painting*.
Acrylic.

**THIS PAGE:**
**Marlborough College
Chapel, Marlborough,
England.**

**After doing a quick sketch, drop the watercolour
onto the wet paper and let it run.**

**Once the paper has dried completely, start
to paint in the lighter washes of colour.**

variations and softer colour. In this exercise, we will be using the more subtle, softer characteristics of watercolour paint, especially when used wet-in-wet. This will also allow us to experiment with colours we would not normally associate with the chosen subject, such as reds and yellows. Because we will use a lot of water for this technique it may be a good idea to stretch your paper or use a thicker paper to prevent buckling when the paper is wet. However, this is not essential. Just make sure your paper is taped down onto a stiff board, with the tape covering all four edges. If you are pre-stretching your paper, then prepare this the day before and leave it to dry flat overnight.

We could start the picture by painting in the wet-in-wet washes before doing the drawing. However, I prefer to put the drawing in first and then do the washes afterwards, so use your 2B graphite pencil to do a quick sketch of the building, in this case the church, and then wet your paper with plenty of clear, clean water. Allow the water to soak into the paper, then apply a little more water and even out the wash with your brush.

The sort of colours to use is entirely up to you, but as this exercise is about experimenting with colours not normally used in building and landscape paintings, now is the time to be brave. If it doesn't work out, start again on a fresh piece of paper. Whilst the paper is wet, drop in the colours you have chosen and let them move around on the paper by themselves. If you push them around with the brush they will mix on the paper and become muddy. Allow the colours to soak in and leave the paper

Using a mixture of dark blue and dark brown,
paint the dark shadows on the buildings.

Use the same dark grey mixture to paint in the cast shadow
on the ground and down the side of the building on the left.

flat to dry. Do not try to speed up the drying process by using a heat source such as a hair dryer. Not only will this push the paint around – if held too close it will also dry some areas out quicker than others and may create backflow shapes.

Once the paper has dried completely, start to paint in the lighter washes of colour. Use the same colours as for the initial wet-in-wet background wash, but use mixes of them to paint in the colours of the building and foliage. For example, mix the blue and yellow together for the trees and bushes. Use the original colours as much as possible, as introducing different colours at this stage will give the picture a disjointed feel.

Now it is time to put in some of the dark shadows. Using a mixture of dark blue and dark brown to create dark grey, paint

in the shadows on the building, especially under the eaves and in the windows, and any cast shadows that you can see. This will provide the contrast needed to give the impression of strong sunlight falling on the building.

Use some of this dark grey mixture to put in the final touches, such as the dark building on the left, the shadow it is casting across the foreground and the figures.

What we have achieved with this exercise is a feeling of warmth, sunlight and also a certain feeling of experimentation and excitement with the colours that we used in the original wet-in-wet wash. Some of these colours are still visible in places, helping to pull the picture together and give the picture a different feel from the traditional watercolour.

## EXERCISE: **USING BOLD PRIMARY COLOURS**

— OBJECTIVE: To produce a striking impressionist painting using primary colours and white.

— MATERIALS: White canvas board, acrylic paints, water container, brush, palette knife, palette, tissues.

Creating an impression of a building is as much about the colour as any other part of the painting process. The use of colour can depict mood, atmosphere and structure and can convey a certain feeling depending on the colours chosen. For this exercise, we will be using colours that give a warm and vibrant feel to the picture. To restrict the number of colours needed, we will be

Cape Trafalgar, Spain.

**Paint the drawing first, then wash over this with a thin reddish orange.**

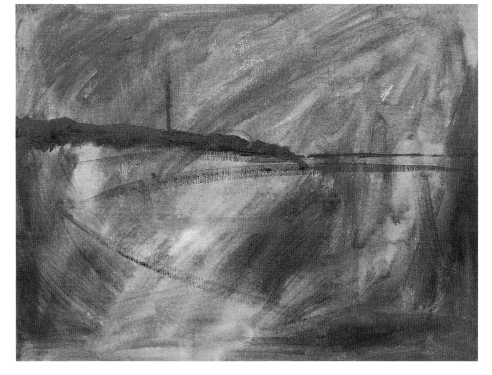

using the three primary colours: red (cadmium red), yellow (cadmium yellow) and blue (phthalo blue red shade), plus white. We will use minimum detail to give an impression of the lighthouse and will employ varied brush strokes with both thick and thin paint to give movement to the surface of the painting.

Start by putting in some colour where the lighthouse and horizon appear in the picture. You may need to move the horizon up or down, because the photograph has the lighthouse and horizon cutting halfway through the picture. If you move the horizon down you will create more sky area; if you move the horizon up you will create more foreground. The latter is my preferred choice.

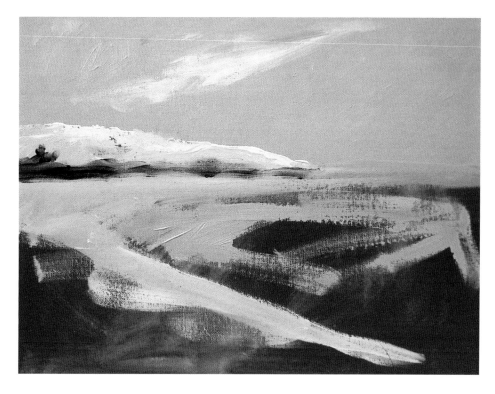

**Use vigorous brush strokes and thick paint to start off the painting.**

**The next stage is to go in with bolder, brighter colours, especially in the foreground.**

Use some white for the sparkle on the water and drag your fingers across the wet paint in some areas to give a mixture of hard and soft edges.

The final stage is to put in the lighthouse and buildings on the spit of land.

When this initial colour has dried, use a large brush to paint a thin wash of warm orange over the entire canvas. This colour will help to warm the picture and pull it together at the end.

The purpose of this exercise is to give an impression of the building in the landscape, so choose large brushes and sweep the paint on, using colours you would not normally associate with this subject. Block in the sky with a mixture of blue and white, using thick brush marks to maintain some kind of movement. Put in the spit of land with some white and a flash of pure yellow. Add some white to the orange colour you used for the initial wash and paint

in the sandy area across the middle of the painting. Use some of the sky colour to paint the water underneath the sandy area.

The next stage is to start going in with bolder, brighter colours, especially in the foreground. Using a bright orange, block in the foreground with brisk, broad marks of the brush and overlap the blue area in the middle, but do not cover it up completely. If you do not like the result, you can wait for it to dry and then paint over it. Pick up some white and yellow on your brush and paint in the middle sandy area underneath the spit of land. Do not overuse the brush as your paint will mix on the canvas and start to look overworked and muddy. Clean your brush regularly to maintain a freshness to the paint.

The only problem with using a brush all the time is that some of the edges can become soft and blurred. This works in the middle ground and distance, but the foreground needs more texture. So, using a palette knife, pick up some of the blue sky colour from your palette and spread this across the water area in the middle. Use some white for the sparkle on the water and drag your fingers across the wet paint in some areas to give a mixture of hard and soft edges. Do the same in the bottom left-hand area of your picture with a red-orange mixture of paint.

The final stage is to put in the lighthouse and buildings on the spit of land. Use a smaller flat brush to paint in the buildings and, whilst this paint is wet, put in the shadows down the right-hand side of the lighthouse to give a sense of the light direction. Do not be too fussy with this; too much detail will produce an image that does not fit in with the rest of the picture.

We now have a painting with bold sweeps of colour that make a statement and give an impression of warmth and vitality. Acrylic is an ideal medium for this technique. The colours are bright and the pigment is thick, while the fast drying time allows us to overpaint areas fairly quickly that have not gone the way we wanted them to. Oil paint can also be used in this way, but if problems occur during the painting process then the slow drying time of oil paint means that we would have to scrape off bad areas rather than painting over mistakes.

EXERCISE: **MIXED MEDIA – WATERCOLOUR AND PASTEL**

— OBJECTIVE: To use a combination of pastel and watercolour to produce soft colour washes and texture.

— MATERIALS: White, 'Not' surface, 300gsm (140lb) watercolour paper, drawing board, watercolour paints, watercolour brush, water container, 2B graphite pencil, pastel sticks and pencils, torchon (optional), pencil sharpener, eraser, tissues.

The term 'mixed media' is used by artists to describe a drawing or painting that has been created by using more than one medium. Any combination of mediums can be used. The only limiting factor is our imagination. When deciding which mediums to combine, we need to consider what sort of effect we are after. For this exercise, we will be combining the subtlety of wet-in-wet watercolour washes with the strength and texture of soft

*Ponte Vecchio*, Florence, Italy.

pastels. Most of the colour will be laid down by the watercolour, while the pastel will be used to add body, strength, shadow and highlights to our painting.

Because of the amount of water involved in the first stage you may need to stretch the paper; however, this is not essential. Tape your paper to a flat board with the tape covering all four edges.

After doing a basic drawing in pencil, use a large brush to wet the paper thoroughly and allow the water to sink into the paper slightly. This only takes a few minutes, so whilst this is happening, mix up the colours required for the initial wet-in-wet painting.

Apply the mixed colours straight onto the wet paper and allow the colours to flow freely into each other. Do not push the

**After doing the initial drawing, drop your watercolour onto the wet paper and let the colours run.**

**Using the same colours as for the wet-in-wet, start to block in the buildings and bridge.**

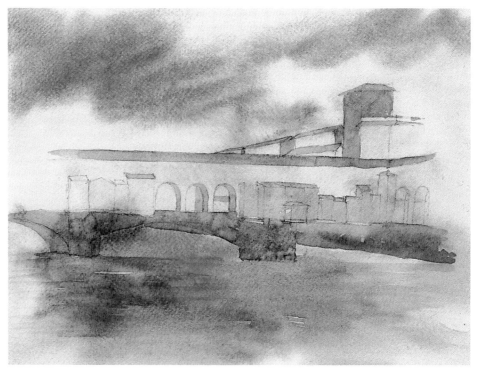

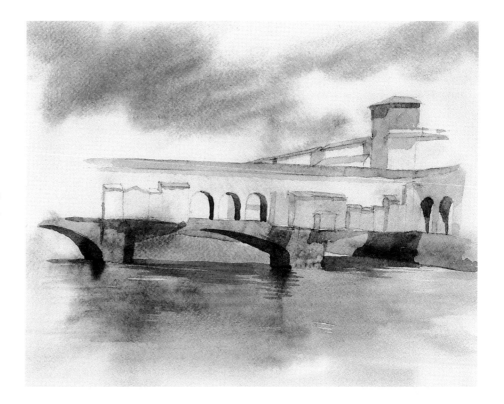

**Next, paint in the shadows with a mixture of dark blue and dark brown.**

**Use the pastels to put in the texture and detail of the buildings and the sparkle on the water.**

colours around with your brush as this will cause the paint to overmix and become muddy. Allow this wet-in-wet wash to dry thoroughly before moving onto the next step.

Using the same colours as for the wet-in-wet, start to block in the buildings and bridge. Work quickly across the painting so that some of the colours flow into each other. Once you have

**141**

put the paint onto the paper, do not go back in with the brush as you will overwork the area and lift the initial wet-in-wet wash. Strengthen the water under the bridge and in the foreground with horizontal brush strokes.

Next, paint the shadows with a mixture of dark blue and dark brown. After this, it is time to decide whether enough water-colour painting has been done and, therefore, whether we should start drawing with the pastel. We cannot put watercolour back onto the painting after we have started to use pastel as the watercolour will wash the pastel off the paper.

Using sharp pastel pencils, begin to draw in some of the detail, such as windows, shutters and some dark lines under the eaves of the rooftops. If the lines appear too strong and hard, gently run your finger over the line in one direction only. This will soften the line slightly, but do not rub too hard as this will discolour the watercolour around it. Continue to put in the detail and strengthen some of the lines and shadows. Use the pencils as if you were colouring in, but soften the pastel with your finger, or a paper stump or torchon, as the pastel will exaggerate the texture of the paper too much otherwise. When you have done enough on the buildings and bridge, use the side of a white pastel stick to put in the sparkle on the water. Again, if

you feel the texture of the paper is showing too much, run your finger over the pastel to blend some of the edges. When this is done the picture is finished.

What we have learnt in this exercise is how to combine two different mediums to produce a painting with soft flowing colour and also texture. Because of the powdery nature of pastel, the picture would need to be protected when storing it or, if possible, framed under glass to stop the pastel from smudging. An alternative method would be to use coloured pencils instead of pastel pencils. The coloured pencils are wax- or oil-based and do not smudge. However, this hardness means that we do not have the flexibility of being able to smudge them deliberately as we can with the pastels.

## EXERCISE: **MIXED MEDIA – CREATING A STORMY ATMOSPHERE**

— OBJECTIVE: To use watercolour and gouache to produce an atmospheric and stormy painting.

— MATERIALS: White, 'Not' surface, 300gsm (140lb) water-colour paper, drawing board, watercolour paints, gouache

**A hotel skyline in the Mediterranean.**

paint, 2B graphite pencil, pencil sharpener, eraser, watercolour brush, water container, tissues.

This is another mixed-media exercise, but this time we will be using two paint mediums that are closely related to each other: watercolour and gouache.

While watercolour is a paint used by many artists and students, gouache is unfamiliar to a lot of people. Gouache is a poster paint that was first developed to be used in the illustration industry. It is traditionally known as body colour and is an opaque paint that is water-soluble so can be thinned with water, but, like watercolour, can also be re-wetted after it has dried.

**Once you have dropped the grey paint onto the wet paper, tip the paper up at a 45-degree angle to make the paint run.**

**Paint the sea and the sand in the foreground, leaving a few white bits for the surf.**

Some watercolour artists will use the white gouache for small highlights because of its opacity, but we will be using the paint to put in the distant skyline shown in the photograph and will use the white to put the sparkle on the water.

The first step is to produce the stormy grey sky. The best way to do this is by using the wet-in-wet technique with the watercolour paint. After taping your paper to a board, mix up a strong dark grey using ultramarine blue and burnt umber, although not too much brown as this will produce a brown sky. After wetting your paper thoroughly, drop the strong grey paint into the top left-hand corner of the paper, then tip the paper onto its bottom right-hand corner so that the paint runs across the paper at a 45-degree

**Mix up a light blue-grey colour with the gouache and paint in the buildings.**

**Finally, add some thick white paint for the sparkle on the sea and the wave in the foreground.**

angle. Once you are satisfied with the stormy sky effect, place the paper back down onto a flat surface and, using a large piece of tissue, wipe horizontally across the bottom half of the paper to remove any paint that has strayed there. Another way to stop the paint running into this area is to wet only the sky area and leave the sea area dry, although the drawback with this technique is that the paint will stop at the dry paper then run horizontally across the division between the wet and dry areas. Allow this first step to dry thoroughly before proceeding with the next stage.

To paint the sea area, mix up a greenish blue with the same blue as used for the sky with a touch of raw sienna added. Start at the horizon, working your way down the paper with horizontal strokes of the brush. As you get towards the bottom of the paper add a little more raw sienna and water. The sandy area can be painted with a wash of raw sienna and raw umber. Allow these areas to dry thoroughly before proceeding with the next stage.

Draw the outline of the distant skyline using a 2B pencil. In the photograph, the buildings stretch all the way over to the left-hand side, but this would not work in the painting as it would make the sea look like a lake, so start the drawing just to the left of centre. Next, mix up a light blue-grey colour with the gouache and paint in the buildings, adding slightly more white for the distant buildings on the left. Overlap the coastline on the right-hand side and add some yellow ochre for the distant beach. When this is dry, add a little blue and black to the mixture and paint the darker parts of the buildings, including the windows, putting in more detail on the buildings to the right and less detail on the buildings in the distance as they move to the left.

Finally, add some thick white paint for the sparkle on the sea and the wave in the foreground. You will need to add a little shadow under the highlight on the wave, but do not make this too dark, otherwise it may jump out of the painting and draw the viewer's eye down to the bottom of the picture.

Some watercolour artists may say that we have used too much gouache in this painting, but if the colours and the paint are not too strong then we should have ended up with a good balance between the softness of the watercolour wash and the strength of the gouache paint.

### EXERCISE: **CREATING A TEXTURED PAINTING**

— OBJECTIVE: To use a photograph of an old wall to produce an impressionistic, textured painting.

— MATERIALS: White canvas board, acrylic paints, brush, palette knife (preferably a wide knife), palette, water container, tissues.

Not all drawings and paintings of buildings need to be accurate reproductions from life or from photographs. Buildings can be used to generate ideas and to experiment with colour and texture. As we have learnt throughout this book, buildings come in all shapes and sizes and in various styles and conditions. If you look closely at a building you will see that it is formed from a variety of materials and these can be affected by conditions such as environment, neglect and the elements. The condition of

**A photograph of an old wall. This will only be used as a guide.**

some older buildings can give us a huge source of reference material to work from, especially worn, faded and crumbling plaster walls. The subject chosen for this particular exercise is a good example of the texture and colour of one of these old and neglected buildings. The wall has faded and crumbling paint-work, cracks in the plaster and bits of the inner part of the wall are showing. In this exercise, we will learn how to take this type of subject to produce an impressionistic and textured painting using thick acrylic paint.

There are a number of ways to start a painting like this. Some artists prefer to do lots of preliminary sketches in both black and white and colour to get the composition right. We will do a brief

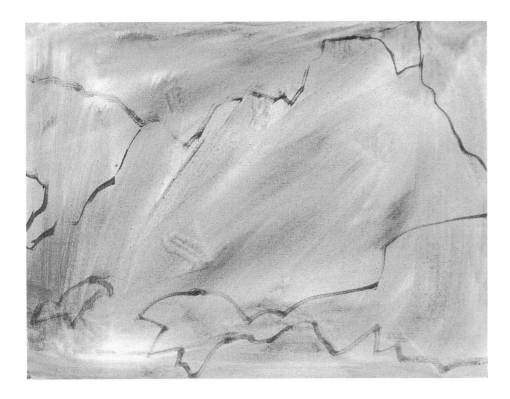

Start with a raw sienna wash on the canvas and, after this has dried, use a dark brown to paint in some cracks and patches.

Using a palette knife, spread some thick white paint over the canvas.

line drawing on the canvas prior to the application of the thick paint. We are not using the whole of the photograph, only one part of it, so you may want to mask off the area you are going to paint by placing some tape or strips of card on the photograph.

Start with a raw sienna wash on the canvas and, after this has dried, use a dark brown to paint in some cracks and patches. Use these to lead the eye around the canvas, thereby enhancing the compositional quality of the painting. Most of these lines will be covered up by successive layers of paint. so if anything needs to be corrected now is the time to do it.

Using a palette knife, spread some thick white paint over the canvas. The best way to do this is to use a wide palette knife and

**The next stage is to block in the basic colour of the wall.**

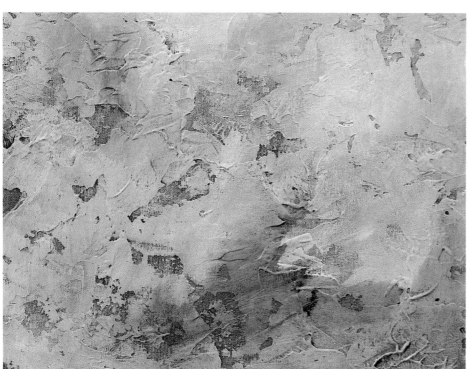

**Use a mixture of black and raw sienna to bring out the edges of the textured paint.**

the flat of the knife rather than the edge. This will enable you to create a 'hit and miss effect' – in other words, leave some areas of the raw sienna canvas showing through in places. Vary the thickness of the paint and also push and pull the knife to sculpt some areas of the texture. Most of the lines you originally drew will disappear under the thick paint, but this is not a problem as

we can paint in these areas later on. Leave the thick paint overnight to dry.

The next stage is to block in the basic colour of the wall. Squeeze out some white, black and raw sienna onto your palette and, using a large, round bristle brush, paint the wall using vigorous brush strokes. Vary the colour slightly as you paint, using

Paint the darker patches where the brickwork is showing through in places.

Finally, using a small brush, paint in the cracks and the brickwork.

more black, more white or more raw sienna, so that you achieve a varied pattern of slightly different colours to create a patch-work of faded and dirty paint.

When this stage of the painting has dried thoroughly, use a mixture of black and raw sienna to bring out the edges of the textured paint. Scrub on an area no bigger than 8cm (3in) square and, whilst this paint is still wet, wipe off the excess with a damp piece of tissue. The paint on the raised surface of the texture will be wiped off, leaving the dark brown mix to bring out the deeper recesses and some of the textured canvas sup-port. Use this technique over the whole of the painting surface. If you find the paint drying before you can finish the wiping off, spray water onto the paint with a plant sprayer.

The next step is to start to build up the composition of the pic-ture by painting darker patches of colour onto the wall. Using a mixture of burnt sienna, white and black, paint in the darker patches where the brickwork is showing through in places. Use a round brush with a good point so that you can get some sharp corners and lines on the patches. Do the same with the grey area at the bottom and a few white patches at the top. When this has dried, repeat the scrubbing on and wiping off technique described above.

Now it is time to put in some detail. Using a very small round brush with a good point, paint in the cracks with dark brown paint. Do not use black as this will create too much contrast and give the painting a cartoonish look. Use the cracks to lead the viewer's eye around the painting, varying the length and thick-ness to give a more realistic cracked plaster effect. Next, use white paint to put highlights on some of the raised surfaces. This will exaggerate the texture and give a more three-dimensional feel to the picture. Finally, add some deeper cracks and high-lights to the darker patches, in order to break up these larger dark areas and draw the eye into the painting.

A lot more could be done to this painting, such as adding weeds or peeling paint, or using it in combination with a paint-ing of a window or a door. The amount of work you put in will depend on what you are trying to achieve. This was an exercise in giving an impression of a crumbling old wall, so we have kept the amount of detail to a minimum.

## EXERCISE: **CREATING IDEAS USING A COMPUTER**

— OBJECTIVE: To learn how to use computer photo-editing software to generate ideas.

— MATERIALS: Computer, scanner, printer, photographic paper.

In this modern age, the computer, and everything associated with it, has, for most of us, become an everyday part of our lives. The art world is still very sceptical about the use of a computer in art, but, nonetheless, computer-generated art is slowly

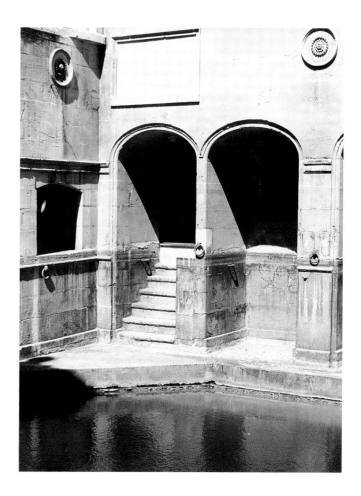

The Roman Baths,
Bath, England.

becoming recognized in its own right. With the proper equip-ment, software and experience, almost anything can be pro-duced on a computer and be called a work of art. A competent computer operator can fill an entire book on methods, skills and techniques that can be achieved with a computer, but for this exercise we will be concerning ourselves with the use of basic computer software and skills to help us to generate new and exciting ideas that we can use for our drawings and paintings.

The following ideas were generated using a basic home per-sonal computer and the photo-editing software that came with the PC when new. I have titled each section with the name that my particular PC gave to the editing technique I chose. You may have similar editing techniques available on your PC, but they may be called by a different name. After scanning in your pho-tograph, experiment with what your PC can do and then 'save as' to a specific folder once you are satisfied with the result. This will protect the original scanned image and allow you to carry out many more experiments using the same photograph.

## Litho

This particular technique has removed all the colour and converted the shadows and dark areas to black, giving us a good idea of where the shadows are in the photograph. This is an excellent way of helping us to determine the shapes of the shadows and the light direction without confusing us with colour. It helps us to concentrate on shapes and contrast and will give us ideas that we could, possibly, develop into a more abstract picture at a later date.

## Solarize

It is difficult to describe what this particular technique has actually done to the photograph. It would seem that the software has converted the warm colours to cool and the cool colours to warm, although this is open to interpretation. But it has without doubt provided us with a completely different look to the photograph and given us plenty to think about. Maybe this could be used as the basis of a wet-in-wet watercolour, using a limited palette of blues and yellows and allowing them to mix on the paper in order to create the green elements of the painting. The effect also has a metallic feel to it, so perhaps the use of metallic papers and card as a collage could provide us with yet another exciting and vibrant picture of a building.

## Jiggle

This is an interesting technique. The editing software has given all the lines and edges a zigzag effect. The initial reaction to this is that it looks a little mechanical and fairly obvious what has been done. However, take a closer look at certain areas of the photograph. The circular motifs on the walls at the top have become a flower shape, the reflections in the water have more of a ripple effect to them and the different colours and patches on the wall have become zigzag stripes of different colours. Any

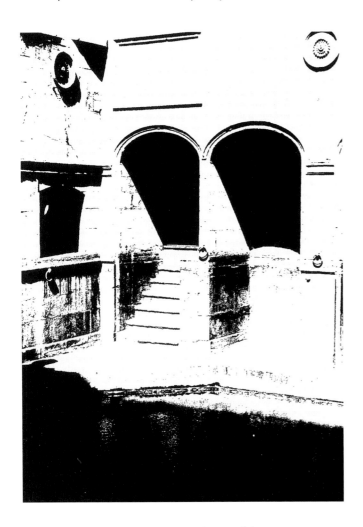

**Converted using a photo-editing technique called Litho.**

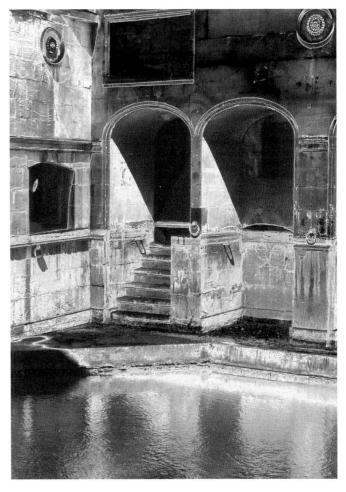

**Converted using a photo-editing technique called Solarize.**

or all of these could become useful ideas. The zooming and cropping tools in the editing software could be used to cut out any areas you feel don't work. Turning the picture on its side by rotating it through 90 degrees can give you another view. Note the triangular shapes formed by the steps and the shadows under the arches. These shapes could be used to produce an abstract image of triangles and lines and the colours would make an interesting contrast with those shapes.

## Litho and Jiggle

This is a combination of litho and jiggle and shows what can be achieved with more than one editing technique. It provides us with even more ideas without the complication of the colour. Again, rotating and inverting can give a different look and feel to the picture, while zooming in will focus on some of the shapes and lines that we would normally miss if looking at the picture as a whole.

## Curve

As mentioned earlier, it is amazing what can be achieved even with a simple, standard editing program on a PC. This technique has taken part of the photograph and curved it upwards, completely transforming this section of the picture. The shape created by the steps and shadow under the arch is now crescent-shaped rather than triangular. Even though this is quite a significant change to the original image, it is still recognizable as a building or part of a building. Reproducing the curved area as an accurate representation of the image without the rest of the picture would make a wonderfully quirky and unusual painting.

## Wave

This is the most dramatic and, therefore, the most abstract of all the images created so far. It is difficult to imagine that this was once an image of a building, although it does still contain an

**Converted using a photo-editing
technique called Jiggle.**

**Converted using a combination
of Litho and Jiggle.**

151

**Converted using a photo-editing technique called Curve.**

**Converted using a photo-editing technique called Wave.**

element of structure. There is a sense that we are looking up the inside of a tower with a green glass ceiling. The steps have been moved to the top right, the shadows from the arches have been split and spread around the image and the motifs have been squashed and moved to the edges of the picture. While this could be painted as it is in the photograph, it would in practice be preferable to soften or break the hard line that appears to split the picture vertically.

The results produced in these exercises are just a small selection of what can be achieved with just basic software programs. If you have access to a PC with a specific photo-editing software program added to it, then there is almost no limit to what can be achieved. Experimenting with these techniques is also a good way of generating ideas that can be enlarged upon with the use of more traditional drawing and painting mediums.

## Summary

This chapter has dealt with techniques that may not be familiar to you as a way of drawing and painting buildings, but they are an excellent way of experimenting with the different mediums available to the artist. There is no limit to what can be achieved and we really are only limited by our imagination. One useful exercise is to produce a sketchbook that incorporates cuttings from newspapers, magazines and any old photographs you may having lying in the bottom of a drawer somewhere. Use these to produce sketches in both black and white and colour. Make photocopies of these pictures and cut them up, move them around, paint over them, use the computer to invert the colours, flip the image and print these off to stick into your sketchbook. You will be surprised at how many ideas can be generated from virtually nothing.

# SUPPLIERS

All contact details correct at the time of writing.

**Daler Rowney Ltd.**
PO Box 10
Bracknell
Berkshire
RG12 8ST
Tel: 01344 461000
Fax: 01344 486511
Website: www.daler-rowney.com
*For a wide range of own brand drawing
and painting materials:*

**Winsor & Newton**
Whitefriars Avenue
Wealdstone
Harrow
Middlesex
HA3 5RH
Tel: 020 84274343
Website: www.winsornewton.com
*For a wide range of own brand drawing
and painting materials.*

**The Cumberland Pencil Company**
Southey Works
Greta Bridge
Keswick
CA12 5NG
Tel: 017687 80898
Website: www.pencils.co.uk
*Manufacturers of a large selection
of drawing materials.*

**Rosemary and Co.**
PO Box 372
Keighley
West Yorkshire
BD20 6WZ
Tel: 01535 600090
Fax: 01535 609009
Email: rosemary@rosemaryandco.com
Website: www.rosemaryandco.com
*Manufacturers and suppliers of handmade artists
brushes. Mail order only.*

**Hobbycraft**
Westgate Park
Fodderwick
Basildon
SS14 1WP
Tel: 0126 82240100
Website: www.hobbycraft.co.uk
*Suppliers of art and craft materials with branches nationwide.*

**Gadsby's**
22 Market Place
Leicester
LE1 5YP
Tel: 0116 2517792
Fax: 0116 2517792
Email: info@gadsbys.co.uk
Website: www.gadsbys.co.uk
*An art materials retailer with branches
across the Midlands and North East England.*

**Society for All Artists (SAA)**
PO Box 50
Newark
NG23 5GY
Tel: 0800 9801123
Fax: 01949 844051
Email: info@saa.co.uk
Website: www.saa.co.uk
*Mail order supplier of art and craft*
*materials including books and dvds.*

**Atlantis Art**
7-9 Plumbers Row
London
E1 1EQ
Tel: 020 73778855
Fax: 020 73778850
Website: www.atlantisart.co.uk
*Supplier of art and craft materials.*

**Bird and Davis Ltd.**
45 Holmes Road
Kentish Town
London
NW5 3AN
Tel: 020 74853797
Fax: 020 72840509
Email: birdltd@aol.com
Website: www.birdanddavis.co.uk
*Suppliers of canvas, stretcher frames,*
*art materials and easels.*

**Green and Stone of Chelsea**
259 Kings Road
London
SW3 5EL
Tel: 020 73520837
Fax: 020 73511098
Email: sales@greenandstone.com
Website: www.greenandstone.com
*Retailer selling traditional artist materials*
*including raw pigment and antique papers.*

**Jackson's Art Supplies**
1 Farleigh Place
Farleigh Road
London
N16 7SX
Tel: 020 72540077
Fax: 020 72540088
Email: sales@jacksonsart.com
Website: www.jacksonart.co.uk
*A retailer and mail order supplier of art materials.*

**John Jones Framing and Art Shop**
4 Morris Place
Stroud Green Road
London
N4 3JG
Tel: 020 72815439
Fax: 020 72815956
Email: info@johnjones.co.uk
Website: www.johnjones.co.uk
*Retailer and warehouse offering bespoke*
*picture framing and art materials.*

**Stratford and York Ltd.**
Whickham Industrial Estate
Swalwell
Newcastle-upon-Tyne
NE16 3BY
Tel: 0191 4960111
Fax: 0191 4960211
*Manufacturers of fine art, handmade brushes.*

**Heaton Cooper Studio Ltd.**
Grasmere
Ambleside
LA22 9SX
Tel: 015394 35280
Fax: 015394 35797
Email: info@heatoncooper.co.uk
Website: www.heatoncooper.co.uk
*Suppliers of art materials. Mail order available.*

**Ken Bromley Art Supplies**
Curzon House
Curzon Road
Bolton
BL1 4RW
Tel: 0845 3303234
Fax: 01204 381123
Email: sales@artsupplies.co.uk
Website: www.artsupplies.co.uk
*Suppliers of art materials. Mail order available.*

**Burns and Harris (Retail) Ltd.**
97-99 Commercial Street
Dundee
DD1 2AF
Tel: 01382 322591
Fax: 01382 226979
Email: shop@burns-harris.co.uk
Website: www.burns-harris.co.uk
*Suppliers of art and craft materials.*

**Greyfriars Art Shop**
20 Dundas Street
Edinburgh
EH3 6HZ
Tel: 0131 5566565
Email: info@greyfriarsart.co.uk
Website: www.greyfriarsart.co.uk
*Suppliers of art materials.*

**Artworker**
Unit 1-3
1-6 Grande Parade
Brighton
BN2 9QB
Tel: 01273 689822
Email: sales@artworker.co.uk
Website: www.artworker.co.uk
*Suppliers of art materials and graphic supplies.*

**Bovilles Art Shop**
127-128 High Street
Uxbridge
UB8 1DJ
Tel: 01895 450300
Fax: 01895 450323
Email: sales@bovilles.co.uk
Website: www.bovilles.co.uk
*Retailer and supplier of art and craft materials. Branches in the home counties.*

**Great Art**
Normandy House
1 Nether Street
Alton
GU34 1EA
Tel: 0845 6015772
Fax: 01420 593333
Email: welcome@greatart.co.uk
Website: www.greatart.co.uk
*Mail order suppliers of art and craft materials.*

**The Art Shop**
8 Cross Street
Abergavenny
NP7 5EH
Tel: 01873 852690
Fax: 01873 852690
Email: enquiries@theartshop.org.uk
*Suppliers of art materials and books. Framing service available.*

**Harris-Moore Canvases**
Unit 108
Jubilee Trades Centre
130 Pershore Street
Birmingham
B5 6ND
Tel: 0121 2480030
Email: sales@stretchershop.co.uk
Website: www.stretchershop.co.uk
*A maker of bespoke artists' stretched canvases and linens.*

**Discount Art**
18 Wood Street
Wakefield
WF1 2ED
Tel: 01924 201772
Fax: 01924 369171
Email: info@discountart.co.uk
Website: www.discountart.co.uk
*Retailer and supplier of art materials. Mail order service available.*

# FURTHER READING

**Buildings in watercolour**
*Author*: Ray Campbell Smith
*Publishers*: Search Press (Leisure Arts series)

**Perspective**
*Author*: Ray Campbell Smith
*Publishers*: Search Press (Leisure Arts series)

**Perspective. Depth and distance**
*Author*: Geoff Kersey
*Publishers*: Search Press

**Artists photo reference: Buildings and barns**
*Author*: Gary Greene
*Publishers*: North Light

**Drawing and painting buildings**
*Author*: Richard Taylor
*Publishers*: David and Charles

**Painting weathered buildings in pen, ink and watercolour**
*Author*: Claudia Nice
*Publishers*: North Light

**A complete guide to perspective**
*Author*: John Raynes
*Publishers*: Collins and Brown

# GLOSSARY

**Acrylic**: A water-based paint that can be used both thick like oils or thin like a watercolour.

**Alla Prima**: A painting done from start to finish in a single sitting.

**Blocking in**: A basic application of flat colour.

**Brickwork**: This refers to any wall or building made from bricks.

**Canvas board**: A stiff board covered in canvas and primed for painting.

**Canvas**: Traditional painting surface used by oil and acrylic painters.

**Cartridge**: A standard, acid-free drawing paper.

**Charcoal**: A drawing medium made from charred willow sticks.

**Chateau**: French word for a castle.

**Cold-pressed**: Middle range of slightly textured paper, sometimes referred to as 'Not' surface.

**Colour chart**: A useful tool for quick colour reference.

**Coloured pencil**: A hard wax- or oil-bound coloured pigment encased in wood.

**Composition**: This refers to the design and balance of the picture and helps the viewer's eye around the picture.

**Conte crayon**: A hard, compacted, coloured stick similar to a chalk pastel.

**Contrast**: The difference between light and dark.

**Cross-hatching**: A technique used in drawing to shade in a darker tone.

**Dark**: A paint mixed from dark blue and dark brown and used as an alternative to black.

**Dip pen**: Traditional nib pen used for drawing with ink.

**Dry brushing**: A technique used to create texture by painting with more pigment and less mediums such as water and thinners.

**Eyeline**: In perspective, this is the horizon.

**Fixative**: A spray used to prevent chalk pastel and charcoal drawings from smudging.

**Flat wash**: A single continuous layer of watercolour paint.

**Focal point**: Used in composition to place an important element of your picture.

**Foliage**: A general term for trees, bushes and leaves.

**Foreground**: The area of a picture at the bottom or front of a picture.

**Glazing**: A thin wash of colour that is painted over an existing drier layer of paint.

**Gouache**: This is a water-based poster paint first developed for use in the illustration industry.

**Granulation**: The effect caused by some watercolour paints that settle into the grain of the paper.

**Graphite pencil**: A standard drawing pencil available in varying degrees of hardness.

**Hog**: A traditional brush used by oil and acrylic painters. Sometimes referred to as 'Bristle'.

**Hot-pressed**: Smooth watercolour paper.

**Life drawing**: Drawing the human figure from a life model.

**Limited palette**: A small collection of colours used in a single painting.

**Linseed Oil**: A medium used to thin oil paint.

**Medium**: A term used to describe a drawing or painting material.

**Mixed media**: A drawing or painting done using more than one type of medium.

**Monotone**: A term used to describe a single colour.

**Mount board**: A hard, smooth card that is used to frame pictures under glass.

**Negative shapes**: The spaces between objects.

**Opaque**: Thick paint that completely covers the painting surface or the previous layer of paint.

**Palette knife**: A tool for mixing paint on a palette. Can also be used to apply paint to a painting surface.

**Palette**: Flat or indented tray used to mix tube paint.

**Pan**: Small plastic cup filled with watercolour paint.

**Panoramic view**: A long, thin horizontal view of a building or rows of buildings.

**Pastel pencil**: Coloured chalk pastel encased in wood.

**Pastels**: Coloured drawing sticks bound with either chalk or oil.

**Perspective**: The illusion of three dimensions on a two dimensional surface.

**Pigment ink pens**: Modern, disposable version of the dip pen.

**Primary colours**: These are the three basic colours of blue, yellow and red.

**Primer**: A thick, white paint used to protect the surface of the canvas from the oil paint. Sometimes referred to as 'Gesso'.

**Proportion**: The relationship between the width and height of a building.

**Protractor rulers**: A mechanical aid for checking angles in perspective.

**Putty eraser**: Very soft eraser used for lifting out delicate areas of a drawing.

**Rule of thumb**: A technique used by artists to check proportions and angles.

**Sable:** Natural animal hair used to make soft, fine quality brushes.

**Scrub**: A very loose and vigorous application of thick paint.

**Sepia tint**: A painting done using dark brown ink or paint.

**Sepia**: Very dark brown ink or paint.

**Sketch**: A drawing or painting done quickly and in one sitting.

**Stay Wet Palette**: A palette specifically for acrylic paint.

**Stonework**: This refers to any wall or building built from any natural stone.

**Terracotta**: A red-brown colour normally used to paint roof tiles and plant pots.

**Thatch**: This refers to the reeds used to make a thatched roof.

**Thumbnail sketches**: Small pencil sketches done prior to painting to determine composition and shadows.

**Tonal balance**: A graduated range of greys from light and dark.

**Tonal value**: How a colour appears in black and white.

**Torchon**: A stick of compressed paper used to blend soft chalk pastels.

**Turpentine**: A solvent used to thin oil paint and clean brushes.

**Underpainting**: An initial stage of painting done to establish line, composition and tone.

**Vanishing point**: This is the point on the horizon where perspective lines converge.

**Viewfinder**: A rectangular piece of card with a rectangular hole cut into the middle to help the artist select a view when sketching outside.

**Wash**: A thin, dilute mix of watercolour.

**Water-soluble coloured pencil**: The same as a coloured pencil but with the added benefit of a pigment that can be loosened with water.

**Wet-in-wet**: The application of watercolour onto wet paper.

# INDEX

The abbreviation 'ex.' refers to an exercise within the book.